MICHAEL ARCHER was born in London in 1954 and educated at Cambridge and Manchester. He is the author of Jeff Koons: One Ball Total Equilibrium Tank (2011), and of the chapters on art since 1960 in Hugh Honour and John Fleming's A World History of Art (2005). A contributor to Installation Art (Thames & Hudson, 1994), he has written numerous catalogues and writes regularly for Artforum. He is Professor of Art at Goldsmiths College, London.

Thames & Hudson world of art

This famous series provides the widest available range of illustrated books on art in all its aspects.

the om. iload

Michael Archer

Art Since 1960

Third edition

253 illustrations, 124 in colour

Thames & Hudson world of art

For Petonelle

Any copy of this book issued by the publisher as a paperback is sold subject to the condition that it shall not by way of trade or otherwise be lent, resold, hired out or otherwise circulated without the publisher's prior consent in any form of binding or cover other than that in which it is published and without a similar condition including these words being imposed on a subsequent purchaser.

First published in the United Kingdom in 1997 by Thames & Hudson Ltd, 181A High Holborn, London WCIV 7QX

www.thamesandhudson.com

© 1997, 2002 and 2015 Thames & Hudson Ltd, London

Second edition 2002 Third edition 2015

All Rights Reserved. No part of this publication may be reproduced or transmitted in any form or by any means, electronic or mechanical, including photocopy, recording or any other information storage and retrieval system, without prior permission in writing from the publisher.

British Library Cataloguing-in-Publication Data A catalogue record for this book is available from the British Library

ISBN 978-0-500-20424-5

Printed and bound in Malaysia by Tien Wah Press (Pte) Ltd

I. Gerhard Richter, 256 Colours,1974 (repainted 1984)

Contents

6	Preface
10	Chapter I The Real and Its Objects
60	Chapter 2 The Expanded Field
109	Chapter 3 Ideology, Identity and Difference
142	Chapter 4 Postmodernisms
182	Chapter 5 Assimilations
212	Chapter 6 Globalization and the Post-Medium Condition
246	Chapter 7 Art After 2000
276	Timeline
279	Select Bibliography
280	List of Illustrations
285	Index

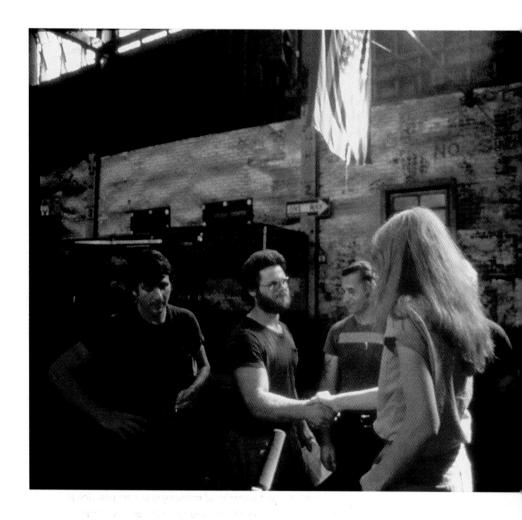

2. Mierle Ukeles, Touch Sanitation, 1978–80. This performance involved Ukeles shaking hands with every worker in the New York Sanitation Department. In doing so, she acknowledged the importance of the normally hidden support structures that make the white space of the gallery possible. At the same time, her action pointed out that because women are overwhelmingly left with the responsibility for domestic chores, they, too, are the invisible prop to the mainly male art world.

Preface

What is immediately noticeable about today's art, compared to art even a few decades ago, is an unprecedented profusion of styles, forms, practices and agendas. From the outset, it appears that the more one sees, the less certain one can be about what allows works to be designated 'art' at all, at least from a traditional point of view. For one thing, there are no longer any particular materials that enjoy the privilege of being immediately recognizable as art media: recent art is made not only with oil paint, metal and stone, but also air, light, sound, words, people, food, refuse, multi-media installations and much else besides. There are few, if any, conventional techniques and methods of producing art nowadays that can guarantee the finished work being thought of as art. A traditionalist can do little to prevent the outcome of even the most mundane activities from being considered art. That painting continues to be important has neither stemmed a rise in the use of other means of representation, such as photography and video, nor halted the adoption of other apparently less likely tactics in making art that have included going for walks, shaking hands and cultivating plants.

In 1961, at the start of a decade in which all previous assumptions about art were to be put to the test, the philosopher Theodor Adorno opened his Aesthetic Theory with the following statement: 'Today it goes without saying that nothing concerning art goes without saying, much less without thinking.' Even the way in which art, at least since the middle of the nineteenth century, had been understood as a challenge to the established social equilibrium has been called into question. And just what it means to describe a work as modern or as avant-garde has changed.

The richness and diversity of contemporary art practice is not, however, symptomatic of a chaotic state of affairs; certain themes reveal themselves and prevail in an overview such as this of the art of the past five or six decades. In particular, artists have re-examined some of the fundamental gestures of the modernist avant-garde made in the twentieth century and have reinterpreted them and carried them forward. Furthermore, as time increasingly divests them of obligations imposed by the

critical debates of previous decades, artists today display ever greater freedom in their choice of media and technique to convey meaning.

What follows is an attempt to account for the profound changes that have occurred and become accepted, not only in the art of Europe and the US from the beginning of Pop art onwards, but globally. Broadly chronological in its treatment of the subject, this book nevertheless uses a number of major themes to examine the huge variety of forms and practices that have appeared since then.

A renewed consideration of the relationship between art and everyday life connects the apparently very different works associated with Pop and Minimalism. Exploring the shared concerns behind these two tendencies provides an understanding of the wide range of post-Minimal work that has included Conceptual art, Land art, Performance and Body art, and the beginnings of Installation. All of this work of the 1960s challenged the modernist account of art history most particularly identified with the US critic Clement Greenberg (1909–94).

A consequence of this challenge has been the recognition that the meaning of an artwork does not necessarily lie within it, but as often as not arises out of the context in which it exists. This context is as much social and political as it is formal, and questions of politics and identity, both cultural and personal, have been central to much art since the 1970s. For instance, prime among the factors at that time, but still remaining of lasting significance, have been the profound impact of gender, feminist and postcolonial notions. Psychoanalytical, philosophical and other cultural theories became increasingly important towards the end of the 1970s in the formulation of a 'critical postmodernism'.

The work which these theories were used to interpret continued the questioning of the nature of art that had begun in the 1960s. Alongside this, however, was a resurgence of broadly traditional painting, which, viewed at the time as a largely conservative reaction to the experiments of the 1960s and 1970s, was supported by the explosion of the art market during the financial boom of the 1980s.

The final chapters of this book look at work in the 1990s, 2000s and beyond, art in which the themes and preoccupations of the preceding years are carried forward and transformed. Nowadays, for example, an expanding calendar of international survey exhibitions bears witness to the growing multicultural profile of the art world, while a rash of new museums of

contemporary art in major cities around the world indicates that some, at least, would now wish to argue that art is part of the larger entertainment and leisure industry.

That people are able to view it in such a way is evidence of a major shift that has occurred in the years charted by this book. The distinction between art and the everyday with which it begins has become increasingly irrelevant over this period, and it no longer makes sense to think of there being an essential contrast between these two terms. Just as older certainties over political and economic differences have been rendered unstable since the fall of the Berlin Wall in 1989, so art today finds itself in a radically altered environment. It is an environment that seems endlessly fluid, with few fixed reference points, and from this the eternal questions of what to make and how to display it, of how to judge and interpret it, and of what is good and what is right, draw renewed vigour.

Chapter I: The Real and Its Objects

At the beginning of the 1960s it was still possible to think of works of art as belonging to one of two broad categories: painting and sculpture. Cubist and other collages, Futurist performance and Dadaist events had already begun to challenge this simple duopoly, and photography had increasingly been making strong claims for recognition as an art medium. Nonetheless, the notion persisted that art essentially comprised those products of human creative endeavour that we would wish to call painting and sculpture. In the years since 1960 there has been a breaking down of the certainties of this system of classification. To be sure, some artists still paint and others make what tradition would refer to as sculpture, but these practices now take their place among a far wider range of activities.

A new magazine, Artforum, appeared on the West Coast of America in 1962. In tongue-in-cheek manner it made its position clear by giving pride of place in the first issue to a statement by Lester D. Longman, Chairman of the Department of Art at the University of California, on the occasion of the opening of a survey exhibition, 'The Art of Assemblage', at the Museum of Modern Art, New York. Over five pages Longman investigated and rejected much that is now notorious in the art of that time: the 'action painting' of Jackson Pollock (1912-56); the large paintings of Barnett Newman (1905-70), monochrome but for one or two thin stripes running down them; the blue canvases executed with a roller, or the performances involving nude women as 'paintbrushes' of Yves Klein (1928-62); the 'combines', such as Bed (1955), wall-mounted bedclothes smeared with paint, or Monogram (1959), a stuffed goat ringed with an old tyre, of Robert Rauschenberg (1925-2008); the sculptures of crushed car bodies by César (1921-98); the mechanized junk sculptures of Jean Tinguely (1925-91) - one of which, Homage to New York (1960) [4], had famously self-destructed in the gardens of New York's Museum of Modern Art in 1960 - and the Happenings of Allan Kaprow (1927-2006), Claes Oldenburg (b. 1929), Jim Dine (b. 1935) and Red Grooms (b. 1937).

Longman's objection to art of this kind was not that it existed, but rather that it seemed increasingly to be speaking for

Robert Rauschenberg, Bed, 1955

mainstream culture. He was right; it was. The work of Robert Rauschenberg and Jasper Johns (b. 1930) since the mid-1950s was referred to as neo-Dada because of its particular use of subject matter derived from the everyday world. Use of the term pointed less to the activities of Hugo Ball (1886-1927), Tristan Tzara (1896–1963) and others at the Cabaret Voltaire in Zurich in 1916, than to the work of the French artist Marcel Duchamp (1887-1968). Duchamp had invented the term 'readymade' to describe the mass-produced objects he chose, bought and subsequently designated as works of art. The earliest of these was Bicycle Wheel (1913), a bicycle wheel mounted on a stool; the most infamous, Fountain (1917), was a men's urinal signed 'R. Mutt'. With the readymade, Duchamp asked the viewer to think about what defined the uniqueness of the artwork among the multiplicity of all other objects. Was it something to be found in the artwork itself, or in the artist's activities around the object? These enquiries reverberate throughout the art of the 1960s and beyond.

There are two key ideas bound up in the word 'assemblage'. The first is that, however much the bringing together of certain images and objects might produce art, those images and objects never quite lose their identification with the ordinary, everyday world from which they were taken. The second is that this connection with the everyday, if one is unashamed of it, gives one free rein to use a wide range of materials and techniques not hitherto associated with the making of art. In the mid-1950s, Jasper Johns made a painting of the US flag, Flag (1954-55) [7]. The painting is certainly a picture of a commonplace object and symbol, but it can also be seen as a formal arrangement of colours, lines and geometric shapes. What is more, the flag in reality, consisting of colours on a piece of cloth, is no more substantial, three-dimensional and object-like than Johns's painting. The same was true of the targets he subsequently painted. At the beginning of the 1960s, following his 'combine' paintings, Rauschenberg produced a series of canvases containing a variety of silk-screened images as well as drawn and painted marks. These images were taken not only from the history of art, but also from the media. Just as images recur constantly in newspapers, magazines, and in one TV bulletin after another, so do elements in Rauschenberg's paintings. John F. Kennedy's repeated hand in Buffalo II (1964), for example, sets up a rhythm across the canvas quite unlike the compositional effects of earlier art.

4. Jean Tinguely, Homage to New York, 1960

5. Robert Rauschenberg, Buffalo II, 1964. American critic Douglas Crimp has pointed out that this series of works is more like printing than painting: 'Rauschenberg had moved definitively from techniques of production (combines, assemblages) to techniques of reproduction (silk-screens, transfer drawings).'

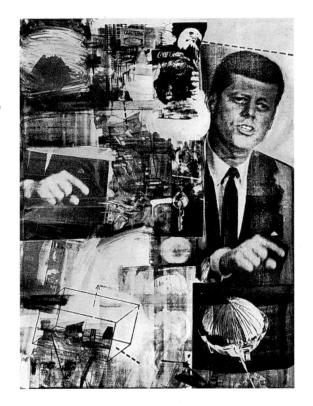

The impulses evident in this work of the later 1950s – an interest in the ordinary, a willingness to embrace chance (not only a legacy of Dada, but also a recognition that in life things just happen) and a new sense of the visual – each led art in two directions: towards Pop and towards Minimalism. Outwardly, work associated with one of these movements seems to share little ground with the other. What do a screenprint of Marilyn Monroe by Andy Warhol (1928–87) and an arrangement of square copper plates on the floor by Carl Andre (b. 1935) have in common? The artists and critics of the time, though, were in no doubt whatsoever that much was shared between the two.

Pop art appeared and was acknowledged as a movement in the US at the very beginning of the 1960s. By 1962, it was possible to identify a common sensibility among a number of artists, notably Roy Lichtenstein (b. 1923), Andy Warhol, Claes Oldenburg, Tom Wesselmann (1931–2004), and James Rosenquist (b. 1933), all of whose work used subject matter drawn from the banality of urban America. In a significant departure from the emotionally charged styles of the Abstract

6. Roy Lichtenstein, I Know How You Must Feel, Brad, 1963

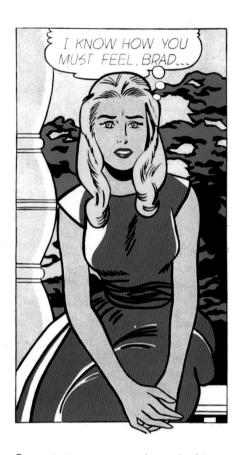

Expressionists, moreover, the work of these artists also appeared to be dependent upon the techniques of mass visual culture. Lichtenstein, for example, selected individual frames from cartoon strips, altering them slightly to suit his purposes, and reproduced these on a large scale in oil on canvas. The process of replication, though, was not inventive, free or playful, but precise and closely observed. Instead of interpreting the comic strip in the expansive, painterly way that Abstract Expressionism had led people to expect, Lichtenstein produced laboriously, by hand, a simulation of the screened dot technique by means of which the original strip had been printed. Because the result was so dry and 'unemotional', it was possible to believe that there had been no interpretation at all. His paintings looked, at first glance, as mechanically fashioned as their source material, although it is evident in a painting such as I Know How You Must Feel, Brad (1963) that the idea of art as an emotionally expressive activity is being ironically considered.

At the end of 1962, a symposium on Pop art was held at the Museum of Modern Art in New York. One of the contributors. the critic Henry Geldzahler, commented: 'The popular press, especially and most typically Life magazine, the movie close-up, black and white, technicolour and wide screen, the billboard extravaganzas, and finally the introduction, through television, of this blatant appeal to our eye into the home – all this has made available to our society, and thus to the artist, an imagery so pervasive, persistent and compulsive that it had to be noticed.' The ensuing discussion, representative of the general questioning of this new art, concentrated on whether Pop had contributed something new in terms of either form or content. Those who wished to play down its originality pointed out that there seemed to be no innovations of form that had not already been tried by Jasper Johns or the Abstract Expressionists. The tinned spaghetti, for example, which appears as a sort of artistic trademark in paintings such as I Love You With My Ford (1961) and the later, huge F-111 (1965) [8], both by James Rosenquist, refers back to the dripped swirls and skeins of paint in Jackson Pollock's work. Likewise, Andy Warhol's repetition of motifs - soup tins, Coke bottles, money, news photos, famous people – borrows a means

7. Jasper Johns, Flag, 1954–55. Johns reported that he dreamed one night that he had painted the American flag, so when he got up the following day, he did just that.

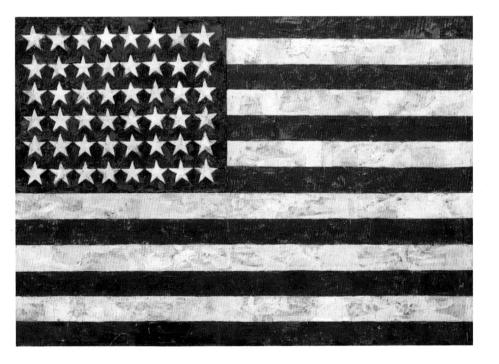

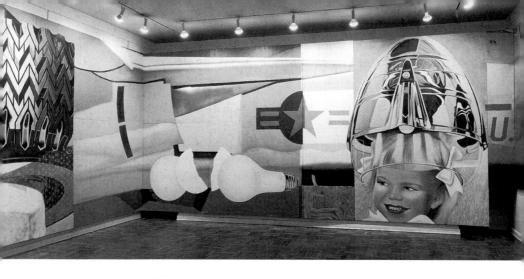

8. James Rosenquist, F-111, 1965. The equivalence of scale between advertising and Pop is brought home by this work which runs round the walls of a gallery. Its mix of imagery drawn from industry, the military, fashion and the home refers to the full breadth of contemporary life, making it more an environment than a painting.

of covering the canvas used by Johns in his alphabet and number paintings. In Johns's case this was a solution to the problem — which originated in Abstract Expressionism — of painting with equal emphasis all over the canvas, instead of placing the main subject in a central position with supporting incident around the edges. Using a number sequence starting in the top left-hand corner and finishing in the bottom right was a suitable system for achieving the desired result. By 1962, as in *Do-It-Yourself (Flowers*), Warhol had ironically outdone Johns by making canvases of the outlined scenes found in children's Painting by Numbers kits.

For Warhol, repetition was also bound up much more fundamentally with the way we see and treat other kinds of images and objects in our daily lives. His first exhibition, at the Ferus Gallery in Los Angeles in 1962, was of 32 paintings of individual Campbell's Soup cans propped up on a narrow ledge running around the walls. Subsequent paintings with multiple images of soup cans, Coke bottles, savings stamps and money reiterated the idea of works of art as commodities. This idea was further strengthened in 1964 by his stacks of Brillo Boxes, an exhibition at Leo Castelli's gallery in New York that covered the walls with a repeated flower image, and another at the Stable Gallery, also in New York, which filled the space with reproduction Campbell's tomato juice boxes. Later, for his 1966 Castelli show, Warhol 'redecorated' the space with Cow Wallpaper. From 1963 onwards, he was also making films. With their use of a fixed camera, lack of narrative structure and excessive length, Sleep (1963: a man sleeping) and Empire (1964: a static shot of the Empire State Building) established

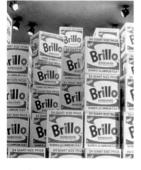

Andy Warhol, Brillo Boxes, 1964

a new relationship between real- and film-time, while investigating the quality of attention paid by an audience when confronted with imagery.

In a 1963 interview, Warhol commented on his preoccupation with imagery associated with death. Tabloid disaster pictures. road crash victims, the electric chair, race riots, North America's most wanted criminals, the recent suicide of Marilyn Monroe, the bereavement of lackie Kennedy, and Elizabeth Taylor (who was reported to be very ill at the time he began to use her face) were all images which dwelt upon the theme of death: 'It was Christmas or Labor Day - a holiday - and every time you turned on the radio they said something like, "4 million are going to die." That started it. But when you see a gruesome picture over and over again, it doesn't really have any effect.' A story covered by every bulletin of the day, reported in all the newspapers and analysed in all the magazines soon loses its immediacy and starts to be absorbed by the systems of communication through which it is made available. The news and the media by which it is delivered are ubiquitous and egalitarian. Warhol's famous statements - that

10. Andy Warhol, Do-It-Yourself (Flowers), 1962. As well as its amusing reference to Johns's paintings, and its acceptance that rather than the reality of space. a painting can only ever create the illusion of depth on the flat surface of the canvas, Warhol's use of Painting by Numbers imagery undercuts the seriousness with which recent painting was habitually addressed. The massproduced children's kits implied that anybody could do it, adding another layer of meaning to Warhol's idea of the 'Factory' production of art.

he wanted to be like a machine, that in the future everyone will be famous for fifteen minutes, that we all drink Coke and no amount of money will get the US president a better bottle than the one being drunk by the bum on the street corner — are all reflections of this. To emphasize his recognition that art could not escape being treated as a commodity in the same way as tins of soup, soap pads and boxes of cereal, Warhol dubbed his studio 'The Factory', and described the way his assistants helped with the multiple screen-printing of the images he selected as similar to a production line. As with Lichtenstein, though, this apparent anonymity of execution was largely an act. Warhol's decisions on which image and what colours to use, and even how, precisely, to introduce mistakes into the screening process, were crucial.

As far as the subject matter of Pop art went, its banality was itself an affront to its critics. Without clearer evidence that the material had undergone some sort of transformation on being incorporated into art, the art itself could not be said to offer anything that life did not already provide. Against this opinion, Lichtenstein was quite clear that transformation was not art's function anyway: 'Transformation is a strange word to use. It implies that art transforms. It doesn't, it just plain forms.'

Pop's formal references to Abstract Expressionism emphasize the degree to which it continued to be art. In dialogue with its precursors it produced the necessary tension between generations, a simultaneous continuation of and reaction to that which had gone before. Somewhat as Pollock is recalled by Rosenquist's tinned spaghetti, the legacy of modern art is repackaged and offered anew by Lichtenstein. A series of 'Brushstrokes' from 1965, carefully and precisely executed, displayed Abstract Expressionism as a style, making obvious the fact that the expressiveness associated with it is not a transparent and absolute record of an emotional state, but a culturally specific set of signs by means of which that state is felt to be best represented.

In 1961, Claes Oldenburg turned his studio, which had once been a shop, back into a shop. He filled it with models of items of food and clothing made from muslin soaked in plaster over wire frames, painted in enamels in the expected colours but in a gloopy, loose, Abstract Expressionist way, and offered them for sale. Oldenburg had staged Happenings under the aegis of his Ray Gun pseudonym, and *The Store* [12], the shop that behaved like a shop, continued this approach. But it also brought issues of time passing and, more particularly, movement closer to the activity

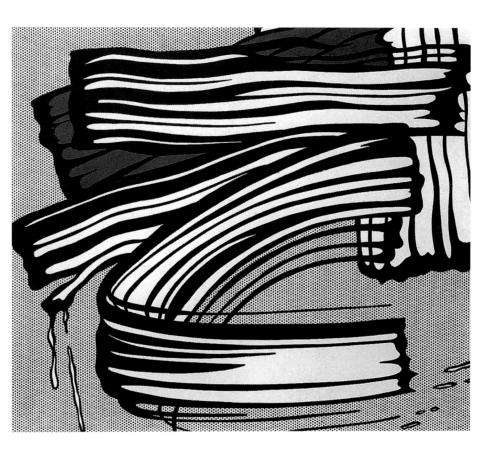

II. **Roy Lichtenstein**, Little Big Painting, 1965

of sculpture. Lichtenstein's comic strips dealt with these as well, unfolding the closed narrative of the artwork into the flow of everyday life. The individual items offered for sale in Oldenburg's store became sculpture for him because of the way in which they were treated. People purchased them, took them home and behaved towards them as if they were pieces of sculpture. By the following year he was exhibiting stuffed vinyl and cloth replicas of a hamburger, a slice of cake and an ice cream cone. With the colour now in the material and no longer applied in dollops and dribbles of paint these new, 'cleaned-up' sculptures looked to the conservative critic Sydney Tillim, 'too much like the things from which they derive'. That they were each the size of a person, or that the pair of blue trousers included in the same show would have fitted a giant, was apparently beside the point. For the more sympathetic, Oldenburg's experiments were startlingly innovative. The outer casings were sewn and then stuffed with kapok. Thus their form was built up from the inside, rather than as a result

12. Claes Oldenburg, The Store, 1961 (interior view)

13. Tom Wesselmann, Great American Nude No. 54, 1964. Like Oldenburg's The Store (opposite), from which the various elements became widely dispersed, Wesselmann's tableaux made it difficult to determine the limits of the artwork. Inclusion of phones, radios and recorded sounds indicated links to places and people far beyond the confines of the constructed scenes themselves.

of traditional carving, or modelling over an armature, from the outside. Because of the lack of rigidity in the materials, gravity ultimately decided the work's final form and not Oldenburg. In this sense the 'replicas' could be understood as things that were somewhat uncomposed. In addition, Oldenburg saw their softness bringing the problems of painting into sculpture. The effect is 'not a blurring (like the effect of atmosphere on hard form) but *in fact* a softening'.

Drawing the environmental expansiveness of Happenings back into art objects was achieved in other ways by Tom Wesselmann. His early works were collages of photographs of the packets of food products found in magazine advertisements. Somewhat akin to the emblematic 1956 collage Just What Is It That Makes Today's Homes So Different, So Appealing? by the British artist Richard Hamilton (1922–2011), the consumer's dream-home interiors Wesselmann created subsequently developed to become mixed media tableaux. Some of these, in his 'Great American Nude' series, for instance, were enlivened by the inclusion of taped

14. Ed Kienholz, Roxy's, 1961

sounds (*Great American Nude No. 54*: 1964), and a radio or an attached telephone ringing intermittently. Another work, *Bedroom Tit Box* (1968–70), even required the presence of a model's naked breast. Tableaux were also made by George Segal (1924–2000) and Ed Kienholz (1927–94). Segal's humdrum scenarios – a café table, a launderette – were populated by life-size white plaster figures. The people in Kienholz's raw scenes – the bar in *Beanery* (1965), the brothel in *Roxy's* (1961), and *Back Seat Dodge-38* (1964) – were not plaster casts but robotic mannequins assembled from junk, scrap and cast-offs.

Kienholz was a West Coast artist, one of a number, including Mel Ramos (b. 1935), Billy Al Bengston (b. 1934), Wayne Thiebaud (b. 1920) and Edward Ruscha (b. 1937), working in a Pop idiom. Ramos and Thiebaud were painters, qualifying as Pop artists by virtue of their subject matter. Bengston's prints and canvases celebrated youth culture through their depictions of the motorcycle. Ruscha's interest lay in the architecture and signs of Los Angeles, the simple language and imagery of billboards, and the rectilinear lines of such commonplaces as gas stations. Robert Indiana (b. 1928), who adopted the name of his home state, took the visual style of his paintings from the conventions of roadside signs. The stark readability of their lettering and the

demotic appeal of their imagery were used in designs whose brief messages both expressed and questioned the attitudes and character of contemporary America.

Pop art, as described so far, was a North American phenomenon: American in terms of those involved, insofar as it treated a kind of social reality, and in terms of viewing the quintessentially American world that went hand in hand with that reality. The name, Pop, though, was older, having been first used in connection with the work of the British artists Richard Hamilton, Eduardo Paolozzi (1924-2005), Nigel Henderson (1917-85), Peter Blake (b. 1932) and others in the 1950s. Their focus, too, had been US culture, although their treatment of it had necessarily been more distanced and reflective while embracing its products and implications. It was what the critic Thomas Hess called, in contrast to the vibrant openness of the US version, not just 'bookish', but actually looking 'as if made by librarians'. That the work of these artists has subsequently been seen as integral to the story of Pop art was in no small part due to the work of Lawrence Alloway (1926-90). Along with Hamilton and Paolozzi, Alloway had been part of the Independent Group of artists, designers and critics who had discussed contemporary visual

15. Edward Ruscha, Actual Size, 1962. At this time Ruscha also produced a series of influential books, whose apparently strange titles – Twenty-Six Gasoline Stations, Several Small Fires and Milk, or All The Buildings on the Sunset Strip, for example – simply stated the images they contained.

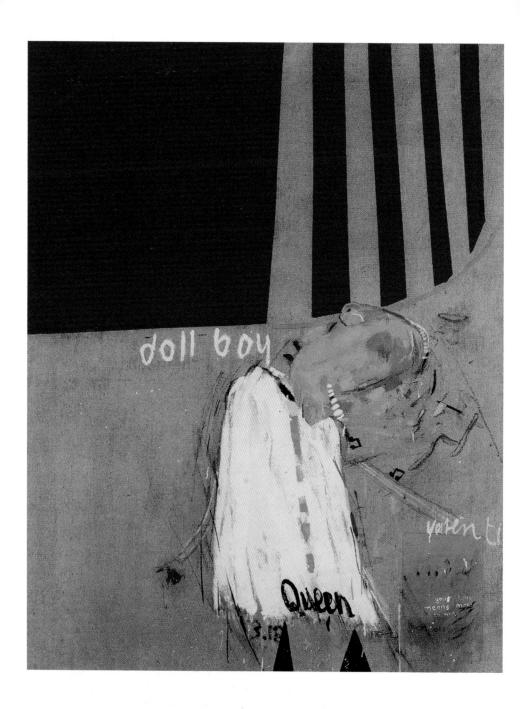

16. **David Hockney**, *Doll Boy*, 1960–61. The numbers 3 and 18 at the bottom of the painting are a simple alphabetical code denoting the letters C and R, the initials of Cliff Richard whose song *Livin' Doll* had been a recent hit.

culture at the ICA. London, during the 1950s. He subsequently moved to the US and his writing and curating of exhibitions there helped to establish links between artistic activity in the two countries. In the early 1960s another group of artists, most of them associated with London's Royal College of Art, started showing work which seemed closely connected, both in terms of subject matter and treatment. Richard Smith (b. 1931). Allen Iones (b. 1937), Derek Boshier (b. 1937), Peter Phillips (b. 1939), the American R. B. Kitai (1932–2007), and David Hockney (b. 1937) all used figurative material culled from the media and from the streets of the cities around them. Kitai had already begun to employ these techniques in his examination of the political and cultural legacies of twentieth-century history. Abstract passages in the paintings of Jones and Hockney brought them close to other contemporaries - particularly Paul Huxley (b. 1938) and John Hoyland (1934-2011) - who had been strongly influenced by the first showings in Britain of Abstract Expressionist works. Certain painting exhibitions at the time even stipulated a minimum size for submitted canvases and demanded, in concert with the insistence on flatness of the US Post-painterly Abstraction then current. that they should not project more than a certain distance from the wall. Hockney's paintings were noteworthy for their wilful mix of abstract and figurative elements, and for the manner in which they used the marks of graffiti and the language of teenage crushes in the expression of sexuality and desire. At a time before the relative easing of the proscriptive laws on homosexuality in Britain, Hockney was openly gay, and in We Two Boys Together Clinging and The Most Beautiful Boy in the World, both from 1961, he began to address subject matter that would be most persistently explored in his series of Californian swimming pool paintings of the mid-decade.

As in Oldenburg's *The Store*, a preoccupation with time and movement is evident in the rationale behind the multiple panels of Lichtenstein's *Whaam!* (1963), where the firing of the missile and its explosion are temporally distinct events, but in other instances mobility was more literally incorporated into the artwork. Kinetic art developed out of a general interest in Constructivism and a more particular interest in the early Kinetic pieces by Naum Gabo (1890–1977). Centred in Paris, particularly at the Galerie Denis René, it brought together a culturally diverse group of artists. Pol Bury (1922–2005) from France, the Israeli Agam (b. 1928), the Argentinian Julio Le Parc (b. 1928), Jesús Rafaël Soto (1923–2005) from Venezuela and the Swiss Jean Tinguely

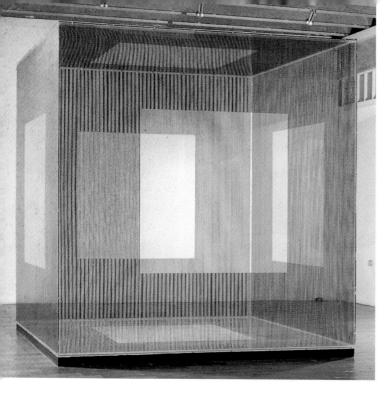

17. **Jesús Rafaël Soto**, Cube of Ambiguous Space, 1969

18. **Victor Vasarely**, plate 2 from the portfolio *Planetary Folklore*, 1964

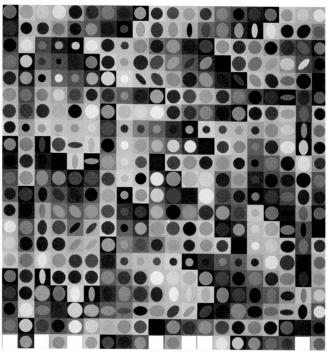

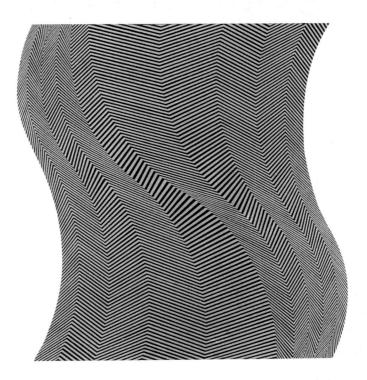

all produced works, motorized or otherwise, with moving parts. Soto's 'Vibration Structures', begun in the late 1950s, had developed an environmental scope by the end of the 1960s, as had Cube of Ambiguous Space (1969). Art of this kind, changing through time, was seen to have close connections with another variant which explored the degree to which pattern and colour could be used to create the illusion of movement. This was dubbed Op short for Optical – art, an abbreviation which brought it into at least semantic proximity with Pop. Because of their concern with surface pattern, the paintings of Bridget Riley (b. 1931) in Britain, Paris-based Hungarian Victor Vasarely (1908–97), Frenchman François Morellet (b. 1926) and Richard Anuszkiewicz (b. 1930) in the US, could be seen as a regression to that art obsessed with retinal sensation to the exclusion of all else so detested by Duchamp. The kind of unsettling effects produced by Vasarely's grids in Planetary Folklore (1964), for example, or the black-andwhite lines of Riley's Twist (1963) or Current (1964), however, were more thoroughly physical than that. There was a somatic element in the viewing of Op art that would draw spectators to ground those illusions of movement in the realities of their own bodies.

20. **Günther Uecker**, Kreis, Kreise, 1970

Kineticism and Luminism were the focus of two Northern European groups: the Nul group in Amsterdam, which included Herman de Vries (b. 1931), and the Zero group in Düsseldorf, formed by Heinz Mack (b. 1931) and Otto Piene (b. 1928), and joined later by Günther Uecker (b. 1930) whose panels, bristling with nails, trapped and scattered light in their undulations. The postwar Spatialism of the Italian Lucio Fontana (1899–1968), defined by him as an art of space and light, had affinities with this. By the 1960s it was influencing artists – Michelangelo Pistoletto (b. 1933), and Mario Merz (1925–2003) – who would later be associated with Arte Povera. Pistoletto in mid-decade, however, was making Pop-like collages of people on mirrored surfaces. It was thus impossible for viewers to look at these works – *Man Reading* (1967) and *Two People* (1962) for example – without themselves becoming associated with the figures depicted.

The concentration upon the commonplaces, even the banalities, of existence evident in Pop identify it as another flowering of realism in art. Hitherto used to describe art as diverse as the mid-nineteenth-century paintings of Courbet, Millet and Daumier, the Cubism of Picasso and Braque, and, within the tag 'Socialist Realism', the glorifying, propagandistic imagery of Stalinist Russia, realism again became useful as a catch-all term

for what seemed a general move away from the abstraction and individual emotional expressiveness of early postwar art. In France, the work of Arman (1928–2005), Daniel Spoerri (b. 1930), Yves Klein, César, Niki de Saint-Phalle (b. 1930), Jean Tinguely and others was, in fact, called Nouveau Réalisme in 1960 by the critic Pierre Restany, in preference to the English label Pop. In part, this terminological difference can be seen as a tactic in a larger ideological battle. The touring exhibitions of US painting in the latter half of the preceding decade had done much to establish New York as the pre-eminent centre of modern art, an honour hitherto held throughout the modern period by Paris. Referring to things as Nouveau Réaliste, an umbrella category that would include Pop, was one way of assuring the world that little had changed with regard to the balance of cultural power. Restany even went so far in a 1963 article to call the trompe-l'oeil paintings of Lichtenstein and Warhol a 'flash in the pan', and asking himself whether we would even be talking about their work two or three years hence.

A tongue-in-cheek instance of the power play was the full-page advertisement placed in the Swiss journal Art International,

21. Michelangelo Pistoletto, Two People, 1962

22. **John Chamberlain**, Miss Lucy Pink. 1963

23. **César**, The Yellow Buick, 1961

in the summer of 1964, by the New York art dealer Leo Castelli. That year saw not only the staging of the third Documenta, the quinquennial international survey of contemporary art held in Kassel, Germany, but also the Venice Biennale. Castelli's artists, Johns, Rauschenberg and others, were showing at both, as well as in Paris and London. The advertisement showed this as the map of a military advance, the artists pushing out from these four centres into the rest of Europe. Rauschenberg won the first prize at Venice that year, a success which was hailed by many as conclusive evidence if not of the general superiority of US art over European, then at least of the challenge which it was throwing down. Annette Michelson, a US critic then living in Paris, reviewed the Biennale for Art International. She described the reception given to the view of the exhibition put forward by Dr Alan Solomon, the American critic and historian, thus: 'in affirming the unquestioned superiority of contemporary American art over that of Europe, in treating this superiority as a matter of course and of common international understanding, [he] indicated that America's artists had not come to participate in a meeting of minds, a "cultural exchange," or to engage in competition with peers, but to collect an official prize and its attendant benefits. The howls of rage which greeted this statement were moderately touching, but no more.'

The term Nouveau Réalisme had been invented in 1960 apropos an exhibition in Milan which included the work of Tinguely, Arman and Klein as well as that of Raymond Hains (1926–2005) and Jacques de la Villeglé (b. 1926), two artists who worked in collages made from fragments of torn posters. Contrast the directness of Robert Indiana's response to signs, or that of Edward Ruscha or Tom Wesselmann, with the selfconsciously manipulative way in which Hains and de la Villeglé reproduced the effect of weathering and ageing on their materials. Another measure of the differences between the US and France can be seen in the comparison between the sculpture of César and John Chamberlain (1927–2011). Both were making art from old car bodies, but whereas César's automobile compressions of 1961 and 1962 used the power imparted by the scrapyard's vehicle crusher to turn the car into its own tombstone, Chamberlain's Coo Wha Zee (1962) or Miss Lucy Pink (1963) appropriated the bent and folded panels because they were ideal material from which to make abstract sculpture. The metal was infinitely pliable, yet held its shape, and its surfaces were coloured in a way that hinted at, but did not quite resemble, painting.

24. Jacques de la Villeglé, Angers, 21 Septembre 1959, 1959

Klein's notorious show, 'Le Vide', at Iris Clert's Paris gallery in 1958 had confronted visitors with an entirely empty space. Arman had responded two years later with Le Plein, emptying into the space the contents of several rubbish carts in a gesture that amplified his 'poubelles', glass cases filled with the contents of wastepaper baskets. In similar vein, Daniel Spoerri's 'Tableaux Pièges', such as Le Fer à Repasser (1960), presented the contents of a tabletop as a wall-mounted panel. Many of Arman's assemblages involved filling glass cases with identical or very similar objects: Arteriosclerose (1961) [26], for example, is a collection of forks and spoons, while the case of En Fer (1961) houses a variety of gas burners. Arman's was a plenitude different from the serial order of repeated images in New York except, perhaps, in Air Mail Stickers (1962) [25] by Yayoi Kusama (b. 1929), or Warhol's trompe-l'oeil painting of 'Glass - Handle With Care' labels. Others associated with Nouveau Réalisme included Martial Raysse (b. 1936), the Italian Mimmo Rotella (b. 1918), and Christo

25. **Yayoi Kusama**, Air Mail Stickers, 1962

26. Arman, Arteriosclerose, 1961

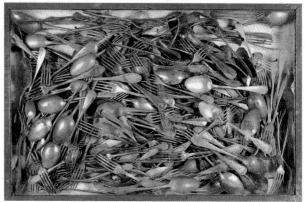

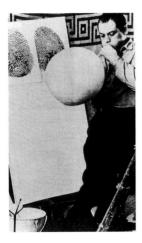

27. Piero Manzoni making The Artist's Breath, 1961

(b. 1935) and Jeanne-Claude (1935–2009), whose wrapped objects were descendants of the prototypical Surrealist work *The Enigma of Isidore Ducasse* (1920) by Man Ray (1890–1976).

Whereas Happenings in the US signal the extension of Abstract Expressionist gestures into the environment, there is an element of showmanship in Nouveau Réalisme which, although greatly influenced by Pollock's example, more significantly involves the actions of the artist in the final work. Klein's designation of a particular blue pigment as his own - International Klein Blue - and his subsequent employment of nude female models to smear it under his direction onto prepared surfaces to make his anthropométries [28] is only the most famous example. Arman's colères (tantrums) attempted to seize the instant in which an object, often an instrument, was violently destroyed, by fixing the resultant fragments in their precise relationships. Tinguely's motorized junk sculptures derived much from their spectacular effects. Niki de Saint-Phalle used a gun to fire paint at her canvases. Klein 'painted' with fire. All of these activities pushed the persona of the artist to the fore, putting a new shine on Duchamp's demonstration that it is the artist, purely because he or she is the artist, who has the power to designate something as art. The Italian Piero Manzoni (1933-63) who, like Klein, died young in the early 1960s, made a number of ironic gestures in this spirit. He signed a model, making her the artwork. Canning his own shit, he offered it for sale, priced according to how much its weight would be worth in gold. Inflating a balloon he made The Artist's Breath (1961), a perishable reflection of Duchamp's glass vial, 50cc Air de Paris (1919).

Matching the instantaneity of Arman's colères, the British artist John Latham (1921–2006) began making 'one second drawings' by applying the merest squeeze to a spray-gun trigger. These were seen not as finished images, but as traces of a Minimal 'event'. Earlier, having made images in the 1950s reminiscent of Klein's anthropométries, he had started to use books in sculptural constructions and wall assemblages. Several of these assemblages had moveable parts and could thus be displayed in a number of configurations. The books stuck to the multi-panelled surface of The Great Uncle Estate (1960) could each be held open by wires at pages painted either red, yellow or blue, thus allowing the work to exist in three different modes. This mobility of final form was also a factor in the 'variable paintings' of the Swede Öyvind Fahlström (1928–76). In these, a number of magnetized or hinged cartoon-like pieces could be moved around the surface

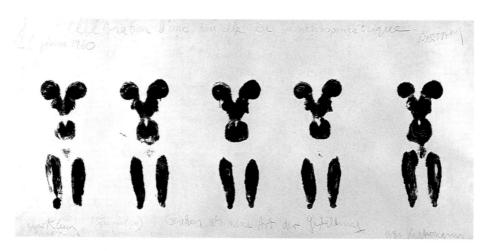

28. **Yves Klein**, Celebration of a New Anthropometric Era, 1960

29. **Gerhard Richter**, *Olympia*, 1967

to produce many different possible paintings. The options built into these game-like works, described by Fahlström as 'machinery to make paintings', enabled him to combine the chance nature of reality with his intentions as an artist.

If what went on behind the Iron Curtain, that postwar political reality made concrete by the Berlin Wall in 1961, was Socialist Realism, there were strong grounds for describing Pop as Capitalist Realism. This label was used in association with the exhibitions organized by René Block in his Berlin gallery in the mid-1960s. It had also been used in 1963 when Gerhard Richter (b. 1932) and Konrad Lueg (1939–96) – better known subsequently as the influential dealer Konrad Fischer – organized A Demonstration for Capitalist Realism, occupying a room tableau in a furniture store. Both Richter and Sigmar Polke (b. 1941), who participated in the Demonstration, were using media imagery as source material for their paintings. Clear superficial parallels exist between their work and US Pop. Warhol's preoccupation with glamour and the coverage of death and disaster in the tabloids is mirrored in Richter's works, such as Olympia (1967), taken from an image in a Readers' Wives magazine, and his painting of the student nurse victims of a serial killer, Eight Student Nurses (1966). Polke, as Lichtenstein was producing cartoonized versions of Picasso. Monet and the Abstract Expressionist gesture, gave us Moderne Kunst (1968) [31]. This 'abstract composition' of splodges and doodles is painted with a white border and its title written

30. Konrad Lueg and Gerhard Richter, A Demonstration for Capitalist Realism, 11 October 1963

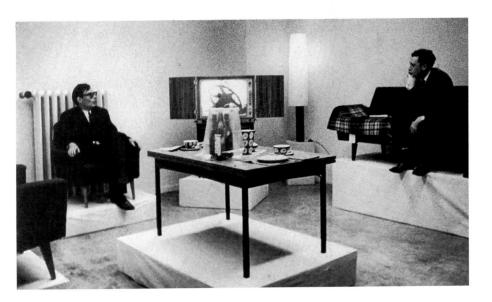

along the bottom edge as if it were, in fact, not an abstract painting at all, but the faithful reproduction of the page of a book. This painting is both modern art and at the same time an invaluable guide to enable us to recognize modern art should we ever encounter it. Polke also used different fabrics as painting surfaces, making it hard to view his art in the rarefied isolation of the gallery without remembering and considering domestic reality.

Wolf Vostell (1932–98), whose works were exhibited in René Block's 'Capitalist Realism' and 'Homage to Berlin' exhibitions. had been blurring pages from illustrated magazines since 1961. Concrete Slabs (1961) makes direct reference to Germany's politically divided state and to the Berlin Wall which was erected in that year. Vostell became involved the following year with Fluxus. As its name implies, this was a loose association of more or less like-minded artists rather than a well-defined group. It shared a Dadaist sensibility with US Happenings, particularly to the ideas of the American composer John Cage (1912-92), and worked across the boundaries between art, music and literature. A close relationship also existed with the contemporary Situationist movement, which, through the engineering of events looked for détournement, the turning of social conditions against themselves to reveal their true character. Situationism had a strong political figurehead in Guy Debord, but art practice featured largely in its original manifestos through the neo-Dada input of the Danish painter Asger Jorn (1914-73). Vostell's Fluxus 'actions', and those of Joseph Beuys (1921-86) whom he met in 1963, very often had explicit political content. Later, Vostell would want to contribute to a Documenta by placing a US F-111, abiding symbol of the political realities of his divided country, on the roof of the main exhibition building in Kassel, a project that remained unfulfilled. His actions remained simple in conception and forthright in intent: 'I want to find out whether rules for types of behaviour in daily life can be obtained from actions with a model character, whether impulses emanating from me can be applied in everyday life to counter intolerance, stupidity and oppression.'

Although there were many points of connection with US Pop, the more overt political tone of this German art and the even more explicitly stated ironies of Polke and Richter were felt to constitute a significant difference. Contrasting Vostell's work with the multiple images silk-screened onto Rauschenberg's canvases of the mid-1960s, the German artist K. P. Brehmer (1938–97) said: 'For Rauschenberg, for example, Kennedy is just a smear

31. **Sigmar Polke**, *Moderne Kunst*, 1968

32. Colin Self, Two Waiting Women and B58 Nuclear Bomber, 1963. The B58 bomber flies above Christine Keeler and Mandy Rice-Davies, who were at the centre of a political scandal involving a Soviet spy and John Profumo, a member of the British government. The story broke shortly after the Russia–US confrontation over arms at the Bay of Pigs in Cuba and contributed further to the high Cold War tension of the period.

Moderne Kunst

of colour. For Vostell, Kennedy is something different – he is a politician, he stands in a political environment and this has a completely different significance.'

In Britain, the 1960s idea of Pop, feeding through from the activities and theoretical discussions of the Independent Group in the 1950s, was largely celebrated as an aspect of the style revolution. There were exceptions, such as the paintings and collages of Colin Self (b. 1941) [32] which commented in a more forthright manner on the politics of the Cold War and the threat of nuclear catastrophe. Richard Hamilton, too, continued to dissect domestic politics. Swingeing London (1968), for example, was derived from a press photo of Mick Jagger and the art dealer Robert Fraser being arrested on a drugs charge, and questioned whether there had really been a liberalizing of attitude during the period. It would be wrong, though, to think of US Pop as being altogether unconcerned with the political dimension of the reality it portrayed. Ed Kienholz's tableaux placed the seedier aspects of life - prostitution, abortion and destitution - centre stage; Oldenburg's humour was not without its acerbic edge: a drawing for a public monument in London proposes a giant ballcock on the Thames near the Houses of Parliament, sinking and rising with the tide; and in spite of Warhol's increasing disinclination to speak about any message his work might have, the combination of monochrome panel and images in a work such

Wolf Vostell, Berlin–Fieber
 V, 1973

as Silver Disaster: Electric Chair (1963) provides social comment in addition to acknowledging the continuing development of abstract painting.

In his 'Unfurled' series of 1960–61, Morris Louis (1912–62) ran paint in rough diagonals off the outer edges of unstretched canvases. Cropping and stretching produced paintings, as with Beta Upsilon (1960) or Omicron (1961) [35], for example, which had a large, central empty V flanked by variously coloured ribbons anchoring the sides to the bottom edge. Influenced by the 'drawing' inherent in Jackson Pollock's skeins of dribbled paint and the integrated flatness of paintings made by staining unprimed canvas of Helen Frankenthaler (1928-2011), Louis had arrived at a way of producing thoroughly flat paintings whose form, derived through the channelling of paint under the influence of gravity rather than purposive application of a loaded brush, served as a bracing structure for an absent image. At around the same time, Kenneth Noland (b. 1924) was executing 'targets', including Song (1958) [36], Breath (1959) and Split Spectrum (1961), which comprised concentric circles of variously coloured paints. Like Louis' 'Unfurleds', these were on unprimed canvas to emphasize their flatness. The absence of conspicuous brushwork in these

34. **Andy Warhol**, Silver Disaster: Electric Chair. 1963

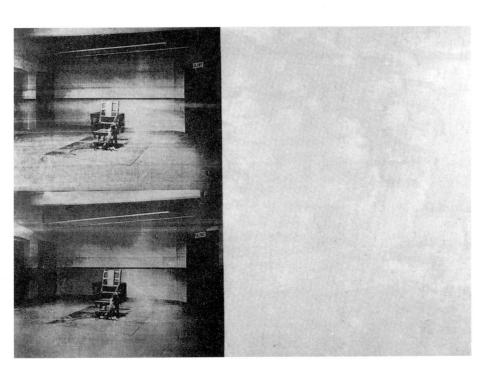

paintings, together with the bright and direct colours of the new acrylic paint they used, differed from the gestural tonality of Abstract Expressionism. The style, consequently, was referred to as Hard-edge painting, or Post-painterly Abstraction.

Critical opinion of these painters in the first half of the 1960s clearly shows that a battle was taking place. Clement Greenberg, the most influential writer on art in the quarter-century after the war, spoke of them as successors to the great flowering of US artistic talent that was Abstract Expressionism. In his writings since before the Second World War, Greenberg had put forward a particularly persuasive account of the history of modern art. According to this, the succession of steps from Impressionism, through Cubism, Matisse and Mondrian, up to Abstract Expressionism could be seen as an internal development of the means and possibilities of painting itself. What could be understood to be taking place in modernism was, for Greenberg, a critical and reflective realization of painting's essential qualities. Painting could be distinguished from other art forms by the rectangle of the canvas and its two-dimensionality. Before the war, in common with many prominent US intellectuals, Greenberg had espoused a quasi-Marxist ideology, but his views, like those of so many others, were profoundly affected by the Holocaust and Stalinism, the latter widely embraced during the war but afterwards perceived as a threat. Subsequently, despite Greenberg's denial that it was good in itself, abstraction became, within his criticism, the provider of a guaranteed realm of aesthetic quality removed from what was now a fatally compromised reality. In this light, the thoroughly flat abstraction of Louis and Noland appeared akin to modernism's ultimate self-realization.

The immediate question that such an analysis raises is, What happens now? If painting has achieved a realization of its essential qualities, what is there left for it to do? One solution was for painting to extend itself into the third dimension, something that had hitherto been the exclusive property of sculptural form. Works such as *Watusi* (1965) by Sven Lukin (b. 1934) and *Tailspan* (1965) [38] by the Englishman Richard Smith, who had gone to New York after attending London's Royal College of Art, laid canvas over stretchers that jutted out from the wall. Lee Bontecou (b. 1931) kept painting's rectangular frame, but constructed within it untitled contoured surfaces of sheet metal and wire. The painted structures of Anne Truitt (b. 1921), such as *Late Snow* (1964), were free-standing, while those of Jo Baer

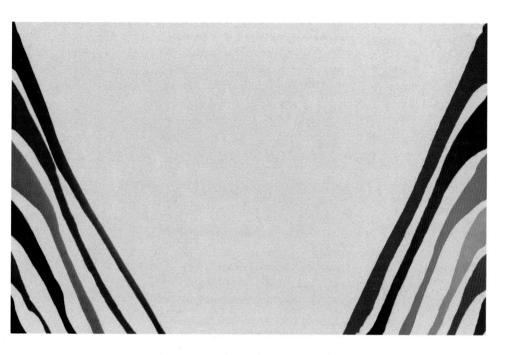

35. Morris Louis, Omicron, 196136. Kenneth Noland, Song, 1958

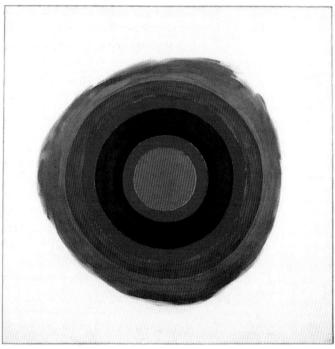

37. Ellsworth Kelly, Orange/ Green, 1966

(b. 1929), in which the visual 'incident' was kept entirely around the deep edges of an otherwise white canvas, remained on the wall although they were not necessarily hung at the standard height. The canvases of Ellsworth Kelly (b. 1923) were divided into a small number of clearly defined areas of flat colour: *Orangel Green* (1966), *Green/White* (1967), and so on. Sometimes the areas of colour would coincide with the shape of the canvas, a logical alternative given Kelly's parallel production of simply-shaped, painted sheet metal sculptures. Rather than moving into an area of production that was neither quite painting nor sculpture, Kelly continued along the lines of Picasso, David Smith (1906–65) and even Barnett Newman, all of whom did both. One of Greenberg's own preferred champions of the continuing strength of modern art was the English sculptor Anthony Caro (1924–2013). Caro,

himself making figurative bronzes, had worked in the studio of Henry Moore (1898-1986) for a time in the 1950s, following which he had visited the US. There he met Kenneth Noland, among others, and David Smith, a painter as well as a sculptor, who used metal in a way which was, if not exactly representational, at least pictorial. After wartime experience in an engine works Smith was not accustomed to casting the fine art material of bronze, but rather to welding the I-beams and plate of industrial steel. In the US, Mark di Suvero (b. 1933) and Charles Ginnever (b. 1931) were also working in this way, the moveable parts of di Suvero's large pieces drawing something, too, from the mobiles of Alexander Calder (1898–1976). The trip was liberating for Caro. Echoing the difference in sensibility between Nouveau Réalisme and Pop, he wrote: 'There is a fine art quality about European art, even when it's made from junk. America made me see that there are no barriers and no regulations.'

On his return to Britain, Caro began to weld, using plates, beams, rods and tubes of steel and aluminium with which to construct his sculptures. These new works were strikingly abstract compositions, the various parts setting up relationships within the overall shape of each piece, a shape emphasized by Caro's habit of painting the finished sculpture a single colour. Nevertheless, the red Early One Morning (1962), in whose profile lingers the ghost of Moore's reclining nudes, and the yellow, expansively horizontal Prairie (1967) [39] are only two examples showing that figuration had been not simply rejected, but transmuted into allusive reference. Alongside Caro, a number of others, notably Phillip King (b. 1934), Tim Scott (b. 1937) and Michael Bolus (b. 1934), made up a 'New Generation' of British sculptors anxious to avail itself of the new freedom to use a greatly expanded range of materials. Scott's For 'Cello (1965) and King's Genghis Khan (1963) [40], for instance, both used plastic and fibreglass. Of them all, though, it was Caro who offered an escape to all those keen to see a continuation of the modernist tradition. After Louis and Noland, his colourful sculptures seemed a way forward, one in tune with the abstract formalism of Ellsworth Kelly, the busier canvases of Larry Zox (1937–2006), the sprayed paintings of Jules Olitski (1922-2007) and the choreographed elliptical dots of Larry Poons (b. 1937). Another noteworthy feature of Caro's sculpture, one shared with the Minimal art contemporary with it, was that it stood directly on the floor. Thus it occupied the same space as those who viewed it rather than a separate, aesthetic realm.

Minimalism, a movement most usually identified with sculptural endeavour, can be understood, in part at least, as a continuation of painting by other means. Like many of the other names of movements in the history of modern art -Impressionism, Fauvism, Cubism – the label 'Minimalist' was applied by critics to the work of Donald Judd (1928-94), Robert Morris (b. 1931), Dan Flavin (1933-96) and Carl Andre in 1965 with pejorative intent. Other artists - Ronald Bladen (1918-88), Robert Grosvenor (b. 1937), Larry Bell (b. 1939), Bill Bollinger (1939-1988), Stephen Antonakos (1926-2013), Judy Chicago (born Judy Gerowitz in 1939), Tony DeLap (b. 1927) among them - were making work that could be viewed, more or less, within what was understood by the term Minimalism. However, just as a discussion of Cubism turns mainly upon the contributions of Picasso and Braque, the key features of Minimalism are most easily recognizable in the art of Judd, Morris, Flavin and Andre. Sol LeWitt (1928-2007) and Robert Smithson (1928-73) were both also associated with the tendency, but their main significance lies elsewhere and will be discussed later.

The critic Barbara Rose offered Duchamp's designation of an object as 'readymade' and the decision of the Russian painter Kasimir Malevich (1878–1935) to exhibit a single black square on a white background as the historical poles of Minimalism. 'It is important to keep in mind', she wrote, 'that both Duchamp's and Malevich's decisions were renunciations – on Duchamp's

39. Anthony Caro, Prairie, 1967

40. **Phillip King**, *Genghis Khan*, 1963

part, of the notion of the uniqueness of the art object and its differentiation from common objects, and on Malevich's part, a renunciation of the notion that art must be complex.' Judd, who began as a painter, wrote in his 1965 essay, 'Specific Objects', that much art then being made could no longer be described as either painting or sculpture. He termed it, instead, 'three-dimensional work'. This was also remarked upon by Clement Greenberg: 'What seems definite is that [artists] commit themselves to the

38. Richard Smith, Tailspan, 1965

third dimension because it is, among other things, a co-ordinate that art has to share with non-art (as Dada, Duchamp and others already saw).'

There were other terms around at the time, most notably ABC art and Primary Structures (the title of an exhibition at New York's Jewish Museum in 1966), but Minimalism is the one that has persisted. The richly gestural paintings of the preceding generation of artists, the Abstract Expressionists, seemed replete with emotional and expressive content. In contrast, this new work looked monochromatic, engineered, impersonal, and by analogy, if a Jackson Pollock or a work by Willem de Kooning (1904-97) was 'full' of art, then the blankness of Morris's low, rectangular plywood Untitled (Slab) (1968), the egregious simplicity of Andre's floor-hugging arrangements of house bricks, or the obduracy of Donald Judd's untitled box-like wooden constructions predominantly painted in his favourite cadmium red light, must have seemed pretty 'empty'. In what is taken as the first use of the term, the philosopher Richard Wollheim wrote in 1965 that the emptiness of these works 'might be expressed by saying that they have a minimal art content: in that either they are to an extreme degree undifferentiated in themselves and therefore possess very low content of any kind, or else the differentiation that they do exhibit, which may in some cases be very considerable, comes not from the artist but from a nonartistic source, like nature or the factory'.

For Judd, the blank look of this art was symptomatic of what he saw as the growing irrelevance of traditional aesthetic attitudes. His work was simple and formally pared down because of a wish not to employ compositional effects. Composition emphasizes internal relationships between the various parts of a work and in so doing plays down the impact of the work as a

41. Robert Morris, Untitled (Slab), 1968

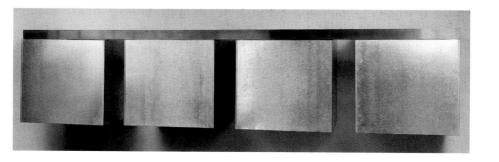

42. Donald Judd, Untitled, 1965

whole. Judd's desire was that the viewer should concentrate, for example, on the upper horizontal bar and the units fixed at regular intervals along its lower edge of *Untitled* (1965) as a single, whole 'thing'. In this he is close to the American composer John Cage who, having met and studied under Arnold Schoenberg (1874–1951), rejected his example because of a wish to produce music that was not composed. This idea can be seen, too, in the paintings being made by Frank Stella (b. 1936) as the 1960s began.

In 1958, Stella made a series of black paintings, the rectilinear pattern of whose striped surfaces was closely related to the shape of the canvas. Getty's Tomb, II (1959) [43], for example, has a band running up one edge, across the top and down the other edge of the canvas, while the remainder of the surface is filled with concentric bands executed in the same way. These works are striking for the interdependence that exists between them as objects - stretched canvases of certain dimensions - and the images they carry on their surfaces. They are, in Judd's terms, 'one thing'. Once decisions have been made as to the dimensions of the stretcher and the organizational logic of the marks, it only remains for the painting to be executed, rather than built up through the balancing of one brush stroke against another. There is a distinct order to these paintings; they are regular and structured. It is an order, as Judd said, that 'is not rationalistic and underlying but is simply order, like that of continuity, one thing after another'. Following the black paintings Stella made some further series using aluminium and then copper paint, each developing the idea of a congruence between painting as object and painting as image. For these series he began to experiment with shaped canvases, cutting notches out of the standard rectangle for the aluminium paintings, and constructing surfaces in a variety of rectilinear shapes for the copper paintings.

43. Frank Stella, Getty's Tomb, II, 1959

Asked by the critic Bruce Glaser why he wanted to avoid compositional effects, Judd replied: 'Well, those effects tend to carry with them all the structure, values, feelings of the whole European tradition. It suits me fine if that's all down the drain.... The qualities of European art so far [are] innumerable and complex, but the main way of saying it is that they're linked up with a philosophy - rationalism.' This perhaps sounds intemperate and dismissive, but it is more important to recognize the positive aspect of Judd's thought at this time. European rationalism was 'pretty much discredited as a way of finding out what the world's like' because the world was now a place of different character. The repetitions of daily life, the proliferation of consumer goods, and all those other things remarked and reflected on in Pop, were forcing a reconsideration of how the passing of time, the making of things and the understanding of an object's uniqueness were to be valued. Judd wrote elsewhere, 'The objections to painting

and sculpture are going to sound more intolerant than they are. They are qualifications. The disinterest in painting and sculpture is a disinterest in doing it again, not in it as it is being done by those who developed the last advanced versions.'

The last advanced versions, for him, were the paintings of Stella, Noland, Louis and, from an older generation, Barnett Newman. The latter's mature style, dating back to his 1948 Onement I, a single stripe running vertically down the centre of an otherwise monochrome surface, made it hard to view his paintings in the conventional terms of a relationship between figure and ground. Because his stripes, or 'zips', always reached the top and bottom edges of his canvases, they served to define and articulate the proportions of a flat surface as much as, if not more than, they appeared to populate a potentially deep colour space. Insofar as they were spatial, this had more to do with the manner in which their large size physically overwhelmed the spectator. For example, the large red expanses of Vir Heroicus Sublimis (1951), or Who's Afraid of Red, Yellow and Blue III (1966–67) [44], both paintings of nearly twenty feet in length, are almost impossible to absorb in their entirety, and thus provide something like an environment of colour that encloses the viewer. This environmental quality was something that would become increasingly important as the 1960s progressed.

Acknowledging the significance of the uneasiness with rationalism, Barbara Rose saw a common root for Pop and Minimalism in the US tradition of pragmatism. Not only the philosophies of William James and John Dewey, but also the Precisionists of the early years of the century were identified as parts of an indigenous tradition. A search for heroism in the industrial landscape or the domestic interiors of the country, evident in the painting and photography of Charles Sheeler (1883-1965) and Charles Demuth (1883-1935) connected with the depersonalized and factory-like methods of Warhol and Judd's insistence upon making art which eschewed illusionism. It is in making considerations of this sort that the spiritual side of Minimal art starts to become apparent. Rose quotes Robert Henri (1865-1929), a key figure in the Ashcan school of US realists at the beginning of the twentieth century, admiring machine tools for the directness with which they fulfil the function for which they were conceived: 'There is no "Art" about them, they have not been made beautiful, they are beautiful.' Similarly, the directness of Shaker design was to influence Sheeler, and its unornamented style was to appear as a precursor to Judd's rigorous approach,

44. **Barnett Newman**, Who's Afraid of Red, Yellow and Blue III, 1966–67

particularly as he moved into furniture design and architecture. Later in his career, Judd moved to Marfa, Texas [46], renovating and altering several buildings in and around the town as optimum environments in which to display his own art and that of his contemporaries which he had collected over the years. The over-arching nature of this project lends weight to Rose's view. She wrote: 'Judd's rejection of illusionism is deeply rooted in the pragmatic tenet that truth to facts is an ethical value. For Judd, illusionism is close to immorality, because it falsifies reality. The pragmatist demands an absolute correspondence between facts and reality; things must be as they appear to be. Any disjunction between appearance and reality, such as illusionism, which

distorts the facts, is sharply felt as an affront to truth, because pragmatism equates truth with the physical facts as experienced.'

Minimal art, then, did not represent anything or refer directly to anything else in such a way as to render its own authenticity dependent upon the adequacy of its illustrative likeness to that other thing. It was not metaphorical and it did not offer itself as the symbol of some spiritual or metaphysical truth. This fact also accounts for the vast number of works of art called 'Untitled', since giving something a name would render it subordinate to whatever it was named after. In the same interview with Bruce Glaser quoted above, Frank Stella said of his paintings, 'What you see is what you see.' He quoted his friend Hollis Frampton

(1936–84), the photographer and film-maker, in stating that his aim was to produce a painting that allowed the paint to look 'as good as it did in the can'. A kind of literalization of this desire can be seen in Stella's 1961 'Benjamin Moore' series [48]. Six different linear patterns were painted in each of the three primary and three secondary colours – red, yellow, blue, green, orange, purple – using colours available in the Benjamin Moore range of household paints.

The non-composed, non-referential abstractness of Minimalism offered considerable resistance to the standard methods of art appreciation, but there were other factors behind its oblique muteness. One was concerned with how its objects were made. For example, Judd's early sculptures were made in wood, but this material soon gave way to metal and perspex. Iron, steel, copper and aluminium had greater strength at smaller thicknesses and could be engineered much more exactly to the required dimensions. In addition, their surfaces could take or present colour in very different ways to wood, and in the case of, for example, the amber perspex used in *Untitled* (1968) [47] the colour was literally in the material, not applied to its surface at all.

In Dan Flavin's case, the colour he used was not 'applied' to anything at all. Flavin first used electric light in his constructions in 1961, moving to fluorescent tubes two years later with *The Diagonal of May 25, 1963*. Placing them initially on the wall in different alignments and combinations, he soon began devising arrangements for specific places. There are several challenges to the *status quo* in these works. Flavin's purchase of standard neon tubes and fitments meant that the evidence of his individual touch on his materials was never going to be an issue. This 'absence' of the artist is corroborated in the decision of Judd, LeWitt and others to have their works fabricated by others according to a set of specifications supplied by the artist. The work may well be unique (though only because the instructions had been carried out once), yet the person or people who physically made it are not necessarily the artists.

The physical presence of the neon tubes and their holders is always significant, but, more than anything, Flavin's material is the coloured light they emit. Newman's 'zips' are suggested in the vertical arrangement of the tubes in *The Nominal Three (To William of Ockham)* (1963), and the title implies that Flavin has used the philosopher's famous razor, 'Entities are not to be multiplied without necessity', to reduce the problems of art-making to the fundamentals of pure, disembodied colour. Several of the works

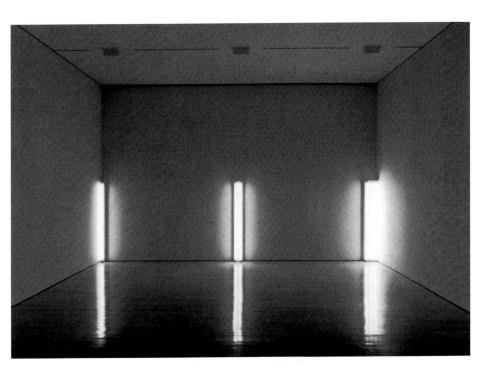

45. **Dan Flavin**, The Nominal Three (To William of Ockham), 1963

of the mid-1960s have the generic title Monument for V. Tatlin, and in 1966 he made the first of his installations set at an angle across the corner of a room. The effect of this is to remodel the space by making the corner 'disappear'. The artist Mel Bochner (b. 1940) wrote of Flavin exhibiting an 'acute awareness of the phenomenology of rooms.... [His] demolished corners convert the simple facts of roomness into operative factors.'

As mentioned earlier, although it differed in many other ways from Caro's composed sculptures, Minimalism shared with them a rejection of the plinth. The plinth, like the frame of a painting, isolates a sculpture, removing it, as it were, to a discrete aesthetic space where it may be contemplated. Art on the floor had to be viewed not as something apart, but as one more thing in the viewer's physical space. Carl Andre's work in brick, wood and metal plate continually emphasized its relationship with the floor on which it was placed. (An early job as a freight guard on the US railways offering him endless views across the plains to the horizon is often adduced as the inspiration behind this preoccupation with horizontality.) Andre's sculptures, made from small units placed together in simple, regular arrangements, are a classic example of the non-rational order Judd referred to as

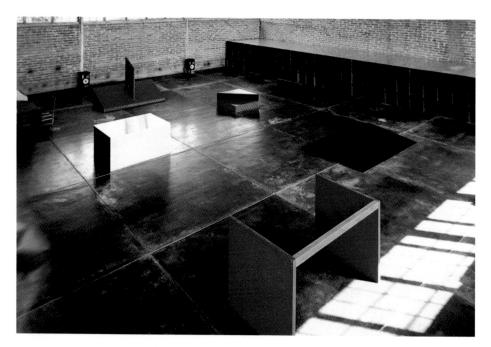

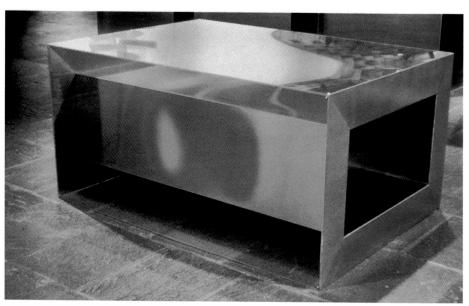

46. Donald Judd's permanent installation of works, East Building, La Mansana de Chinati, Marfa, Texas

47. Donald Judd, Untitled, 1968

48. **Frank Stella**, *Delaware Crossing*, from 'Benjamin Moore' series, 1961

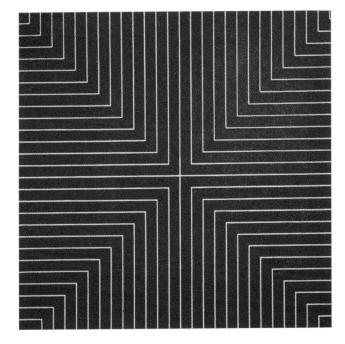

'one thing after another'. The 137 bricks in Lever (1966), placed in a single line along the floor, exhibit the pulse of repetition that Judd and, of course, a Pop artist like Warhol were anxious to deal with. When Warhol was asked, 'Why did you start painting soup cans?', he replied, 'Because I used to drink it. I used to have the same lunch every day, for twenty years, I guess, the same thing over and over again.' The extended modularity also recalls, in a different orientation, Constantin Brancusi's 'Endless Columns', the first of which was made in 1920. This work Andre had previously acknowledged in the double pyramid of his 1959 Cedar Piece.

In the early 1960s, Andre made a group of works using large blocks of expanded polystyrene. Although not permanently fixed together in any way, they were interleaved so as to form simple joints. Eschewing even this level of complexity, he subsequently opted for a straightforward placement of one element next to another. Wanting his sculpture to be 'low' and ground-hugging, he decided, on a 1965 canoeing trip in New England, that it needed to be as flat as water. Andre's New York exhibition of the following year realized this aim in his showing of Equivalents I–VIII [49], eight sculptures each made from 120 bricks. Comprising two layers of 60 bricks, their shapes were determined by four of the possible factorial combinations of the number, each combination

49. **Carl Andre**, Equivalents I–VIII, 1966

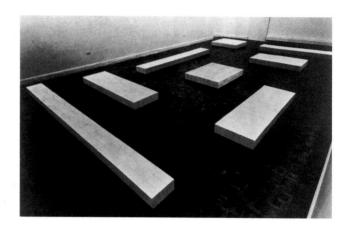

leading to two shapes depending upon the orientation of the bricks. The eight were therefore equivalent numerically and volumetrically. In the years following, Andre's works would get lower still, using square plates of a variety of metals arranged in simple configurations on the floor, sometimes to spectacular effect as with 37 Pieces of Work (1969) which brought 36 separate works together to make a 37th in the atrium of the Solomon R. Guggenheim Museum in New York. In order that they be experienced in full, the spectator was invited to walk on these 'plains'. The literal feel of the work, the particular density of the metal, its sound and its resistance to the tread are all part of what it can give to the 'spectator'. Yet again Duchamp is called to mind for his strictures against a visual art that was purely 'retinal'.

An art that saw itself as new in some way suggested that it should also be judged as good or bad according to new standards. Greenberg had asked that art might demonstrate 'quality', and his argument for this derived from Kant's aesthetic theory. In place of quality, however, and in defiance of the rationalist tradition within which Kant figures prominently, Judd asserted that 'a work of art need only be interesting'. The media theorist Marshall McLuhan had already noted that television promotes interest as the key quality in the viewing experience. More than the particular subject matter of a programme, it is the manner in which the camera gets close to and penetrates its subject that draws us in. Not only should art resemble ordinary things, but the way in which the spectator views it should be grounded in an everyday experience. Of all the artists associated with Minimalism, it was Robert Morris who did most to describe this aspect of the style. Starting in 1966, he published a series of articles in which the creation and viewing

of sculpture were analysed in depth. In particular, he elaborated the understanding of Minimalism in relation to phenomenology. The French philosopher Maurice Merleau-Ponty had published his study *The Phenomenology of Perception* in 1961, and there are many parallels between the nature and experience of Minimal art and the way in which Merleau-Ponty characterizes the reciprocal nature of the process whereby individuals come to an awareness of the space and objects around them: 'Space is not the setting (real or logical) in which things are arranged, but the means whereby the position of things becomes possible.'

50. Carl Andre, 37 Pieces of Work, 1969

In a way which seems akin to Judd's stress on the work of art as 'one thing', 'a whole thing', Morris, in 'Notes on Sculpture',

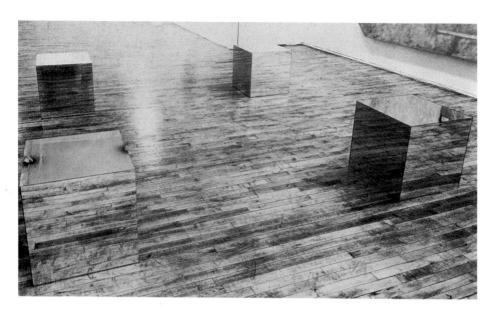

51. Robert Morris, Untitled, 1965

proposes a work of sculpture as a gestalt object. That is, a simple form whose total shape can be immediately apprehended by the viewer. A consequence of such simplicity of form is that, once recognized, 'all the information about it, qua gestalt, is exhausted'. This then frees one to consider other aspects, of scale, proportion, material, surface, for instance, in cohesive relation to this fundamental unity. Given the undifferentiated character of this type of work, the onlooker becomes aware of the viewing process as having duration. Whereas looking into a painting had allowed one to lose oneself in the world it offered, an exploration that was often described as timeless, or as occurring outside time, this was quite clearly not the case when one was confronted with Morris's Untitled (1965): four, waist-high mirrored cubes. Walking around and between the separate parts of this sculpture allows one to experience the gallery space and one's own and others' bodies as a fractured and disjunctive reality. His earlier exhibition, in 1963, at the Green Gallery, New York, similarly articulated the space with a number of plain, quasi-architectural rectilinear forms.

In contrast to the positive tone of Morris's 'Notes' and Judd's 'Specific Objects', the critic Michael Fried's position was to resist the artistic claims of Minimalism. Fried had been a pupil of Greenberg and to a certain extent continued in his critical tradition. His uneasiness in the face of Minimal art was due largely to its rejection of composition. You could not go 'into' these works in the same kind of way because there were no internal

parts whose relationships could be pondered. This, rather than their literal boxy emptiness, is what Fried was referring to when he criticized Minimal sculpture, particularly the work of Judd and Morris, for being 'hollow'. They are devoid not of palpable stuff, but of the wherewithal to discern meaning. No longer can one ask, 'What is this about?' and expect the object in front of one to offer up an answer. What it can provide instead is a set of cues by which one can orient the experience of being in the gallery with it. This shift of the location of meaning out of the object and into its surrounding environment, was characterized by Fried in negative terms as a falling away from what art really was. 'Art', he said in his 1967 essay 'Art and Objecthood', 'degenerates as it approaches the condition of theatre.' Modernist art, which is to say the historical procession of images and objects produced within the social, industrial, economic and political conditions defined by the Industrial Revolution, sought authenticity in the rigour with which a medium explored its own techniques and materials. Minimal art, which Fried called 'literal' art, did not display this self-sufficiency. It existed for an audience (as Pop art did according to another influential American critic, Thomas Hess): it was something not quite life and not quite art, but rather the one somewhat self-consciously presenting itself as the other; an engineered 'situation' that occasioned reflection upon the qualities of the moment. Any meaning this kind of art had, then, was dependent upon the experience of the person viewing it. Such meaning was contingent, an aspect of the flux of everyday life.

Fried's notion of theatricality was not to be confused with drama, itself an art form that, along with music and dance, was now degenerating in a manner similar to art. The result was that, like the boundaries that were being blurred within art, those between the different art forms were, if not disappearing altogether, at least becoming thoroughly penetrable. Thus, Morris collaborated with the dancer Yvonne Rainer and as late as 1969 was describing himself in exhibition catalogues as a dancer; the composer Philip Glass (b. 1937) found the art world a more sympathetic context for his systems-based and unconventionally instrumented music than the concert hall; the taped speech of Steve Reich (b. 1936), looped and repeated as a means to introduce not only semantic content but also pitch and rhythm, paralleled art's pragmatic focus. Art now existed, in Morris's words, in a 'complex and expanded field'.

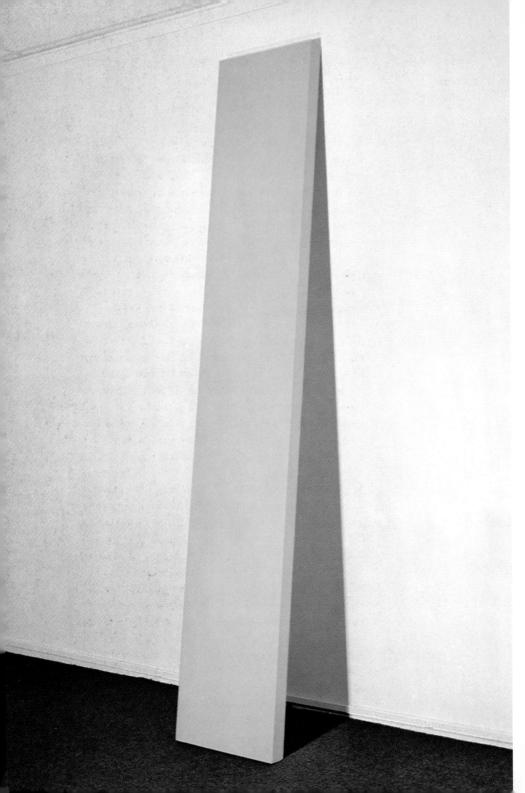

Chapter 2 The Expanded Field

By the time Fried wrote about the dangers of art's degeneration towards theatre in 1967, the process was well under way. Fried's target was Minimalism, but Thomas Hess had made similar remarks about Pop in 1963. He wrote: 'The presence of a big audience is essential to complete a theatrical transformation. It is impossible to conceive of a Pop painting being produced until some plans are laid for its exhibition. Without its public reaction, the art object remains a fragment.' The consequence of the loosening of categories and the dismantling of interdisciplinary boundaries was a decade, from the mid-1960s to the mid-1970s, in which art took a great many different forms and names: Conceptual, Arte Povera, Process, Anti-Form, Land, Environmental, Body, Performance, and Political. These and others had their roots in Minimalism and the various offshoots of Pop and new realism. During this period there was also an increasing ease of access to and use of communication technologies: not only photography and film, but also sound, with the introduction of the audio cassette and the wider availability of recording equipment, and video, following the appearance on the market of the first standard non-broadcast machines.

When the US critic Lucy Lippard tried to document these developments in the mid-1970s her solution was to make what was in effect a scrapbook of articles, interviews and statements. There was no simple way in which all these tendencies could be disentangled from one another and examined separately. Likewise, the major survey exhibitions of the time, notably 'Live in Your Head: When Attitudes Become Form' (Kunsthalle, Berne and ICA, London, 1969), 'Software' (Jewish Museum, New York, 1970), 'Information' (MOMA, New York, 1970), and Documenta V organized by the Swiss curator Harald Szeeman in 1972, included most of these tendencies. Both the titles of those shows and the name of Lippard's book, Six Years: The Dematerialisation of the Art Object from 1966 to 1972, also spoke of the difficulty of grasping just what, during this period, art was becoming. Did the artwork have substantial form or was it a set of ideas on how to perceive the world? Was it a single object or was it more diffuse, occupying a much larger space? Was art to

52. **John McCracken**, There's No Reason Not To, 1967

be found inside or outside the gallery? Art's changing face was neither the inexorable, nor indeed the inevitable forward march that the modernist notion of the avant-garde would understand. There was no preferred way of working that would cover all circumstances and requirements, and the idea that an artist should have a signature style, as Newman had his zips and Mark Rothko (1903–70) his fuzzy rectangles (the former also died in 1970), ceased to make much sense.

After Minimalism came post-Minimalism. That, at least, is the phrase the critic Robert Pincus-Witten coined to describe what followed. An alternative term was Process art, because in its final form, the materials and stages of manipulation that had been required in achieving it were made explicit. At other times it was dubbed Anti-Form. Taken together the names indicate what was beginning to appear by 1968 or so: an art that chronologically succeeded Minimalism which seized the freedoms it had brought and yet reacted against its formal rigidity.

One Ton Prop (House of Cards) (1968–69) by Richard Serra (b. 1939) is simple and approximates a cube, but the four large, extremely heavy square metal plates of which it consists are only balanced against one another, not welded or otherwise rigidly fastened together; One Ton Plate Prop (1969) holds a plate

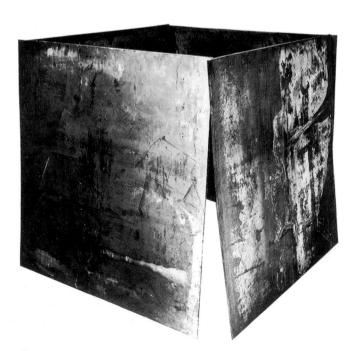

53. **Richard Serra**, One Ton Prop (House of Cards), 1968–69

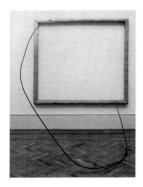

54. **Eva Hesse**, Hang Up, 1966

upright and away from the wall by means of a lead cylinder equally precariously. But as well as this kind of play, in which the certainties, revelations and reassurances of art are shown as the potentially dangerous illusions they are, Serra was, from the outset, also concerned with the particular qualities of the environment in which his work was shown. Later this would result in a series of large-scale works for public places, but to begin with he dealt with the enclosed space of the gallery. *Casting* (1969) involved hurling molten lead into the angle between the floor and the wall of the gallery. The resultant, hardened moulds were then eased from the surfaces, turned, and displayed as a certain kind of evidence, both of the particular characteristics of the viewing space and of the process by which the work had been achieved.

A number of the sculptures of Eva Hesse (1936-70) also made use of the various planes of the gallery. Like Serra, the geometric forms and repeated units of Minimalism make an appearance in her work, but not at all in the distanced, engineered way characteristic of that tendency. With one of her first major works, Hang Up (1966), Hesse made explicit the shift towards establishing an equivalence between the space of art and the space of its viewing. The piece is a large rectangular frame, thickly wrapped in bandage and painted in evenly graded shades of grey. Looping out from this frame to touch the floor some feet in front of it is a length of pliable metal rod. She wrote: 'It is extreme and that is why I like it and I don't like it. It's so absurd to have that long thin metal rod coming out of that structure. And it comes out a lot, about ten or eleven feet, and what is it coming out of? It is coming out of this frame – something and yet nothing and – oh! more absurdity - it is very, very finely done. The colours on the frame are very carefully graduated from light to dark – the whole thing is ludicrous.' This is as far from a Minimalist reliance on fabrication as a means to avoid 'craft' in art as it is possible to go.

The nonchalant pose adopted by the many handmade fibreglass tubes of Hesse's Accretion (1968) [55] is reminiscent of the highly finished plank-like sculptures of John McCracken (1934–2011), such as his ten-foot-high There's No Reason Not To (1967) [52], but the individual glitches and modulations in the units perhaps point more towards the anchoring structure of the edge-to-bottom dribbles in Morris Louis's 'Unfurled' paintings. The sculptures of Lynda Benglis (b. 1941) certainly have this pedigree. Pooling pigmented polyurethane produced works such as Bullitt (1969). Subsequently, as with For Carl Andre (1970), successive

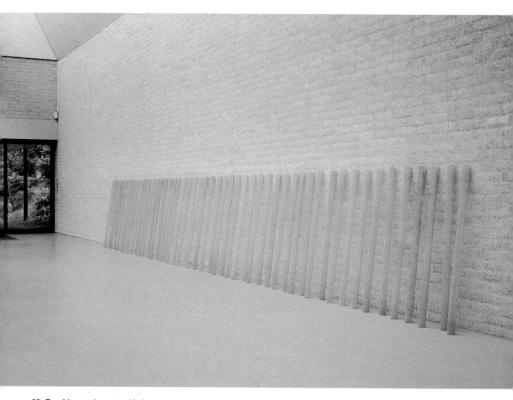

55. Eva Hesse, Accretion, 1968

57. **Lynda Benglis**, For Carl Andre, 1970

layers of variously coloured polyurethane foam were poured on top of one another.

'Anti-Form' was the title given to a short essay by Robert Morris in 1968. Looking back to the paintings of Morris Louis and, before him, Jackson Pollock, Morris promotes an art which takes process and 'holds on to it as part of the end form of the work'. The American artists Alan Saret (b. 1944), Keith Sonnier (b. 1941), Barry Le Va (b. 1941) and Morris himself were all at this time producing work which, instead of taking the form of distinctly bounded, discrete objects, involved the deployment of various materials over a large area.

Morris had followed his Minimalist pieces with large piles of felt strips, arrangements which could not possibly be replicated if the piece were to be shown subsequently in a different venue. In 1969 he selected an exhibition, 'Nine at Castelli', which included Hesse, Saret, Serra, Sonnier as well as Bruce Nauman (b. 1941), Bill Bollinger and Stephen Kaltenbach (b. 1940) as well as the Italian Arte Povera artists Giovanni Anselmo (b. 1934) and Gilberto Zorio (b. 1944). This show had considerable impact and made a strong case for the importance of process over product. In some respects the work it contained resembled a kind of dematerialization, an art made of the leftovers from some prior activity. Such appearances led the critic Max Kozloff to refer to it in his review as 'leavings'. This was literally the case with Nauman's *Composite Photo of Two Messes on the Studio Floor* (1967), a collaged photo-documentation of

56. **Bruce Nauman**, Composite Photo of Two Messes on the Studio Floor, 1967

58. Robert Ryman, Winsor 6, 1965

the splashes, spillages and general detritus remaining after the completion of another work.

There had also been a show the previous year at John Gibson's gallery in New York, actually titled 'Anti-Form', which included some of those who would take part in the Castelli show as well as the Americans Robert Ryman (b. 1930) and Richard Tuttle (b. 1941) and the Belgian Panamarenko (b. 1940). During the previous decade Ryman had restricted himself to the use of white paint alone. Narrowing his palette in this way allowed for greater control in experimenting with other elements of a painting: its surface, scale, whether it was framed, how it was fastened to the wall, and so on. Panamarenko's plans and construction of idiosyncratic flying machines - his 1967 Cockpit was made from, among other things, a tin can and cellophane - are close in spirit to the interest of the British sculptor Barry Flanagan (b. 1941) in 'Pataphysics, the "science of imaginary solutions", proposed at the beginning of the century by the French writer Alfred Jarry. Flanagan's 'soft' sculptures of the midto late 1960s - fabric bags either filled with sand or into which plaster had been poured and allowed to set, or lengths of rope that snaked and curled around the floor, marking out, defining and colonizing the space as in four cash 2'67, ring/1'67, rope (gr 2sp 60) 6'67 (1967) – incorporated ad hoc-ism as a formal principle and not, as in the US, as an index of the happenstance of the real world.

In Britain, the combination of attitudes prevalent in the US and in Europe was behind the remarkable diversity of response to the work of Anthony Caro, who was then teaching on the advanced sculpture course at St Martin's School of Art in London. Students during the 1960s included Gilbert (b. 1943) and George (b. 1942), Barry Flanagan, Bruce McLean (b. 1944), John Hilliard (b. 1945), Richard Long (b. 1945) and Hamish Fulton (b. 1946). The Dutch artist Ian Dibbets (b. 1941) was also there on a scholarship for a short time. All these artists responded in various ways to the openness of enquiry that the course allowed by producing work that contrasted greatly with the formal qualities of Caro's sculpture. For instance, Flanagan's Pile 3 (1968), a pile of loosely folded pieces of coloured hessian, takes the layer of coloured paint applied by Caro to unify his finished pieces, but mixes it with the staining of Louis and Noland and Minimalist techniques of arrangement.

59. **Barry Flanagan**, four casb 2'67, ring/1'67, rope (gr 2sp 60) 6'67, 1967

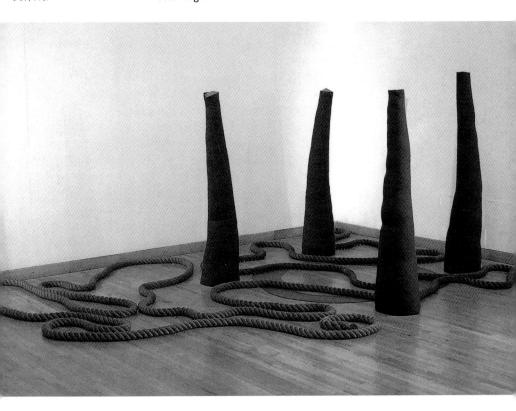

The Summer 1967 issue of Artforum that crystallized the debate around Minimalism contained Fried's 'Art and Objecthood' and Sol LeWitt's 'Paragraphs on Conceptual Art'. Although 'Concept art', an art composed of ideas, had been mooted by the artist Henry Flynt (b. 1940) as far back as 1960, an art of that kind now seemed an increasingly realizable possibility within the 'complex and expanded field' opened up by Minimalism. 'In conceptual art', wrote LeWitt, 'the idea or concept is the most important aspect of the work. When an artist uses a conceptual form of art, it means that all of the planning and decisions are made beforehand and the execution is a perfunctory affair. The idea becomes a machine that makes the art.' The link between idea and finished work is evident in the deadpan descriptive titles LeWitt gave his works: Ten thousand lines, five inches long, within an area of 61 × 51/2 inches (1971), for example, or Four basic kinds of straight lines and their combinations (1969) [60]. In some ways, then, Conceptual art continues what has already begun. The serialism is there, as is the understanding that the final artwork should not be subordinate to or illustrative of something else.

The idea of a process of preplanned moves suggests a connection between Conceptual art, mathematics and philosophy. LeWitt, though, insisted that 'conceptual art doesn't really have much to do with mathematics, philosophy or any other mental discipline. The mathematics used by most artists is simple arithmetic or simple number systems. The philosophy of the work is implicit in the work and it is not an illustration of any system of philosophy.' This echoes the rationale behind Mario Merz's use, since 1970, of the Fibonacci sequence of numbers, in which each number is the sum of the preceding two. The beginning of the sequence -1, 1, 2, 3, 5 - is what Merz calls 'biologically thinkable.... For example, we have one nose, two eyes, five fingers, precisely according to the series.' From this root in the body of the individual, the sequence's 'rapid and controllable expansion' spreads to encompass everything. For LeWitt, the idea from which the work issues was not sufficient in itself. It was first and foremost the idea to make that artwork; its strength, or lack of it, is not revealed until the work is complete. This need to complete things helps to make sense of LeWitt's insistence that, in spite of any impression given that Conceptual art is overly rational or predictable, it remains intuitive.

As with Minimalism, though, the act of making did not require LeWitt to lay his hands upon material and transform it himself. A wall drawing for which the instructions were 'Ten thousand lines not short, not straight, crossing and touching' could be executed by any number of people. In each case the drawing would 'look' different, but in each specific instance it would be an expression of LeWitt's idea (in the sense that a gene, as a set of coded instructions, is expressed). LeWitt began executing wall drawings in 1968. Sticking a drawing on paper onto the wall was fine, but drawing directly onto the brick or plaster of the available surface made the drawing more thoroughly a part of the architecture of the space. Working with similar preoccupations, the monochrome panels of masonite by Robert Mangold (b. 1937) functioned more as fragments for a putative remodelling of the gallery space than paintings, and, for a 1967 exhibition, William Anastasi (b. 1934) hung canvases in New York's Dwan Gallery carrying screened images of the walls they covered.

Nevertheless, there remains the thought that Conceptual art was somehow unexpressive. LeWitt spoke positively of making a thing 'emotionally dry' in order for it to be 'mentally interesting' for the spectator, and the French artist Daniel Buren (b. 1938) referred to an art that was 'impersonal'. Buren, who adopted the candy stripe as a sign of art's presence, quoted and emphasized the French writer Maurice Blanchot's phrase, 'a work of art of which nothing can be said, except that it is'. His constant use of the stripe began with his 1966 agreement with Niele Toroni (b. 1937) and Olivier Mosset (b. 1944) that each would make one painting over and over again, whatever the situation. As true to the agreement as Buren, Toroni has continued to cover his surfaces with evenly spaced dabs of a broad, flat brush [62]. The lawyer and critic Michel Claura noted in 1967 that this tactic called into question another cornerstone of the artistic edifice built upon the need for originality and innovation. He wrote: 'In order to discuss a forgery, one must refer to an original. In the case of Buren, Mosset, Toroni, where is the original work?"

Their tactic was adopted in order to achieve a 'position indispensable to the questioning process'. Buren was particularly concerned with the question of art's presentation, with where it could be placed and what consequences might follow from the choice of different sites: a domestic, commercial or gallery space, for example, or an exterior rather than an interior position, such as a wall or a billboard. Enquiries of this sort led to a redrawing of the artwork's boundaries. In March 1970, Buren had a blue and white striped poster included in the upper right hand corner of the Arts & Entertainments advertising panel in over 130 stations of the Paris Metro. Although done on the occasion of the '18 Paris

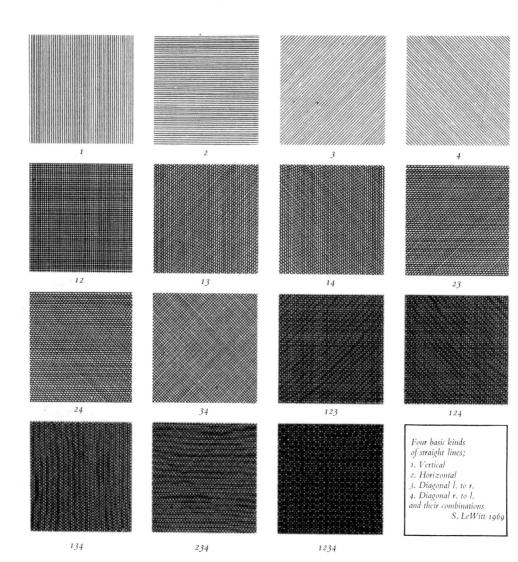

60. **Sol LeWitt**, Four basic kinds of straight lines and their combinations, 1969

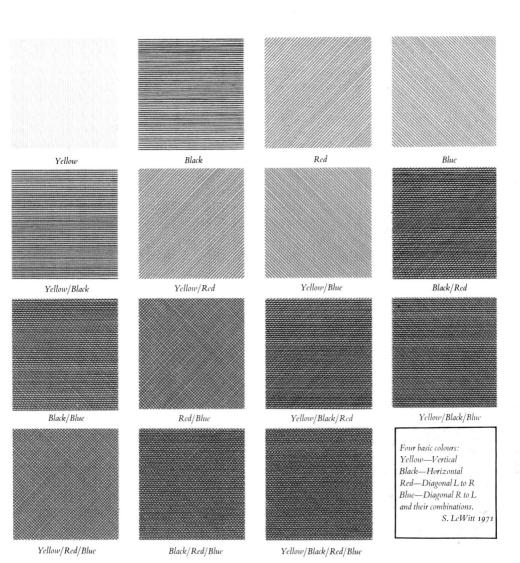

61. **Sol LeWitt**, Four basic colours and their combinations, 1971

62. **Niele Toroni**, Présentation: imprints of a no. 50 brush repeated at regular intervals of 30 cm, 1966–96

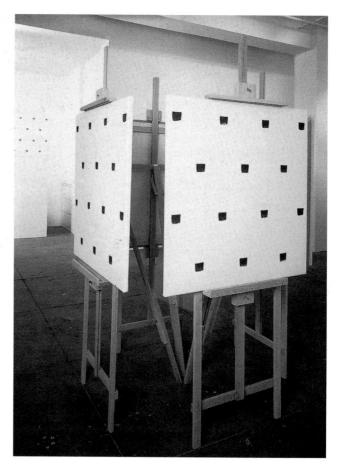

IV 70' exhibition, 'these pasted pieces of striped paper', Buren wrote, 'were and still must be considered as part of a work which began, was carried on and is still in process outside and beyond the place and time of this particular proposal'. Furthermore, the posters provided the 'pretext' for a set of photographs, published as the book *Legend I*, which itself could only be 'a partial representation of what is (only) a fragment of a work in progress'. Buren's point was not that it would be difficult to see his work in its entirety, but that it would be impossible. The understanding of art as a set of products can be seen here to give way to the idea of it as a process that is coextensive temporally with the life of the artist and spatially with the world in which that life is lived. The contribution of Robert Barry (b. 1936) to the Düsseldorf exhibition 'Prospect 69', a question and answer text, made similar assumptions:

63. **Daniel Buren**, *Opéra*, from *Legend I*, 1970

- Q: Which is your piece for Prospect 69?
- A: The piece consists of ideas which people will have from reading this interview.
- O: Can this piece be shown?
- A: The piece in its entirety is unknowable because it exists in the minds of so many people. Each person can really know only that part which is in his own mind.

64. **Hanne Darboven**, *Untitled*, 1968

In the same spirit, the Japanese artist On Kawara (b. 1933) made his art from the 'historical fact' of his life. From the mid-1960s, his paintings have merely recorded the date on which they were executed. In accord with this matter-of-factness, Kawara's communications would also do no more than baldly confirm his continued existence: 'I am still alive. On Kawara' [65]. Like Kawara, both the Polish artist Roman Opalka (b. 1931) and the German Hanne Darboven (b. 1941) developed methods of working that laid stress on the relationship between their practice as artists and their individual being. In her drawings, Darboven tabulate simple number sequences, often derived from the date, putting them through a variety of straightforward permutations and transformations. Opalka began in 1965 to paint the numbers from $1 \rightarrow \infty$. In all three cases one sees art as a very direct form of marking time.

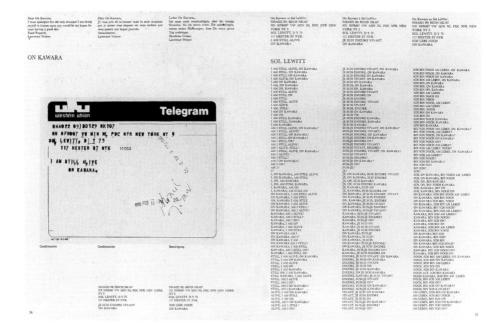

65. On Kawara, I am still alive, and a response from Sol LeWitt 1970. The July/August 1970 issue of Studio International was effectively an exhibition of conceptual art. Six critics were each given eight pages of the magazine to 'curate'. Lucy Lippard's section, from which this spread is taken, was a round robin that involved the first artist sending instructions to the next on the list about making a work, which was completed before instructions were transmitted to the subsequent artist.

As the thrust of Buren's enquiries implies, Conceptual art concerned itself to a great degree with an examination of what art was: what were the necessary and sufficient characteristics required for a thing to be deemed art, and how might it be exhibited, curated and criticized? For some, this kind of examination remained a necessary activity prior to the making of art, while others considered that the enquiry itself constituted their art. Boundaries had once seemed more certain than this. There was art, which was one thing, and there were the things people said and wrote about it, which were another. Where Minimalism had found the meaning of an art object to lie to a certain extent 'outside' itself in its relationships with its surroundings, Conceptualism drew the tasks of criticism and analysis into the realm of art-making. What complicates the matter is that by this time a number of artists had begun to use language itself as a material. Conceptualism is often identified as a period during which art became insubstantial. Where there had once been paintings and sculptures, there were now items of documentation, maps, photographs, lists of instructions and bits of information in the work of among others Douglas Huebler (b. 1924), Robert Barry, Mel Bochner, Stephen Kaltenbach, Edward Ruscha, John Baldessari (b. 1931) and Victor Burgin (b. 1941). As Lawrence Weiner (b. 1942) and Joseph Kosuth

(b. 1945) demonstrated in their different ways, however, even words have a quiddity which it is perfectly proper for the visual artist to investigate. Weiner, in a 1969 interview, considered the subject matter of his work to be materials, even though what was there to be seen in a gallery would be no more than a text naming substances and/or objects and what might be done with them: One standard dye marker thrown into the sea (1968), or A 36" × 36" removal to the lathing or support wall of plaster or wallboard from a wall (1968). Additionally, Weiner refused to make assumptions about the viewer, always accompanying his texts with the following short statement:

- 1. The artist may construct the piece.
- 2. The piece may be fabricated.
- The piece need not be built.
 Each being equal and consistent with the intent of the artist, the decision as to condition rests with the receiver upon the occasion of receivership.

Effectively, the work according to Weiner 'can be presented just in language', and the options given to the viewer are important because 'art is always a presentation. It is never an imposition.' Again we find discomfort with the concept of art as the expression of an idea or emotion belonging to the artist.

66. Lawrence Weiner, A 36" × 36" removal to the lathing or support wall of plaster or wallboard from a wall, 1968

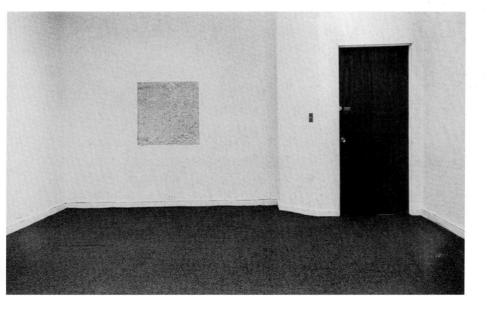

Rather than asking what a piece means, that is, trying to work out what the artist is trying to tell us, it is now more appropriate for the 'receiver' to consider in what ways the information given could be meaningful. In like manner, Douglas Huebler could make a piece which designated a place, a particular site in New York, by locating a number of points. What can be done with this information by the viewer is left entirely open: 'I think "here it is" and that's all.' The piece cannot be experienced perceptually, but 'can be totally experienced through its documentation'. For the exhibition 'January 5-31, 1969', organized by Seth Siegelaub in New York, Huebler exhibited photographs taken on a trip from Massachusetts to the city, not framing them but placing them in plastic sleeves on a window ledge. The images of Site Sculpture Project, 50 Mile Piece, Haverhill, Mass. – Putney, Vt. – New York City (1968) are evidence of, or ephemera relating to the journey rather than intentionally finished things in themselves.

In February 1969, Arts Magazine published four interviews — with Lawrence Weiner, Robert Barry, Douglas Huebler and Joseph Kosuth — conducted by 'Arthur R. Rose', a pseudonym of Kosuth himself. That its adoption was an aspect of Kosuth's practice as an artist, rather than a convenient means to pursue a parallel career as a critic, is evident in the homage which the name pays to Marcel Duchamp's female alter ego, Rrose Sélavy ('Eros, c'est la vie'). Kosuth spoke, in his auto-interview, of what it meant to be an artist:

Being an artist now means to question the nature of art. If one is questioning the nature of painting, one cannot be questioning the nature of art. If an artist accepts painting (or sculpture) he is accepting the tradition that goes along with it. That's because the word 'art' is general and the word 'painting' is specific. Painting is a *kind* of art. If you make paintings you are already accepting (not questioning) the nature of art. One is then accepting the nature of art to be the European tradition of a painting—sculpture dichotomy.

In saying this, Kosuth was influenced by Ad Reinhardt (1913–67), an artist of the Abstract Expressionists' generation who, for most of the decade up to his death in 1966, painted square, black paintings. These were not uniformly monochrome, however, but structured according to a broad, rectilinear cross design. Close inspection of each area of this pattern reveals

SITE SCULPTURE PROJECT 50 Mile Piece

Haverhill, Mass. - Putney, Vt. - New York City

- I. Massachusetts Route 125
- 2. New Hampshire Route 101
- 3. Vermont Route 5
- 4. Interstate Route 91 (Mass.)
- 5. Interstate Route 91 (Conn.)
- 6. Wilbur Cross Parkway (Conn.) 11. Connecticut Route 15-44
- 7. Merritt Parkway (Conn.)
 - 8. Deegan Expressway (N. Y.) 9. Merritt Parkway (Conn.)
- 10. Interstate Route 91 (Conn.)
- 12. Massachusetts Turnpike
- 13. Massachusetts Route 495

This work is formed by thirteen photographs that serve to mark the location of the sites listed above (and marked in that sequence) which actually describe 50 mile intervals of highway space.

All photographs were taken fifteen paces from the edge of the road with the camera held above the site and at a right angle to it.

Marked October 1968

DOUGLAS HUEBLER

67. Douglas Huebler, Site Sculpture Project, 50 Mile Piece, Haverhill, Mass. - Putney, Vt. - New York City, 1968

different colours in the underpainting. 'Art is art as art,' Reinhardt had said, 'everything else is everything else.' What Kosuth drew upon was the way in which Reinhardt's critical and pedagogical activities around his painting had provided a context within which it might best be viewed and understood. His series of works, 'Art as Idea as Idea' pay homage to Reinhardt not only in their title, but also in their form, which mimics the older artist's black paintings. Each work is a photostat of the dictionary definition of a word - 'art', 'idea', 'meaning', 'nothing' - blown up and printed in reverse, white out of black. Kosuth maintained that it was not the actual photostats that were art, but the ideas they represented:

68. **Joseph Kosuth**, One and Three Chairs, 1965

'The words in the definition supplied the art information.' The definitions of 'Art as Idea as Idea' followed One and Three Chairs (1965), which comprises a wooden chair, a large black-andwhite photograph of the chair and a photostat of the dictionary definition of the word 'chair'. Customarily the two wall-mounted elements would be seen as secondary facts, supporting and describing the primary object, the chair. What the piece asks, though, is whether we can be satisfied with that, or whether, in fact, the photograph and photostatted text do not themselves exist as chairs. To what extent can the photograph be relied upon as evidence of a state of affairs? It certainly appears to be an image of the real chair before us, but it might just as well be of another, almost identical item of furniture. If this were so its dependence upon the chair here is denied. The definition names the object before us, tells us what it is, but it also marks out a category of which the 'real' chair is only a single example.

In thinking about the interplay between reality, idea and representation, Kosuth drew heavily on the philosophy of Ludwig Wittgenstein, whose thoughts on the tautologous nature of mathematical propositions in his *Tractatus Logico-Philosophicus* were transferred to the field of art by Kosuth in his 1969 essay, 'Art After Philosophy'. He wrote: 'A work of art is a tautology in that it is a presentation of the artist's intention, that is, he is saying that that particular work of art is art, which means is a *definition* of art. Thus that it is art is true a priori (which is what Judd means when he states that "if someone calls it art, it's art").' A central idea of the *Tractatus*, that a proposition is like a picture

of the world, appears widely applicable to 'dematerialized' art. As early as 1960 the French critic Pierre Restany had described Yves Klein's blue paintings as propositions. Mel Ramsden (b. 1944) an English artist working in New York in the late 1960s and early 1970s, made several paintings of texts stating facts about their own make-up, such as 100% Abstract (1968): 'Copper Bronze Powder 12% / Acrylic Resin 7% / Aromatic Hydrocarbons 81%'. These were in the line of Morris's self-explanatory Box with the Sound of its Own Making (1961) and his 1963 self-cataloguing File Card. John Baldessari, working on the West Coast, employed a sign painter to put his laconic statements on canvas: Pure Beauty, or A painting with only one property, or Everything is purged from this painting but art; no ideas have entered this work (all 1966-68). Terry Atkinson (b. 1939) and Michael Baldwin (b. 1945), two British artists, began working together in 1966. An early work, Map to not indicate (1967) [71], showed a rectangular area containing the outline of Iowa and Kentucky together with a list of all those surrounding states, provinces and areas of sea which are not in evidence. Their status as absent is akin to the situation described in Barry's piece All the things I know but of which I am not at the moment thinking - 1:36pm; June 15, 1969.

The collaboration between Baldwin and Atkinson led in 1968 to the establishment, with Harold Hurrell (b. 1940) and David Bainbridge (b. 1941), of Art & Language. All four taught in Coventry at the time, developing and running an art theory

69. **John Baldessari**, Everything is purged from this painting but art; no ideas have entered this work, 1966–68

70. **Robert Barry**, All the things I know but of which I am not at the moment thinking – 1:36pm; June 15, 1969, 1969

ALL THE THINGS I KNOW BUT OF WHICH I AM NOT AT THE MOMENT THINKING— 1:36 PM; JUNE 15, 1969

Robert Barry

Major and different CANADA, JAMES BAY, ONT RED. OF THE CAST, LAWRESTER RIVER. NEW BENNIFICE, MANYTONA ARCHINES INSLAND, LEAK FER ITHE WORLD FOR A FER ITHER CASE OF THE CAST OF THE CASE O

71. Terry Atkinson and Michael Baldwin, Map to not indicate. 1967

course at the art school. In their writings and discussions, which themselves constituted the 'work' of A&L, they addressed with a severely critical eye the recent developments in art and their implications for the prevailing theories of modernism. The relationship between 'art' and 'language' for the group was never a straightforward one of form and material, practice and interpretation, and certainly not of image and commentary. The two were much more intimately bound up within a discourse carried on by a collective whose individual members 'sought not to be the authors of [their] work so much as agents in a practice which produced it'. For them the formalist stance taken by Greenberg, far from being the most persuasive consequence of the kind of art it championed, could better be understood as an expression of the values and expectations that produced the art in the first place. The French theorist Michel Foucault, most responsible for elaborating the idea of discourse during this period, described it more completely as not only the sum of statements made (or in this case, works of art produced), but also the operations of those institutions - here, museums and galleries, the art market, criticism and publishing - which provide the framework within which they are seen and are able to have an impact. Much as Art & Language saw Greenberg as in a real sense 'responsible' for Post-painterly Abstraction, Foucault described

discourses as 'practices that systematically form the objects of which they speak'. *Index 01*, exhibited at Documenta V in 1972, included texts and charts pasted around the walls of a room in which stood eight filing cabinets full of closely cross-referenced excerpts from a range of theoretical texts. This was art that could not bestow idle visual pleasure, but which demanded work from the viewer. Art & Language, though, were not aiming at obscurantism for its own sake, but at resisting the easy assimilation of their work into a comfortable 'story of art'.

In 1969, Art & Language published their journal, *Art-Language*, the first issue of which contained essays by members of the group and contributions from the Americans LeWitt, Weiner and Dan Graham (b. 1942). Graham, who had previously published an article in the magazine *Arts* drawing comparisons between Minimalism's modularity and the forms and arrangements of homes in suburban America, submitted the reflexive *Schema* (1966) [73] which listed the number and type of words, numbers and other symbols contained in its own layout, along with information about the paper stock on which it was printed. The connection between Art & Language's project and the activities of some artists in New York, notably Kosuth, Christine Kozlov (b. 1945), Ramsden, and the Australian lan Burn (1939–1993), led for a short while in the early 1970s to the establishment of an Art & Language there.

The documentary aspect of much Conceptual art, of course, lent itself to magazine publication. *Artforum* had been the main source of information but was by no means unique. In addition to several other US publications, in Europe there were *Art International*, published in Switzerland, *Interfunktionen*, in Germany,

72. Art & Language, Index 01, 1972 (partial view)

Schema for a set of pages whose component variants are specifically published as individual pages in various magazines and collections. In each printed instance, it is set in its final form [so it defines itself) by the editor of the publication where it is to appear, the exact data used to correspond in each specific instance to the specific fact(s) of its published appearance. The following schema is entirely arbitrary; any might have been used, and deletions, additions or modifications for space or appearance on the part of the editor are possible.

SCHEMA:

(Number of) adjectives (Number of) adverbs (Percentage of) area not occupied by type area occupied by type (Percentage of) columns (Number of) (Number of) conjunctions (Depth of) depression of type into surface of page (Number of) gerunds (Number of) infinitives (Number of) letters of alphabets (Number of) lines (Number of) mathematical symbols nouns (Number of) numbers (Number of) participles (Number of) page (Perimeter of) paper sheet (Weight of) paper stock (Type) (Thinness of) paper prepositions (Number of) (Number of) pronouns size type (Number of point) typeface (Name of) words (Number of) words capitalized (Number of) words italicized (Number of) (Number of) words not capitalized words not italicized (Number of)

Schema' 1966 Daled Collection, Brussels

and a revitalized *Studio*, now dubbed *Studio International*, in Britain. Publications could deliver not just a picture of an artwork that existed elsewhere, or some news about it, but, in the case of work which comprised textual and photographic elements, the actual artwork. In 1970, *Studio* made use of this, producing an exhibition in the form of a book whose pages had been curated by six invited critics. The curator Seth Siegelaub, in particular, concentrated on this aspect of Conceptual art, organizing a number of exhibitions that existed primarily in catalogue form.

The ease with which information could be circulated contributed to the internationalism of Conceptual art. In his catalogue introduction to the 'Information' show at the MOMA in New York in 1970, the curator Kynaston McShine made a point of remarking on the show's inclusion of artists from Brazil, Canada and Argentina. Comments by the Brazilians Cildo Meireles (b. 1948) and Helio Oiticica (1937–80) reiterated this

74. Marcel Broodthaers,

Museum of Modern Art, Eagles Department, Section des Figures (The Eagle from the Oligocene to the Present) (detail), 1972. Broodthaers 'opened' his fictitious 'Museum of Modern Art' with an exhibition in his apartment in 1968, and it appeared in different locations and guises over the next four years. For the Department of Figures, Broodthaers collected a wide variety of objects pictures - books, sculptures, magazines, photographs, prints, jewelry, specimens, knick-knacks, etc. all of which took the form, or bore an image, of an eagle. Each item was presented to its best advantage, regardless of both age and relative value, together with a numbered label stating, 'This is not a work of art', an assertion that combined ideas from Duchamp and Magritte. Broodthaers's careful display thus paradoxically challenged the authority of the museum and gave each item back its individuality.

view and interpreted the terms of their participation as being of a similar nature to their art. The art was what it was, and not a representation of anything else; they, too, were who they were, and were not there as representatives of their country.

Conceptual art proposed that images can be recognized as being language-like: an artwork can be read. The reverse is equally true: words can work in a picture-like way. An older instance of this is Magritte's painting *The Treason of Images* (1929), a picture of a pipe beneath which appear the words 'This is not a pipe.' Marcel Broodthaers (1924–76), also a Belgian, made constant reference to his fellow-countryman's 1929 painting in his own work. Broodthaers was a poet, but observing, as he said, that artists were doing the same thing as him with the significant difference that they were making money, he had decided to become an artist. His first act was to make a sculpture, *Pense-Bête* (1964), by embedding the remaining copies of an edition of his poetry in plaster. Word and object remained closely connected in his work thereafter.

In the four years between 1968 and 1972, Broodthaers's work provided an extended critique of the museum system. It took the form of a fictional 'Museum of Modern Art', whose different departments came into existence as he staged successive exhibitions. The first section, the Department of Eagles, Nineteenth Century Section, was sited in his Brussels flat. It was a collection of crates, postcards and texts. 'This invention,' he said, 'a jumble of nothing, shared a character connected to the events of 1968, that is, to a type of political event experienced

by every country.' The largest section, seen at the Düsseldorf Kunsthalle in 1972, contained over 250 artefacts borrowed from collections around the world. Each exhibit depicted an eagle, the widespread symbol of power and authority, and emblem of Broodthaers's own museum. The way in which he organized these objects cut across normal systems of classification such as age, geographical location or function, and questioned how far the rationale of such groupings might contribute to the meanings of the individual items which they contain. Ordinary museums, relying on classification, are only able to present one form of the truth: 'To talk about this museum', said Broodthaers, 'means speaking about the conditions of truth.' Beside every item in his display he placed a label stating in either French, German or English: 'This is not a work of art.' This was meant as a challenge to the imagination: could these things, having once been designated as art by the system, be 'thought' back into the flow of reality from which they were plucked?

Arte Povera, impoverished art, was a phrase coined by the Italian critic Germano Celant in 1969, to describe the work of his countrymen Michelangelo Pistoletto, Alighiero e Boetti (1940-94), Giuseppe Penone (b. 1947), Giovanni Anselmo, Luciano Fabro (1936–2007), Giulio Paolini (b. 1940), Pino Pascali (1935–68), Gilberto Zorio, Mario and Marisa Merz, Pier Paolo Calzolari (b. 1943) and Jannis Kounellis (b. 1936). Art objects had hitherto been fashioned as the repository for emotions and ideas, 'a procedure', according to Celant, 'along binary parallels, art and life, in quest of the intermediate value'. In contrast, Arte Povera was 'the convergence of life and rich art', that paid more attention to 'facts and actions'. It was, '...almost a rediscovery of aesthetic tautology: the sea is water, a room is a perimeter of air, cotton is cotton, the world is an imperceptible ensemble of nations, an angle is a convergence of three coordinates, the floor is a portion of tiles, life is a series of actions'.

There were close affinities between Arte Povera's factual treatment of materials and the three-dimensionality of US art. A sense of the literal immediacy of materials, however, was achieved neither at the expense of their historical or poetic resonance, nor of their metaphoric or symbolic potential. Celant's 'convergence' was the meeting of an ordered past with the contingent jumble of the present. Pistoletto's *Venus of Rags* (1967) [77] juxtaposed the smooth perfection of a Classical nude statue – a composed, integral, halcyon ideal – with the chaos of a heap of fabric scraps. As here, Italy's past weighs heavily in much Arte Povera work.

75. **Jannis Kounellis**, *Horses*, 1969

76. **Giuseppe Penone**, *Twelve* Metre Tree, 1970

77. **Michelangelo Pistoletto**, *Venus of Rags*, 1967

The outline of the country appeared frequently in Fabro's art, suspended upside down. It was, he said, necessary to discover the order of things, 'to induce the causes of the effects that are felt', rather than to search for essences. Paolini's search for order led to the frustration or dismantling of previous systems - Renaissance perspective, the rhythms of a Baroque façade, for example - in his mixed media works. The effects of natural processes and time on materials figured in Penone's Twelve Metre Tree (1970) [76], and similar works that teased saplings from the trunks of mature trees. Anselmo extended the period under consideration in pieces that relied on the relative durability of granite and iron. For an Incision of an Indefinite Thousands of Years (1969) was a steel bar leant against the wall. Greased, and hence protected at its top end, the clean bottom half was open to the air and prone to oxidation. Ultimately the bar would disintegrate and slowly sink down the wall, inscribing a mark with its top edge as it did so. The two smooth granite blocks of Untitled (1968-86), one small, the other larger, were tied tightly together with vegetables squashed in between them. As the vegetables aged, shrivelled and dried up, the smaller stone, released from

78. **Giovanni Anselmo**, *Untitled*, 1968–86

its binding, would fall to the floor. Regular replenishment was therefore required.

The conjunction and interaction between inert and organic matter, implicit in the sensuous form of Penone's 'Soffi' ('Gusts') - a series of large hollow clay pots which he began in 1978 - were also characteristic of Kounellis's work. A multi-part untitled piece of 1967 comprised four troughs planted with living but slow-growing cacti, a metal bin stuffed to overflowing with recently grown and harvested raw cotton, and a rod protruding from a wall-mounted metal panel on which perched a macaw. For a 1969 exhibition in Rome eleven horses were tethered in the gallery [75]. Fire as a purifying or transforming presence, or as a sooty trace, was also used regularly in association with the coal, sackcloth and metal of an industrial past, or with sculptural fragments redolent of lost cultural origins. The latter had a particular significance for the Greek-born Kounellis, a wanderer steeped in and yet removed from his past. Merz, in fact, made most obvious use of the notion of the artist as wanderer with his igloos. Writing of these structures, some made of soft materials, others, such as Objet Cache Toi (1968), from jagged-edged sheets of glass clamped to metal frames, Celant said: 'A shelter and a cathedral of survival, from the politics of art as much as from the winds, such buildings are also the image of the nomad or vagabond, who does not believe in the secure object, but in the dynamic contradiction of life itself.'

79. Mario Merz, Igloo de Giap, 1968. Merz has long made use of the Fibonacci number sequence — 1, 1, 2, 3, 5, 8, 13... — seeing in it a model of human life. Starting from our one body, one head, two arms/legs/eyes, etc., we spiral out into the universe. The space within which we conduct our nomad existence is therefore infinite.

Arte Povera challenged the settled order of things, and valued more the processes of the artist's life which sought poetry in the presence of materials, than objects offering meaning alone. The viewer of these works of art, confronted with the fact of their existence, ought to feel equally free to explore the information they offered.

Richard Long made art by going for walks. A route which could be easily conceptualized – a line, circle or square – would be followed on the ground. The walk itself could not be directly experienced by an audience who instead saw some form of documentation of it: a map with the route of the walk drawn on it, a text listing things passed or seen en route, a photograph, a tabulation of the walk as the carrying of a found object until such time as another was spotted and substituted, and so on. The preplanned logic of many of these was close to the sensibility of Conceptualism: A Six Day Walk Over All Roads, Lanes and Double Tracks Inside a Six Mile Wide Circle Centred on the Giant of Cerne Abbas (1975). Equally, Long might stop during the walk and make a line or circle with loose sticks or stones or by scuffing the ground with his boots. These would be left to disintegrate under the forces of nature and thus could only really be seen, too, as a photograph on a gallery wall. Working in a closely related way, although eschewing even the slight manipulation of the landscape undertaken by Long, Hamish Fulton would do no more than take a photograph in the course of a walk, or produce a text, either of which could be exhibited in a gallery on his return. In the face of such work the question 'Where is the art?' is often posed. Is the photograph Walking a Line in Peru (1972), for example, a work in its own right, or is there, somewhere in the Andes, a real work by Long of which we in the gallery see only documentary evidence? This conundrum is insoluble in terms of a logic which depends upon the primacy of the collectable art object, but the result of this should not be frustration at an inability to determine that here, and not there, is where the art lies. The options are not mutually exclusive, and, if there is a lesson in this, it is that the question had by now become irrelevant. The absence of an object from the gallery clearly identifiable as the 'artwork' encourages the notion that what we, as viewers, should be doing is deciding to look at the phenomena of the world in an 'art' kind of way. One would then be asking oneself the question: Supposing I look at this as if it were art. What might it then mean for me?

Long's walks could be seen in plain sculptural terms as a description of form in space, but there was another important

80. **Richard Long**, Walking a Line in Peru, 1972

strand to his work. Materials – slates, sticks, driftwood, mud – from a particular place might be removed and exhibited in a gallery. Here, the question is not so much 'Is the real work in the landscape or the gallery?' as 'What contribution does the landscape make to the particular effectiveness of the work in the gallery, given that the origin of the materials makes a difference?' From early on, Long was described as continuing in a specifically British tradition of landscape artists. His England (1967) is a photograph of a landscape in which a rectangular frame has been placed vertically in the foreground. Through it, another, circular one can be seen laid on a hillside in the distance. The treatment of framing, composition, viewpoint and perspective was something the work shared with Jan Dibbets's series of 'Corrected Perspectives', but it also calls to mind Andre's remark that the English landscape is the largest earthwork in the world.

Much more than Long or Fulton, the American Robert Smithson was concerned to develop a theory of the relationship between a particular location in the environment (which he called a 'site'), and the anonymous, essentially interchangeable spaces of the galleries in which he might exhibit (which he referred to as 'non-sites'). Among other things, sites had open limits, scattered information and were some place; non-sites, such as *Gravel Mirror with Cracks and Dust* (1968) [81], had closed limits, contained

information, and were no place, that is, were an abstraction. Because of the modular composition and geometrical simplicity of his first sculptures, Smithson was originally seen as a Minimalist, but even in these works his inspiration in crystal structure indicated that the 'impersonality' often attributed to Minimalism was not what he sought. Crystals occur naturally, and therefore thinking of simple geometrical forms as exclusively cultural as opposed to natural made little sense to him. That connection with nature and the environment would be a constant preoccupation. In the physical concept of entropy, the decaying of order into chaos, Smithson found a model for a practice that would result in some very large landscape interventions.

In contrast to Long and Fulton, Smithson's art and that of Walter de Maria (1935–2013) and Michael Heizer (b. 1944) demonstrated a preparedness to manipulate and alter the landscape on a far greater scale. One of Smithson's essays began: 'Imagine yourself in Central Park one million years ago. You would be standing on a vast ice sheet, a 4,000 mile glacial wall, as much as 2,000 feet thick. Alone on the vast glacier, you would not sense its slow crushing, scraping, ripping movement as it advanced south, leaving great masses of rock debris in its wake.' In comparison to forces of that magnitude, anything accomplished by an individual artist would be insignificant,

81. **Robert Smithson**, Gravel Mirror with Cracks and Dust, 1968

and Smithson considered misplaced the growing sensitivity to environmental issues when it manifested itself as an exaggerated preciousness towards nature. Partially Buried Woodshed (1970) involved piling earth on top of a shed in the grounds of Kent State University until the central roof-beam cracked under the weight. The structure was then left. Asphalt Rundown (1969) was just that, truck-loads of asphalt poured down a slope outside Rome. Several other major works (including Amarillo Ramp, during the construction of which Smithson died in a plane crash in 1973), required the shifting of enormous quantities of rocks and earth. Most famously, his Spiral Jetty (1970) projected out from the shore into the Great Salt Lake made red by a particular type of algae. In the years since it was constructed, fluctuating water levels have first inundated and more recently revealed again the entire work.

For Smithson there was a close relationship between the formation and life of these sculptures – all of which, like Long's, were left to their fate – and mental activity. The laying of memory upon memory, the struggle to form a clear image from a jumble

82. **Robert Smithson**, Spiral Jetty, 1970

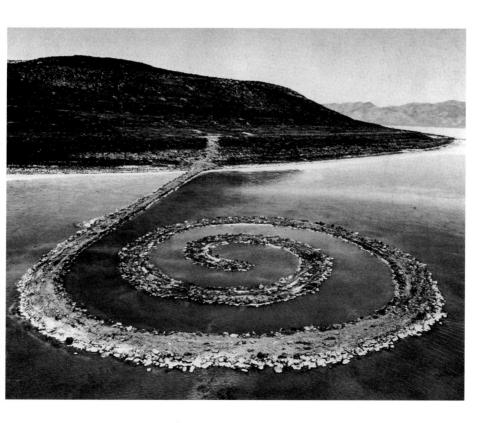

83. **Bernhard and Hilla Becher**, *Typology of Water Towers*, 1972 (detail)

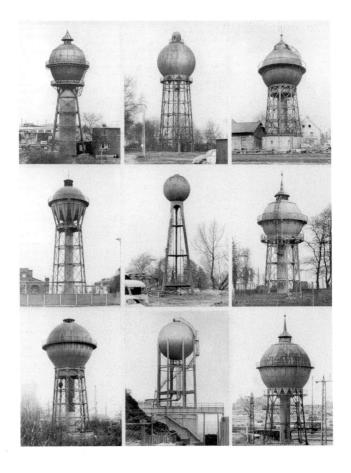

of impressions, and the connections made between disparate ideas and loss through forgetfulness all mirror sedimentation, folding, plate tectonics, seismic fracturing and other geological phenomena. Smithson would also document the environment as he found it, presenting, for example, photographs of the factory outflows, bridges and pontoons on the Passaic river in industrial New Jersey as a series of 'monuments'. In recognizing industrial structures as the true monuments to culture and civilization in the twentieth century, Smithson's attitude was close to the Germans Bernhard (1931–2007) and Hilla Becher (b. 1934) who had been photographing their 'anonymous sculptures' – water towers and pit-heads – since the late 1950s.

Until James Turrell (b. 1943) began working on an extinct volcanic crater in Arizona in 1972, the only other really large mover of earth had been Michael Heizer for his *Double Negative*

(1969-70), a project in the Californian desert that drew formally on Heizer's father's experiences as an archaeologist working on pre-Colombian civilizations. On a more intimate scale, Walter de Maria's 50 m³ Level Dirt (1968) filled Heiner Friedrich's Munich gallery to a depth of one metre. By no means all of the gallery could be seen from the doorway, so much of the work had to be either imagined or taken on faith, like the landscape from which its materials had been drawn. De Maria subsequently made two more versions of the work, the latest of which, The New York Earth Room (1977), uses 197m³ of earth and is permanently installed and maintained by the Dia Center for the Arts in New York. Dia also has on permanent display de Maria's Broken Kilometer (1979), which consists of 500 brass rods, each two metres in length, arranged on the floor in five parallel rows. This visible work is the companion piece to Vertical Earth Kilometer, a brass rod one kilometre long buried vertically in the ground outside the Museum Fridericianum in Kassel for Documenta VI in 1977. Also outside, de Maria used the floor of the Mojave desert on which to make a Mile Long Drawing (1968), and in New Mexico he placed regularly-spaced, vertical steel rods over an area of a mile by a kilometre to make his Lightning Field (1971-77) [85]. Lightning Field is permanent but isolated: 'Isolation', said de Maria, 'is the essence of Land Art.' Those who wish to see it can do so in small groups, an overnight stay in the nearby cabin allowing them sufficient time to make the requisite walk around the area. The way in which the work is seen is not extraneous to its condition and meaning, but part of it. In his notes for the work, de Maria points out, for instance, that viewing Lightning Field from the air would be of no value since the relationship between sky and earth is so important; the centrality of that relationship is clearly visible from the ground, especially when the lightning so common in the area is forking through the air.

In 'Specific Objects', Judd had observed of sculpture that: 'since it isn't so general a form [as painting], it can probably only be what it is now — which means that if it changes a great

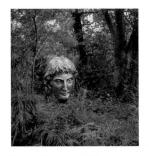

84. Ian Hamilton Finlay with Alexander Stoddart, Apollon Terroriste, by the Upper Pool, Little Sparta, 1988

85. Walter de Maria, Lightning Field, 1971–77

deal it will be something else; so it is finished'. A decade and a half later, in 1979, the US critic Rosalind Krauss proposed a rationale for understanding the subsequent proliferation of art forms which, for want of a better word, continued to be grouped under the general heading of sculpture. Taking Morris's idea of the 'expanded field', Krauss argued that, for example, Land art might best be defined in terms of a double negative: it was neither architecture nor landscape. Furthermore, Krauss suggested, other works could better be placed in one of three other, related categories: landscape and architecture, architecture and not architecture, and landscape and not landscape. At first sight these seem merely self-contradictory, but when held up against much that was dubbed Land art. Environmental art and Installation. they started to make sense. The large wooden structures of the American artist Alice Aycock (b. 1946), Maze (1972) and A Simple Network of Underground Wells and Tunnels (1975), are not quite buildings, but are certainly more than the site on which they are constructed. Works by the American artists Nancy Holt (b. 1938) and Mary Miss (b. 1944) are additions to a place and yet serve essentially to reveal the landscape itself to the observer rather than to impose themselves upon it as a new presence. Miss's Untitled (1973) consists of a series of wooden panels placed one behind the other. A circular hole is cut in the first and an increasingly smaller segment in subsequent panels so that, when viewed end on, the hole appears to be sinking into the ground. The Manhattan skyline visible in the distance over the top of the

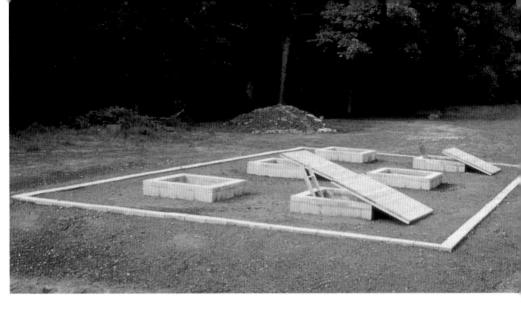

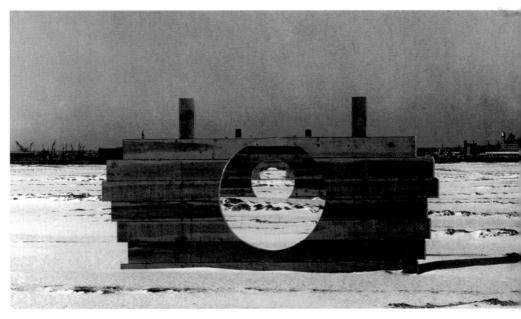

86. **Alice Aycock**, A Simple Network of Underground Wells and Tunnels, 1975

87. Mary Miss, Untitled, 1973

88. **Bruce Nauman**, *Green Light Corridor*, 1970–71

panels ties the piece down, bringing about a 'complete integration between materials, idea, and place'.

Both 'Environmental' and 'Installation' are labels that have gained in currency since the 1970s to account for the increasing frequency with which spectators found that they had to be in an artwork in order to see and experience it. In America, the elasticity of Environmental art has stretched to encompass de Maria's Lightning Field and Turrell's remodelling of Roden Crater, the large ecological projects of Helen (b. 1929) and Newton Harrison (b. 1932), and the gallery-contained eco-systems of Alan Sonfist (b. 1946) and Hans Haacke (born in Germany in 1936) as well as the spatial reworkings of Robert Irwin (b. 1928) and Michael Asher (1943-2012). In Slant Light Volume, for example, from a series of works from 1970 onwards, Irwin stretched sheer linen scrims of various colours across gallery spaces, changing the spectator's perception of their volumes through the least substantial means. Asher's piece for Pomona College in 1970 changed the gallery into two triangular rooms so that expectations of quality of light and sound as one moved away from the door were subtly confounded. Like Asher's work, the wall paintings of the German artist Blinky Palermo (1943-77) were site-specific and derived from the particular architectural details of the gallery that was to house them. A 1970 proposal for London's Lisson Gallery, for example, stipulated: 'A white wall with a door at any place surrounded by a white line of a hand's breadth. The wall must have right angles. The definite form of the line is directed to the form of the wall.'

The installations of the American artists Dan Graham and Bruce Nauman, sometimes using delayed video monitoring loops to place the spectator in two spaces at the same time, or Nauman's constructions such as his Green Light Corridor (1970-71), all surround the spectator as architecture surrounds them, but in ways that belie and at the same time emphasize the functionality of 'real' architecture. Graham was interested in the links between architectural, built space and its phenomenal treatment in Minimalism. His pavilion-like structures, both inside and outside the gallery, use variously transparent and semi-mirrored glass, introducing the viewer to reciprocal vision, surveillance and self-reflection while walking around and through them. Present Continuous Past(s) (1974) [89] introduced delay into the video playback between two mirrored rooms so that, by walking from one to the other, viewers could watch themselves being watched (see pp. 98-99).

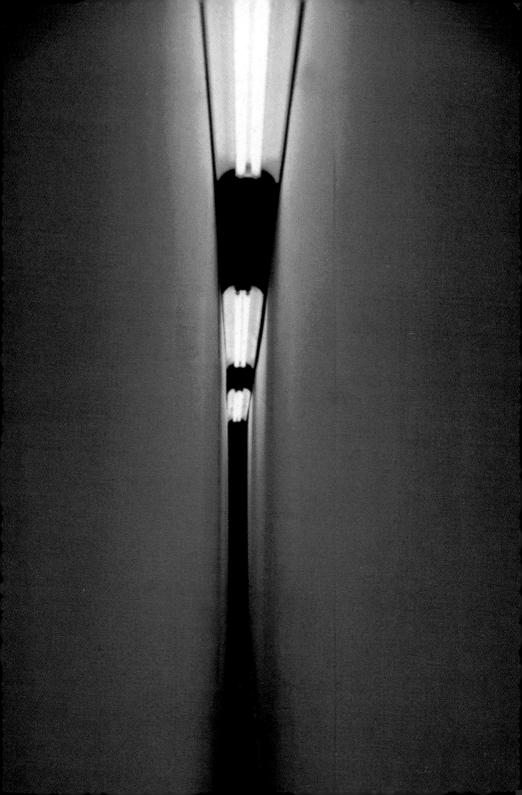

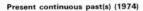

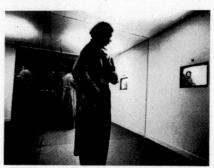

The mirrors reflect present time. The video camera tapes what is immediately in front of it and the entire reflection on the opposite mirrored wall.

immediately in front of it and the entire reflection on the opposite mirrored wall. The image seen by the camera (reflecting everything in the room) appears 8 seconds later in the video monitor (via a tape delay placed between the video recorder which is recording and a second video between the video recorder which is recording and a second video the video in the second record of the room and the reflected mirror the camera is one to directly obscure the lens' view of the facing mirror the camera is one to the record of the room and the reflected previously reflected from the mirror sews that time recorded 8 seconds previously reflected from the mirror sews to the temperature of the record of the mirror from the monitor, 8 seconds ago of himself was reflected on the mirror from the monitor, 8 seconds ago of himself was reflected on the mirror along with the then present reflection of the viewer? An infinite regress of time continuums within time continuums (always separated by 8 seconds intervals) within time continuums (always separated by 8 seconds intervals) within time continuums is created.

The mirror at right-angles to the other mirror-wall and to the monitor-wall gives a present-time view of the installation as if observed from an objective' vantage exterior to the viewer's subjective experience and to the mechanism which produces the piece's perceptual effect. It simply reflects (statically) present time.

Proto showing installation of 'Present Continuous Past(s)' at exhibition Projekt (1974) in Continuous Kurishalie Dibugoqueurity the work was installed at ARC Paris, 1974 and in 1974 at John Gleson Gallery. New York at the Institute for Contemporary Art, Chicago, and at Obliection: Mare Althorat d'Art Moderne Paris.

There is so little space between the walls of Nauman's Green Light Corridor that one can scarcely do more than squeeze between them. That, though, is precisely what should occur. The work is not merely something to be looked at, but a space to be entered and experienced in a fully physical manner. Nauman's work took many forms, although all were rooted in his own bodily presence. Reprising Duchamp's Fountain, the urinal readymade, he presented himself as the found object and photographed his upper body while spouting water from his mouth in Self-Portrait as a Fountain (1966-70) [90]. Window or Wall Sign (1967), a related work in neon, is equally ironic in its offering of the artist as a fount of aesthetic satisfaction. Set in a spiral, the text reads: 'The true artist helps the world by revealing mystic truths.' That the statement is ironic comes not only from its impossible idealism, but also from the juxtaposition of its idealism and the mundanity of Nauman's means. It is a

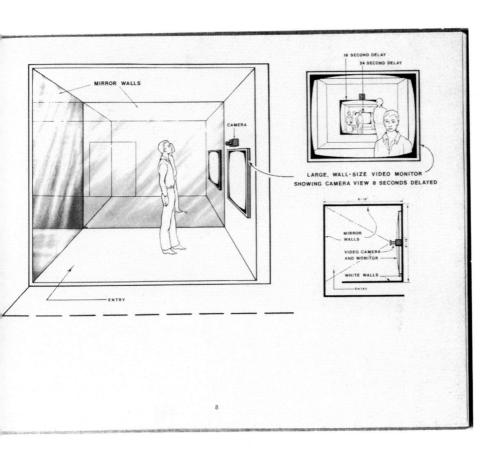

89. Dan Graham, Present Continuous Past(s), 1974

reiteration, too, of LeWitt's assertion that art-making is in essence an intuitive process. In the late 1960s, he frequently used his body as a template for work, as well as focusing on other aspects of his identity: his signature, for example, rendered in neon but ludicrously exaggerated in one dimension or another. Nauman also undertook certain actions in his studio, recording them on video. These were very simple — walking in a particular way, pacing a square marked on the floor while playing the violin, bouncing two balls until he lost control, applying and removing make-up, manipulating a neon tube to examine the body in light and shadow — and were filmed in real time. They were neither scripted nor edited, but instead lasted just as long as it took to perform the task in question.

Video was a brand-new medium, Sony only bringing the first domestic equipment onto the market in the mid-1960s. One of the first to use the technology in his work was the Korean Nam

90. **Bruce Nauman**, Self-Portrait as a Fountain, 1966–70

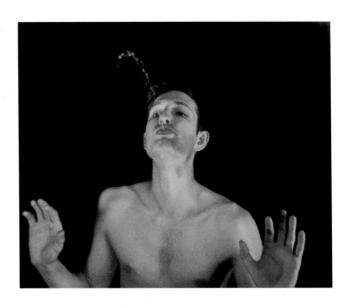

June Paik (b. 1932). Paik had studied musical composition in Japan before moving to Germany and working with the musicians in the circle of Karlheinz Stockhausen (1928-2007), although his interest in randomness and chance events and his use of prepared and ur-instruments made from junk placed him much closer in spirit to Cage. In Germany, and later, New York, he became involved with Fluxus alongside its mix of artists, poets and composers including Beuys, Vostell, George Maciunas (1931–78), Dick Higgins (b. 1938), Alison Knowles (b. 1933), Yoko Ono (b. 1933), George Brecht (1926-2008), LaMonte Young (b. 1935) and many others. Paik's first video work in 1965 was a film of Pope Paul VI's visit to New York made the day it was shown. He later produced many works that crossed between sculpture, Performance, music, video and TV, often in collaboration with the cellist Charlotte Moorman. He had been using TV sets - in Zen for TV and Moon is the Oldest TV (both 1963) - since the early 1960s, but his 1970s video installations Fish Flies on Sky (1975), a constellation of monitors on the ceiling, and TV Garden (1977), where monitors 'bloom' amidst lush green vegetation, involved and immersed the viewer to a far greater extent. Paik's snappily edited and colourful tapes such as Global Groove (1973) show that it is the medium of TV that shapes his work's content, and not the particular subject on the screen.

Once the emphasis in art had begun to shift from the end product to the process of its making, an acknowledgment of the

bodily presence of the artist as a crucial factor in that process became all but unavoidable. Performance is that acknowledgment. Ad Reinhardt stated in an interview the year he died: 'I never go anywhere except as an artist.' Gilbert and George designated their whole life as art in a rather more overt manner: 'On leaving college and being without a penny, we were just there.... We put on metallic make-up and became sculptures. Two bronze sculptures. Now we are speaking sculptures. Our whole life is one big sculpture.' Their first performances, in 1969, involved their appearance in public in just such a guise. The Singing Sculpture (1970) had the two of them, dressed smartly and with their faces and hands painted with metallic paint, standing on a pedestal

91. **Gilbert and George**, Singing and Sculpture, 1970

miming to the Flanagan and Allen song 'Underneath the Arches'. Later performances strengthened not just the social, but the socializing aspect of the work: for example, they served dinner to David Hockney in front of an audience. From the early 1970s, they would indulge in evenings spent doing nothing more productive than getting drunk to be documented in multiple photo pieces: Smashed (1972-73), Raining Gin (1973), and so on. Under the slogan, 'Art for All', Gilbert and George offered themselves to their public again and again: 'With tears streaming down our faces we appeal to you to rejoice in the life of the world of art.' The question immediately arises as to whether this is guileless or ironic activity. Gilbert and George would maintain that they are being utterly sincere, but that might be a pose too. One solution to the problem might be to think of their work as both guileless. and ironic: life paralleled or overlaid by an equally extensive representation of itself.

Such coextensiveness was one aspect of Performance. Throughout the 1960s, the Dutchman Stanley Brouwn (b. 1935) stopped passers-by, offering them a pad and pen with which to give him directions to a certain place. The instructions, useless as maps without his starting point and destination, and stamped This Way Brouwn, were then exhibited. Later he would account for his movement in other ways. During a trip to Czechoslovakia in 1972, for example, he recorded taking 150,815 steps, and in Poland 272,663. André Cadere (1934-78), a Romanian, had by the same year made his first Barre de Bois Rond. These bars were segmented, multicoloured rods which Cadere carried around and left propped up in a variety of art and non-art locations. They were, he said, 'exhibited in all places where [they were] seen: through any museum, placed in any exhibition by any artist, shown anywhere (street, underground, supermarket...)'. Cadere's statement appeared in Studio alongside a photograph of himself holding one of his 'Barres'. The importance of documentation in this kind of work is different again to that in Conceptualism or the Land art of Long and Smithson. Even when it takes place in a gallery, a performance can only exist as a photograph or report for everyone except the very few present as its audience.

The peculiar status of the photograph is most luridly illustrated by the critical fate of *Aktion* 2 (1965) by the Viennese artist Rudolf Schwarzkogler (1941–69). Schwarzkogler was one of a number of Austrian artists – others included Gunter Brüs (b. 1938), Hermann Nitsch (b. 1938) and Otto Muehl (b. 1925) – whose ritualistic, often elaborate Performance works were

termed Actionism. Nitsch's OM Theatre (Orgy Mystery Theatre) staged protracted rites involving large amounts of red dye, blood and the disembowelment of animals. They were, for Nitsch, 'an aesthetic way of praying'. Nitsch's actions were total experiences encompassing excessive stimulation of all the senses. Ritual had its place, too, in Schwarzkogler's art, as a defence against, or as a means of overcoming an otherwise irrevocable fragmentation and dissolution of the self. His first actions had been staged before an audience, but Aktion 2 took place in private. Despite the privacy it remained an action, just as Nauman's video pieces were performances. Like Nauman, the Germans Reiner Ruthenbeck (b. 1937) and Ulrich Rückriem (b. 1938) had 'performed' solely for the video camera, as had Ulrike Rosenbach (b. 1944) in her 'Video Live Performances'. Using his friend Heinz Cibulka as the performer, Schwarzkogler set up tableaux that were to be photographed. In one image, Cibulka stands holding a gutted fish open in front of his genitals. Suggestive of both mutilated penis and open vagina, the fish's symbolism undermines the integrity or completeness of the sense of identity of the performer, Schwarzkogler's surrogate self. In another photograph, a fish-head is placed over Cibulka's penis.

Schwarzkogler died in 1969, and by the time his work became more widely known through its exhibition at Documenta V in 1972, the rumour mill had made the action and his death into one event. The critic Robert Hughes wrote of Schwarzkogler as 'the Vincent van Gogh of Body Art', who 'proceeded, inch by inch, to amputate his own penis, while a photographer recorded the act as an art event'.

The performances of the American Vito Acconci (b. 1940) explored similarly intense territory: he would bite himself, rub himself against the wall, lie under a platform masturbating while fantasizing about the people he could hear walking overhead and try to pull his chest out into the shape of a breast. In *Trappings* (1971) [92], he spent three hours dressing his penis in doll's clothes and talking to it 'as a playmate'. Acconci described his activity as: 'Turning in on myself – dividing myself in two – attempting to turn my penis into a separate being, another person.' There was, in fact, much Body art and Performance that was excessive in one way or another. Largely, though, they came about as the result of working through an idea. Some were sensational: the paint-drenched performers in *Meat Joy* (1964) by Carolee Schneeman (b. 1939) rivalled Nitsch's spectacle, and the Californian Chris Burden (b. 1946) variously crawled across

a floor strewn with broken glass, had himself shot and was crucified on a car. Barry Le Va hurled himself against a wall until he collapsed, exhausted. Dennis Oppenheim (1938–2011) had stones thrown at himself, and allowed himself to be badly sunburned. In Europe, aside from the Actionists of the 1960s and the related work of Peter Weibel (b. 1945), Arnulf Rainer (b. 1929) and Valie Export (b. 1940), there were the investigations of Gina Pane (1939-90) of the perennial Vanitas theme which often involved self-laceration. Stuart Brisley (b. 1933) in Britain, both alone and in collaboration with others, underwent severe trials of endurance while questioning social institutions, our incorporation into them and possible means of resistance to their hegemony. In the early 1980s, Brisley examined some aspects of Body art and Performance in the film Being and Doing, exploring in particular the significance of the art form in Eastern European countries. Under such regimes, an artistic gesture which laid stress on the physical presence of the artist as an individual agent had a political dimension wholly absent in a Western social context.

92. **Vito Acconci**, *Trappings*, 14 October 1971

The Serbian Marina Abramovic (b. 1946) pushed her body to its physical limits as a way of emptying it in readiness for a fuller spiritual experience. Her solo performances in the early 1970s, many called 'Rhythms' after prior work in sound installation, required her to shout until she was completely hoarse, to dance until she collapsed from exhaustion, be buffeted by a wind machine until she passed out, to flagellate herself, take mindaltering drugs and perform other perilous acts. Lying down in the centre of a fire in Rhythm 5 (1974), she passed out through lack of oxygen and had to be rescued by onlookers. In her final 'Rhythm' performance, Rhythm 0 (1974) [94], she placed herself silently in the Studio Mona Gallery in Naples next to a table holding 72 varied objects. Visitors were invited to use them, and her, as they saw fit. Proceedings were halted when Abramovic, having had all her clothing cut from her, was forced to hold a pistol, placing the barrel in her open mouth. It was difficult to enjoy a ghoulish frisson of delight in front of these works since the risks Abramovic took with her own body placed such heavy responsibilities upon her audience. These responsibilities had less to do with saving her from herself than with the larger point – relevant to all Performance – that however committed an artist might be. such commitment is of little value unless it is met with equal involvement on the viewer's part.

The matted, informal structure of felt made it ideal for Morris's purposes in his post-Minimal works. It was, though,

93. Valie Export, Tapp und Tast Kino (Touch Cinema), 1968. In this action, passers-by were invited to place their hands in the box to feel Export's naked breasts. Would they carry out in reality what they had so often performed in their mind while walking down the street?

a material already closely associated with the German artist Joseph Beuys. The story of Beuys's wartime experiences and how he was shot down without a parachute, rescued and kept alive by being smeared with fat and wrapped in felt to stay warm, had become an integral part of the mythic, almost shamanistic power of his art. Fat and felt remained his prime materials and although there were formal similarities between his work and that of the Minimal and post-Minimal artists – notably his *Fat-corner* (1960) and the space-altering works of Flavin, Morris and Hesse - there were in other respects guite considerable differences. The greatest of these concerned Beuys's conception of himself as a 'transmitter'. The problem, as far as Beuys was concerned, lay not in the attempt to find an art practice appropriate to the changed circumstances of the world, but in communicating to an audience just what that art was about. He said, 'Sculpture must always obstinately question the basic premises of the prevailing culture. This is the function of all art, which society is always trying to suppress.... Art alone makes life possible – this is how radically I should like to formulate it. I would say that without art man is inconceivable in physiological terms.' In 1965 he had staged his performance, How to Explain Pictures to a Dead Hare in a gallery from which the audience were excluded. His head smeared with honey and covered with gold leaf, Beuys sat talking to the dead hare on his lap – because hares understand better than humans

94. Marina Abramovic, Rhythm 0, 1974

95. Joseph Beuys, How to Explain Pictures to a Dead Hare, 1965. Beuys said of his time with the hare, 'I explained to him everything that was to be seen. I let him touch the pictures with his paws and meanwhile talked to him about them.... A hare comprehends more than many human beings with their stubborn rationlism.'

- while the audience could only observe through the window. In 1967, Beuys started a political party for animals, stating that their 'elemental energy' might well achieve more in the way of political innovation than any human. He was invited to contribute to Morris's 'Nine at Castelli' show in 1969, but declined. When he finally did show in New York, in 1974, it was in a manner which emphasized the necessity for and difficulty of achieving reciprocity in communicative action. For Coyote, 'I like America and America likes me' (1974) [96], Beuys had himself transported by ambulance, wrapped in felt, from the airport direct to René Block's gallery where he spent five days in an enclosure with a coyote before being carried back to the airport. Whereas the thrust of three-dimensional work was towards an openness within its environment that allowed interpretative activity on the part of the viewer, Beuys kept much more closely to the traditional idea of art as something which embodied or offered a particular

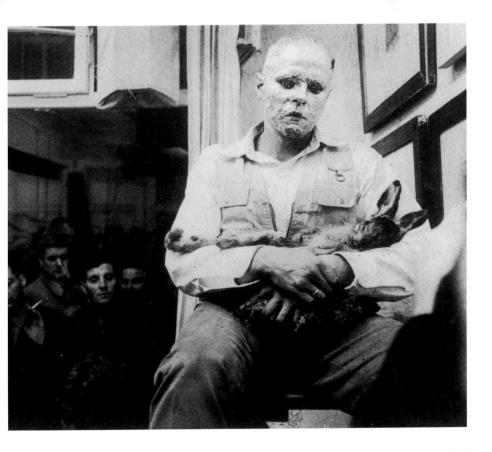

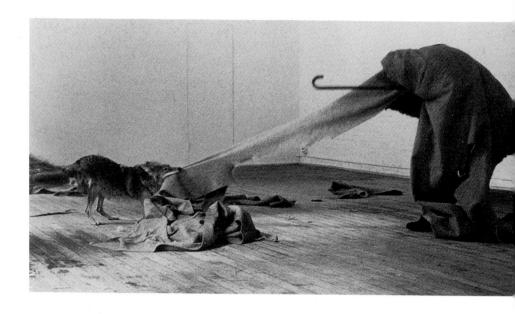

96. **Joseph Beuys**, Coyote, 'I like America and America likes Me', 1974

meaning: 'If I produce something, I transmit a message to someone else. The origin of the flow of information comes not from matter, but from the "I", from an idea,' he said.

In more general terms, the distinction between American and German art of the period could also be demonstrated by a comparison between the character of Happenings and of Fluxus events. Both drew on Dada, but while Happenings were extensive, a multiplicity, full of things, Fluxus events were simple and unitary in conception. In addition, the 'anti-art' of the Fluxus artists, and this of course included Beuys, was aimed at reconnecting art with life in a fully political sense.

Chapter 3: Ideology, Identity and Difference

The kind of art produced by Andy Warhol's Factory — depersonalized, mechanized, using multi-unit production processes — characterized the 'ideology' of most Pop art: art, like all industrial products manufactured for a capitalist market economy, was just a commodity and no more. The dealer's job was to create a market in which such commodities could be bought and sold. Faced with that reality, thoughts of beauty, aesthetic value and transcendent worth are irrelevant. Ultimately, a work of art is worth what someone is prepared to pay for it; concomitantly, the question as to what drives people to devote themselves to art finds an easy answer: they do it for the money.

Throughout the later 1960s and early 1970s, anything which fed a market and thereby contributed to the commercial well-being of the Western economies was perceived by some US artists in particular to be lending tacit support, however indirectly, to US involvement in, among other things, the Vietnam War. There was, therefore, an additional reason to explore the thoroughly non-mercenary nature of Conceptualism and the transience of performance: an art which could assert itself as such, while denying the saleability of objects, carried a certain ideological and political efficacy that was contrary to the tenets of a capitalist market economy.

Asked by Artforum to comment on 'the deepening political crisis in America' for a 1970 symposium the periodical published on 'The Artist and Politics', respondents offered a range of opinions on the relationship between the making of art, the issue of commitment, and a more direct involvement in political activity. The answers made explicit the belief of many artists whose work was radically abstract that their activities had clear political implications and overtones. Don Judd, Jo Baer, Carl Andre and Richard Serra, among others, explained how, and Baer also described how the political dimension of their activities implicated the spectator. She said: 'Works of art are no longer presented as a precious class of objects. Will a special class of subjects also be relegated to history?'

This recognition of the mutual responsibility of artist and spectator for any political meaning in art was at the opposite

pole from the belief that, in order to instigate social change. art's messages should be simple and unambiguous. The way a work fitted into the successive history of objects was of less importance than the connections it forged with its context, and that context was as much political as it was spatial, visual or aesthetic. Artists, traditionally seen as unclubbable individualists, began to organize themselves into pressure groups, which carried further the idea prevalent within Conceptualism that it was the artist's responsibility to establish the context for his or her work as much as to make the work itself. Context now was more than the critical environment provided by the specialist magazines; it was the world at large. The Art Workers' Coalition (AWC), for example, was set up in early 1969. This group of members of the New York art community organized protests and representations not only about the war, but also about civil rights and the right of artists to be consulted about the way their work is displayed and deployed within the museum and gallery system. One of their demands, for instance, was the presence of a Puerto Rican on the board of any museum or gallery that might be expected to exhibit Puerto Rican art. Original members of the AWC included the critic Lucy Lippard, the Greek Kinetic and Sound artist Takis (b. 1925), Hans Haacke and Carl Andre. Haacke, born

97. Hans Haacke, Shapolsky et al. Manhattan Real Estate Holdings, a Real-Time Social System, as of May 1, 1971, 1971

in Germany, had been living in New York for some years. His early work examined self-contained systems of an ecological or environmental nature, but by this time his focus had shifted to economic and social systems. Like many others, Haacke viewed Political art as a rejection of the formalist approach to practice and criticism espoused by Greenberg. He stated, 'For decades now [Greenberg's formalist doctrine] has managed to have us believe that art floats ten feet above the ground and has nothing to do with the historical situation out of which it grew. It is presumed to be an entity all to itself. The only acknowledged link with history is a stylistic one. The development of those 'mainstream' styles, however, is again viewed as an isolated phenomenon, self-generative and unresponsive to the pressures of historical society.'

Although Haacke produced work that was often extremely critical of the power brokers and vested interests of the art world, he chose to continue to show in the mainstream museum and gallery system since it was only there that his message was likely to have any impact. Using information freely available in the public domain, he conducted in-depth analyses of the business dealings of those involved in the arts. Looking at firms in the arms trade generously sponsoring the arts, or whose investments

in South Africa helped to prop up apartheid, or revealing the oppressive work practices in factories owned by one of Europe's leading art collectors, Haacke made the links between art and commerce more visible. Shapolsky et al. Manhattan Real Estate Holdings, a Real-Time Social System, as of May 1, 1971 (1971) [97] documented the large number of buildings in Lower Manhattan owned and controlled by members of one family. Haacke planned to include the work in his 1971 exhibition at the Guggenheim Museum in New York. The Guggenheim's director, Thomas Messer, refused to accept the work on the grounds that it was not art, a decision that caused the cancellation of the entire exhibition. Haacke has always been careful to exercise control over the selling of his work. His investigation of the working conditions at the factory of Peter Ludwig, The Chocolate Master (1981), for example, was not allowed to be sold to its subject. This was to prevent it being stored unseen in the basement of Cologne's Museum Ludwig, where the rest of the industrialist's large collection is housed.

This level of control over the fate of one's work contrasts with that of a deeply politicized artist such as Leon Golub (1922–2004) whose paintings might be taken as comment on a

98. **Leon Golub**, Interrogation II, 1981

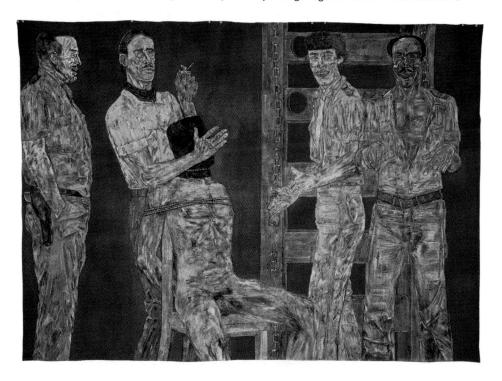

particular conflict, but which speak more generally of the horrors of oppression and the abuse of power. From the 1950s onwards. successive series of paintings have been stimulated by examples of US military involvement, notably, as in Interrogation II (1981), in Asia and Latin America, and by social injustice and the civil rights struggle at home. In 1968, Golub was one of the group which tried to persuade Picasso to withdraw Guernica from display in New York's Museum of Modern Art: a work critical of German bombing of the Basques in the Spanish Civil War should not offer implicit support to the US bombing policy in Vietnam by remaining on show. But Golub, aware, as a member of society, of his own unavoidable complicity in these matters, is prepared to exploit the ambiguity of a person's position. On the one hand, the person who buys his paintings 'owns him', and 'takes possession of his mind'. Equally, however, the purchase means that the paintings enter the new owner's home and their message has to be confronted there. As he wrote, 'Even if they would glamourise it and even if they would give it a special aspect temporarily, I think the message is sufficiently clear that the violence in the work, the vulnerability in the work will have its effect.'

In 1967, Joseph Beuys started a student political party at the Düsseldorf Academy where he taught. This was one of the earliest organizational manifestations of his belief in the connections between learning, creativity and the social processes of change or revolution. Engaged in Mao-inspired activity and notable among his pupils at the time was Jörg Immendorff (b. 1945) who, under the aegis of his own Lidl 'academy', made a number of anti-establishment actions. By 1972, Beuys had been fired by the Academy for insisting, in line with his beliefs, that his classes be open to unrestricted numbers. A year later, he formed the Free International University, aimed at stimulating discussion across the boundaries of academic disciplines. Freed from the restrictions placed upon research by the political and economic imperatives of departmental operation, Beuys hoped that it might be possible to advance thinking on various issues by approaching them from a number of different theoretical viewpoints at once. A similar interdisciplinary approach to that of Beuys's FIU could be seen at the heart of John Latham's Artist Placement Group in Britain.

The organizers of the 'Information' show at the Museum of Modern Art, New York in 1970, had included a book-list at the back of the catalogue, the principal aim of which was to indicate further reading in and around art and art theory to

explain the proliferation of materials and techniques available to the contemporary practitioner. By the time of 'Art into Society/ Society into Art', an exhibition of German art including work by Beuys, Wolf Vostell, Dieter Hacker (b. 1942), K. P. Brehmer and Gustav Metzger (b. 1926) held at London's ICA in 1974, things had changed. The reading list had become an exercise in pedagogy, not only suggesting related writings on art, but also detailing texts by philosophers and political and cultural theoreticians including Adorno, Marx, Lukacs, Goldmann and Marcuse. Interest in the work of such authors was an aspect of the protracted debate during the 1970s over the correct relationship between art and politics, largely inspired by neo-Marxism. Could art communicate and be understood politically, or would the perception that it was performing some political function necessarily undermine its aesthetic purpose?

Much work was done at the time in analysing earlier modernist models, notably the conjunction of experimentalism amongst artists and social reconstruction following the Russian Revolution, and the exemplary work of political agitation undertaken by John Heartfield (1891–1968) in his anti-fascist photomontages of the 1930s. The modernist medium of photomontage was significant as a technique within socially concerned art practices; photography itself was considered to be important in analysing social reality. In the tradition of realist and reportage imagery - August Sander (1876-1964), Paul Strand (1890-1976), Diane Arbus (1923-71), and Margaret Bourke-White (1906–71) – it could be seen as an index of the real conditions of the world. Coupled to the kinds of visual analyses then being developed by critics of film, it seemed to offer even more. The various details in a photograph could be understood as signs in a visual language and therefore images could give up their meaning through being 'read', as the French theorist Roland Barthes had been exploring in his semiological analyses of media imagery since the 1950s.

Heartfield's techniques were borrowed heavily by, among others, the German Klaus Staeck (b. 1938) and the British artists Victor Burgin and Peter Kennard (b. 1949). Like Heartfield's, these artists' work was designed for the medium of print, conceived for mass production on cards, posters and in magazines, and distributed widely. For example, Kennard's work on Chile's 'Disappeared' and the economics of mineral exploitation that contributed to US involvement in Pinochet's overthrow of the Allende government was designed for, and appeared in, a 1978

issue of the photographic journal *Camerawork*. His subsequent work concentrated on social conditions in Britain and the Campaign for Nuclear Disarmament campaign against cruise missiles. Victor Burgin's 1978 poster of a young couple embracing, as if in an advertisement for diamonds, bore the copy line: 'What does possession mean to you? 7% of the population own 84% of the wealth.' Could work like this do anything more than reaffirm the distaste of those already unhappy with such statistics? If art were not capable of being straightforwardly instrumental in bringing about social change, in what might its effectiveness consist and how would that be measured? The necessity for an art that was realist 'for society', and by extension 'social realist', was pondered in the light of questions such as these, especially in view of the crudely propagandistic image that Soviet Socialist Realism had in the West.

One of the most important influences in some art and art criticism in the early 1970s was the impact of feminism. As we have seen, the relationship between the political viewpoint of a society and its art had been the focus of much attention already, mainly within a neo-Marxist theoretical framework. Whatever the rights and wrongs of the distribution of power among those who produce and those who own the means of production, the vast majority of players on both sides appeared to be men. Statistical information produced by early activists made the case in stark terms. In 1971, for example, the Los Angeles Council of Women Artists issued a statement pointing out that, over the previous ten years, of 713 artists who had exhibited in group shows at the Los Angeles County Museum, only 29 had been women. Over the same period the museum had mounted 53 one-person shows, only one of which had featured a woman. Similar ratios pertained in museums and galleries everywhere.

In New York, Women Artists in Revolution (WAR) had formed in 1969 out of the Art Workers' Coalition. The ambivalence with which its aims were greeted is exemplified by the response of Lucy Lippard, already a major critic and someone who would go on to become an important figure in the development of feminist critique. In the introduction to her 1976 collection of essays on women's art, *From the Center*, she recalls her early annoyance at the provocative partisanship of WAR and then, later, her acceptance of its significance. Of her previous book of essays, *Changing*, she wrote: 'All through *Changing*, I say "the artist, he," "the reader and viewer, he," and worse still – a real case of confused identity – "the critic, he." Lippard

recognized in her use of language what almost amounted to a certain complicity on the part of women - however unwitting in maintaining the status quo. The various strategies adopted in an attempt to remedy the imbalance of opportunity and reward in the art world relied, in the first instance, on separatism: a setting-up of projects, discussion groups, exhibitions and journals to be run exclusively by women for women, and in writing the history of women's art. It was recognized at the same time that elements within recent art, as well as culture generally, had to some extent paved the way for art's engagement with feminist consciousness. Lippard, for instance, saw: 'the seeds of my feminism in my revolt against Clement Greenberg's patronization of artists, against the imposition of the taste of one class on everybody, against the notion that if you don't like so-and-so's work for the "right" reasons, you can't like it at all, as well as against the "masterpiece" syndrome, the "three great artists" syndrome, and so forth'.

In 1971, the art historian Linda Nochlin published an essay posing the question, 'Why Have There Been No Great Women Artists?' In answering, she pointed to the curatorial practices of museum and gallery staff, and to the values inculcated and reinforced by art history. She wrote, 'A feminist critique of the discipline of art history is needed which can pierce cultural-ideological limitations to reveal biases and inadequacies not only in regard to the question of women artists, but the formulation of crucial questions of the discipline as a whole.'

The language of art history and criticism did not even acknowledge women in order to deny them. It assumed, rather, that women would simply not need to be considered. A great artist was an 'old master', and a great work of art was a 'masterpiece'. Within such an evaluative framework, 'genius', whatever that may be, becomes an exclusively male preserve. To perform a simple act of reversal and to think of accomplished women artists not as old masters but as 'old mistresses' was to reveal the completeness of male dominance in the field. It was so pervasive as to seem natural. In order to combat this, male dominance had to be explained as the outcome of social factors. The fight was on against such attitudes as those expressed, for example, on more than one occasion by the British sculptor Reg Butler (1913-81), who suggested that women made art, that is, were creative, only until such time as they could fulfil their true nature and be procreative. Art, for women, was a kind of stopgap, filling the time before children came along.

What feminism provided was a means of visualizing and discussing this issue without having to fall back on a simple nature/culture dichotomy. Through its critique of patriarchy, feminist theory emphasized that those polarities which appeared to characterize natural differences in the essential qualities of man and woman – intellect/intuition, day/night, sun/moon, culture/nature, public/private, outside/inside, reason/emotion, language/feeling – were only meaningful within culture. Where the real differences between them lay was in the play of power: who had it and who did not.

From the outset, a number of major initiatives made themselves felt. The first of these was an exercise in historical reclamation, the second a critique and reappraisal of the criteria of judgment, and the third a prolonged examination, through the production of further work, of how this activity called 'art' and this set of ideas referred to as 'feminism' might be related and how they might act reciprocally upon one another. First and foremost, there was a need to go back through the history of art to rediscover the work of those many women artists whose careers had been obscured through neglect and whose work had even been attributed to men on certain occasions. One had to visit the basements and storerooms of the major museums and pull out into the light all those works by women that had been relegated there because they were not deemed to be of sufficiently high quality to remain on permanent display, or because they were not adequately representative (i.e. were considered to be derivative of male work in the same style), and even because they dealt with the wrong kind of subject matter.

The large installation *The Dinner Party* (1974–79) [99] by Judy Chicago was conceived as just such an attempt at reclamation, 'a symbolic history of women's achievements and struggles'. In 1970, Judy Gerowitz placed a full-page advertisement in *Artforum*, appearing as a boxer in the ring and stating that, as the endemic male domination of the art world militated not only against the acceptance of her work but that of all other women artists, she would renounce the name given to her by her father and would henceforth be known, after the city of her birth, as Judy Chicago. Together with her colleague Miriam Schapiro (b. 1923), she set up the first Feminist Art Program at the California Institute for the Arts. Chicago had begun as a painter and, towards the end of the 1960s, had moved into making atmospheric works using coloured smoke in a way that paralleled the preoccupation with light and environment in the work of her West Coast

99. Judy Chicago, The Dinner Party, 1974–79. Chicago remarked that those celebrated in the work, 'tried to make themselves heard, fought to retain their influence, attempted to do what they wanted. They wanted to exercise the rights to which they were entitled by virtue of their birth, their talent, their genius, and their desire; but they were prohibited from doing so—were prohibited from doing so—were ridiculed, ignored, and maligned by historians for attempting to do so—because they were women.'

contemporaries Robert Irwin, James Turrell and Larry Bell. The next move beyond that, which saw atmosphere not as an abstract, universalized space, but as something pervasively socialized and politicized, was something quite new. For a triangular table, a shape which both denied a hierarchical seating arrangement and suggested female sexual identity, Chicago designed 39 place settings, each celebrating the life and work of a famous woman. The needlework on the place mats and the images painted and glazed onto the plates reflected the achievements of the place settings' subjects. Underneath the table, the porcelain floor of golden triangles bore a further 999 names of 'supporting' women.

Related to work of this kind were several attempts to search out and establish an alternative spiritual legacy, one that would speak to the needs and desires of women rather than men. Was there, perhaps, some form of matriarchal social system, one watched over by goddesses, not gods, that could be seen to have preceded the current patriarchal domination of things? God Giving Birth (1968) by Monica Sjoo (b. 1942) is a straightforward

and early example of this. Mary Beth Edelson produced a 'Great Goddesses' series (1975) of which she said: 'The ascending archetypal symbols of the feminine unfold today in the psyche of modern Everywoman. They encompass the multiple forms of the Great Goddess. Reaching across the centuries we take the hands of our Ancient Sisters. The Great Goddess, alive and well, is rising to announce to the patriarchs that their 5,000 years are up. Hallelujah! Here we come.'

Eva Hesse had died in 1970 from a brain tumour, too early for her work to have been thought to be particularly influenced by feminist ideas. It did, however, provide a powerful example for those who wished to avoid Minimalism's cool impersonality, a trait that was increasingly being seen as indicative of masculinity. Hesse had retained Minimalism's modularity, but had used it in a very un-Minimalist way. Her work was not engineered but

100. **Monica Sjoo**, God Giving Birth, 1968

101. Eva Hesse, Accession V, 1968

102. **Louise Bourgeois**, *Fillette*, 1968

handmade, bringing a quite different bodily sense to the very similar but by no means identical elements in her multi-part works. There was also an overt psychological dimension, for example, the lengths of plastic tubing threaded through the open cube of Accession V (1968), recalling the disturbing image of Meret Oppenheim's emblematic Surrealist object, the fur-covered cup and saucer of 1936. The sexuality of Hesse's forms was close in form to the sculpture of Louise Bourgeois (1911-2010). From an older generation, Bourgeois' eroticized works in marble, plaster and latex came to provide a richly inspirational resource for many women artists. Starting in the early 1960s, she had made a succession of works on the theme of the lair. Although enclosing and reassuring, these spaces could also become traps, and so always needed a second entrance at the rear to allow for escape. The phallic Fillette of 1968, hanging by its tip from a wire hook, and the soft folds and contours within the aggressive overall shape of Femme Couteau (1969–70) [105] exemplify Bourgeois' constant drawing together of destruction and seduction. She wrote, 'These

women are eternally reaching for a way of becoming women. Their anxiety comes from their doubt of being ever able to become receptive. The battle is fought at the terror level which precedes anything sexual.'

The grids of the Canadian artist Jackie Winsor (b. 1941) also made idiosyncratic use of Minimalism as in the case of Hesse. Regular in their pattern, they were nevertheless unpredictable due to Winsor's use of irregular branches rather than planed wood. The repetitive unevenness of these grids has something of the 'anti-formalist structuring' spoken of by the American Nancy Graves (1940–95). More than the unsettlingly tender and diverse installations of Ree Morton (1936–77), Graves's mixed media works – Paleo-Indian Cave Painting, Southwestern Arizona (To Dr. Wolfgang Becker) (1970–71), for example – drew on social realities outside the male dominance of Western culture. As with Hesse, though, there is also a strong antecedent for her work in the gestural freedoms of Pollock's drip paintings, and the same was true of another American artist, Harmony Hammond (b. 1944). Hammond constructed her 'Presences' from threads [104], hair

103. **Nancy Graves**, Paleo-Indian Cave Painting, Southwestern Arizona (To Dr. Wolfgang Becker), 1970–71

104. Harmony Hammond, Presence IV, 1972

and paint-covered strips of cloth torn from dresses. In these works, whose collective title expresses the desire to assert an identity neither subordinate to, nor dependent upon the authority of a male, Hammond aimed to 'contact a whole tradition of women's feelings', and to 'break down the distances between painting and sculpture, between art and "woman's work", and between art in craft and craft in art'.

In spite of the many positive facets of Chicago's endeavour, some questions soon arose. The Dinner Party was a huge project and Chicago did not work on it alone, requiring the collaboration of a number of helpers for its completion. The nature of her collaboration, that of a leader and amanuenses, was essentially no different to the kind of hierarchical structures which obtained throughout society. Despite her partial success in bringing the large number of women artists to the attention of the curators, collectors and critics responsible for deciding what would be shown and reviewed, what guarantees existed that such attention could be sustained? What was to stop those same curators, collectors and critics, after a decent interval, from finding further, equally 'valid' reasons for putting the works of art back in the basement again? Evidently it was not enough to promote women artists without at the same time working to dismantle the assumptions and institutional orthodoxies of the museum and gallery system, the collectors and the critics. In the years after the 'Great Goddesses' series, Mary Beth Edelson made a number of posters aimed at just such a subversion. In Death of Patriarchy/A. I. R. Anatomy Lesson (1976), for example, she took Rembrandt's Anatomy Lesson and collaged the heads of contemporary women artists onto the shoulders of the onlooking students, while

105. **Louise Bourgeois**, Femme Couteau, 1969–70

106. Adrian Piper, I Am the Locus #2, 1975. 'The early street works', said Piper, 'were very important and even frightening experiences for me. I always felt threatened, I mean a policeman could have arrested me for disturbing the peace. At the same time, I felt my personality become more flexible, stronger, because I altered my physical appearance in so many different ways.'

transforming the cadaver from the body of an individual male into the corpse of patriarchy itself.

The wider implications of feminist thinking for art were becoming clearer by this time in the mid-1970s. Insisting on one's right to act as neither a neuter subject nor a surrogate male, but as a woman, had brought the issue of identity to the fore. Once recognized, it was, however, not an issue that could be contained within the debate on gender alone. Identity and an understanding of one's difference from the identities of others encompassed considerations of sexuality, social class and racial and cultural backgrounds.

Many artists who had already had some involvement with political issues in their work extended their analysis of these into the area of feminist consciousness. Adrian Piper (b. 1948) had begun her career as a hard line Conceptualist, but became increasingly aware of the degree to which her identity as a black woman affected the form and intent of her work. In her Performance work, she would adopt an androgynous, culturally ambiguous identity. With white face make-up, pencilled-on moustache, Afro hairstyle and mirrored shades, she would, as in *I Am the Locus #2* (1975), become a point of concentration for beliefs, attitudes and social forces. She stated: 'I am an anonymous third world young boy, wandering through the crowd, telling myself in an audible undertone that I am the locus

107. **May Stevens**, Rosa from Prison, 1977–80

of consciousness.... I am both hostile to and removed from the presence of others.'

Also in the US, May Stevens (b. 1924) made a body of work centred on Rosa Luxemburg, the murdered German communist, and Martha Rosler explored *anorexia nervosa*, her *Losing: a conversation with the Parents* (1976) linking the condition not just to the question of female identity, but also to the role of the food industry in the larger play of economic and political forces which formulate our notion of ideal beauty. Nancy Spero (1926–2009) made extended, scroll-like panels containing drawings, fragments of text and repeated imagery of a mythic nature. In *Torture of Women* (1976), for example, the Babylonian legend of Marduk and Tiamat – in which Tiamat's body is bisected to form the earth and the heavens – is laid alongside the account of a Chilean model who was arrested and tortured by General Pinochet's secret police.

Much work in Europe was expressly concerned with social issues such as equal pay, child care, wages for housework and union representation for part-time working. All of these affected women predominantly and connected with their more pervasive concern to find a voice. As Lippard's comments on her own

writing testify, the problem extended right down to the basic tool of expression, language itself. Even this, through its structure and the ideas attached to words, contributed to the dominance of patriarchal attitudes. However false the assumption, a man, while speaking, could be assumed to be himself. In contrast, a woman was forced to utilize a language which, in a real sense, did not belong to her, and could not be made to speak for her. In order to speak, she was always playing a part, or adopting a persona, or pretending to be something or someone she was not. If this were true of language, it was doubly true of the techniques of art. How could a woman paint without acknowledging the history of a medium in which her sex had played such a small part? Could traditional sculptural materials be separated from their inherent value within a market system founded upon equally traditional male-dominated power structures?

Even a cursory look at the history of painting would reveal the depiction of women as the object of men's desire. How, women began to ask, might it be possible for them to represent themselves in ways which would not automatically lead to their furtherance of that tradition? Just as separatism set up a distance from men for the purposes of organization and decision-making, so the use of new (or at least newer) materials and techniques pre-empted, to a certain extent, the problem of having to deal with the entire history of art before one could say anything new. Photography, video, film, sound, Performance – those information-providing tactics that had so recently begun to expand the bounds of art – all seemed more appropriate means with which to address this subject matter.

108. Nancy Spero, Torture of Women, 1976 (detail)

In the US, both Martha Wilson (b. 1947) and Jackie Apple (b. 1941) performed pieces in which they shifted identity and redefined themselves. Working together and with others in Transformance: Claudia (1973) they lunched, dressed for the part, in an uptown Manhattan hotel before descending in an aggressive and acquisitive posse upon the SoHo galleries. Eleanor Antin (b. 1935), too, made performances as, and constructed biographies for, a number of different personae. Although some of these - a prima ballerina, a nurse - accentuated accepted feminine qualities, others – a king, a black movie star – explored the question of who she was in unexpected ways. Antin said of these alter egos that 'the usual aids to self-definition – sex, age, talent, time, and space - are merely tyrannical limitations upon my freedom of choice'. In Carving: A Traditional Sculpture (1972), Antin photographed herself naked every day during a period in which she lost several pounds while dieting. Others in the US, including Laurie Anderson (b. 1947), Julia Heyward (b. 1949) and Joan Jonas (b. 1936) with her alter ego, Organic Honey, were involved in performance, sound and video work.

The split between the male-dominated public sphere and the conventionally pressured, 'contrasting', 'female' privacy of the home was undermined by work which embodied the feminist conviction that the personal is political. Instead of something which stifled artistic activity, domestic life, reflected upon and transformed, became art's very subject matter. The 'Maintenance Art' series by Mierle Ukeles (b. 1939), begun in 1969, focused on the necessary functions of daily urban existence, particularly the disposal of waste and general cleanliness, usually ignored. One performance, Touch Sanitation (1978-84) [2], involved her shaking hands with every employee of New York's sanitation department. In Britain, the performances of Bobby Baker (b. 1950) revolved around her inescapable responsibilities as a mother required to shop, cook and provide for her offspring. This focus on domestic reality, also present in the work of Tina Keane, Rose Finn-Kelcey (b. 1945), Kate Walker (b. 1938), Sally Potter (b. 1949), Rose English and many others, defied the conventional wisdom that certain types of subject matter were more important than others. During the late 1970s, Keane, rather than being limited by the responsibilities she had to her young daughter, instead exploited them, incorporating playground rhymes and children's games as content and structuring principle on a number of occasions. For the tape/slide work Speaking in Tongues (1977), Potter intercut a recording of herself addressing a crowd at Speakers' Corner

in Hyde Park in London with a meditation on the character she had to adopt in order to be able to perform. Helen Chadwick (1953–96), a student in the early 1970s, began work using as her material her own body, its experiences, memories and potential and the inescapable fact of its mortality. In all such work, the overriding intention has been to make identity and personal experience reputable subject matter once again.

In 1973, the US artist Mary Kelly (b. 1941), then living in England, began her long-term project, *Post Partum Document*. The work's aim was to examine the process of socialization through which her newly born son was to pass during the first five years of his life. In order to do this Kelly collected and analysed the communications between her son and herself. In the first stage of the child's life, before his acquisition of any language, she was reliant on other signs to gauge his well-being, notably the

109. **Mary Kelly**, Post Partum Document, Documentation VI, 1978–79

state of his bowels as revealed by the contents of his nappies. These later gave way to words, drawings, sentences and more extensive, self-aware signals. Through this material, Kelly built up a picture of the process of entering into society and at the same time revealed how her participation in this process, as the child's mother, reinforced her own subordinate social position. Crucial to Kelly's thinking in carrying out this work was not only neo-Marxist theory, but also the structuralist reinterpretation of Freud carried out by the French psychoanalyst Jacques Lacan.

The photographic, film and performance work of the German artists Ulrike Rosenbach and Rebecca Horn (b. 1944) was concerned with personal and psychological, rather than overtly political aspects of identity. The artworks Horn made featured

110. **Rebecca Horn**, *Unicorn*, 1970–72

as props in her first films. Usually designed to be worn, they exaggerated or constrained some aspect of the body's anatomy or function: by extending the head, as in *Unicorn* (1970–72) and on other occasions elongating the fingers, enclosing the body in feathers, or elaborately tying the legs and arms of two protagonists to each other so that independent movement became impossible.

Susan Hiller (b. 1942), another American living and working in Britain, had been trained as an anthropologist and continued to use something of the technique of fieldwork in her art. Collecting fragments of material culture - postcards, potsherds, newspaper clippings, wallpaper patterns – she incorporated these often cheap or trivial artefacts into installations that revealed and examined how they reflect and reinforce attitudes and beliefs within the society that produced them. Dedicated to the Unknown Artists (1972-76) [111, 112] was begun when Hiller noticed that many towns on the British coastline sell postcards depicting rough sea conditions. She wrote, 'I treated the materials as keys to the unconscious side of our collective, cultural production. Dedicated to the Unknown Artists was about the contradictions between words and images, and dealt with the fact that words don't explain images - they exist in parallel universes.' Hiller's interest in the realm of dreams and the night led to a feminist appropriation of the Surrealist technique of automatic writing which, as 'fruitfully incoherent' writing, speech and song, has featured in many paintings and a number of sound and video installations since the 1970s.

A 1978 work of Hiller's, Fragments, recorded, arranged and interpreted Pueblo Indian potsherds. Each fragment of pottery formed a link, both real and imaginative, between Hiller's own culture and that from which it originated. This kind of connection, in which a mythologically rich ancestry breaks into contemporary reality, could also be found in the installations of Charles Simonds (b. 1945). Simonds fabricated miniature archaeological sites, ruins of some putative pre-Colombian civilization, and left them in the nooks and crannies of buildings in New York's Hispanic neighbourhoods. The critic Alan Moore wrote that his diminutive dwellings, 'provide a model of a civilization divorced from its context and remarried to another while at the same time they stamp the community with an imaginary underlife'. Outside/Inside (1974), as its name suggests, was built either side of a shop-front window so that as time progressed the exterior portion disintegrated while the protected half remained pristine.

111, 112. **Susan Hiller**, *Dedicated* to the *Unknown Artists*, 1972–76 (single panel, detail; installation, partial view)

This contrast between the fate of the two parts of Simonds's work highlights a dilemma for many artists in the 1970s. The thoroughgoing questioning of art and its institutions that had been accomplished in the preceding years would be of little value if the understanding it had revealed - of the importance of such things as environment, power, ownership, and cultural and sexual identity in determining what an artwork could mean - could not be put to some 'use'. The commercial gallery system was, of course, only one part of the larger capitalist market economy. There was inevitably conflict when art that expressed its rejection of that system was forced to rely upon it for its display, appreciation and consumption. Public art developed in part as a result of a desire to circumvent this dilemma. Using alternative locations such as shops, hospitals, libraries and the street itself as exhibition sites, and using the communication media - television, radio and advertising hoardings - as a more direct route to a broader, more egalitarian audience, public art turned its back on the galleries.

113. Christo and Jeanne-Claude, Wrapped Coast, Little Bay, Australia, 1969

As feminism had argued with regard to work by women, just changing the venue was not enough. The method of working had to be reappraised as well. No longer was it acceptable for artists commissioned to make works for public places simply to impose their solutions upon a passive public. Lengthy periods of consultation, public meetings and discussion were entered into to establish the wishes and requirements of the local population before any work was undertaken. A working method such as that of Christo and Jeanne-Claude – who have never executed commissioned works and pay for all their projects themselves - could come into its own in such a climate. It has always been the case with their large temporary works of art, such as Running Fence, California (1972–76), Valley Curtain, Colorado (1970–72) and Wrapped Coast, Little Bay, Australia (1969) [113], that the long period required to obtain the necessary permissions and permits and to organize resources and workers was as much a part of the work as the finished result.

Russian revolutionary art and the murals of the Mexicans Diego Rivera (1886-1957) and David Alfaro Siqueiros (1896-1974) were looked to as influential precursors by the public artists of the 1970s. The task of the mural was twofold: to depict events that celebrated the political power of the working class (in whose areas they overwhelmingly appeared) and to provide some visual excitement in what was otherwise usually a depressed and run-down area. Many of these community-based projects were completed across the US and Europe. To reject the gallery system on account of its inherent élitism would only be acceptable if the alternatives sought were a popular art rather than a populist one. If it were to appear in a public place this art should be acceptable to the majority and clear in its meaning, but should not simply pander to people. Consultation during the planning of the mural by Desmond Rochfort on the underside and supports of London's Westway, for instance, generated sufficient paperwork to constitute an exhibition display in its own right at the Serpentine Gallery's 'Art for Whom?' show in 1978.

Stephen Willats (b. 1943), who also showed in 'Art for Whom?', worked within well-defined, closed systems. Using the housing estates of west London as geographically distinct social units, he developed a series of questions through dialogue with some of the residents that the community at large was invited to answer. Collected answer sheets were then displayed for all to see how shared problems with health, noise, lack of leisure facilities, access, education, and so on, might be solved. From a Coded World

(1976), Vertical Living (1978) and the West London Social Resources Project (1974), however, were not social work by another name. The works lasted for as long as it took to generate the questions and collect the answers. Any change that might be occasioned by the projects was not part of them, which is to say that Willats emphatically remained an artist and not a social worker.

In order to satisfy the criterion of general public acceptability, such work was often formally traditional and unambiguous in its meaning, displaying a strong sense of moral and educative purpose. One notable exception to public art's accommodation of figuration was the *Vietnam Veterans Memorial* (1982) in

114. **Maya Ying Lin**, Vietnam Veterans Memorial, 1982

Washington D.C. by Maya Ying Lin. Here the restrained, radical abstraction of 1960s Minimalism, instead of being rejected as irrelevant to all but a privileged, specialist few, was embraced as particularly appropriate for a commemoration without celebration. An important phenomenon which rose to prominence at this time was graffiti art, which is discussed later.

Community-based work was no more free of economic constraints than the art from which it tried to distance itself. The difficulty of 'consuming' Performance, Installation and public art in the normal manner – buying them and taking them home - meant that they required subsidy funding in order to be able to exist at all. The 1970s witnessed a growth in public patronage. This was not a defeat of the art market, but a transfer of its operational imperatives into the field of national and local government. It is easy to be cynical and smile patronizingly at the misplaced idealism of those who thought that by making a direct appeal to the population as a whole they would convince many of art's value. But out-and-out cynicism would be inappropriate, since the expansion of governmental and quasi-governmental involvement in funding of the arts was symptomatic of a growing belief in the necessity of art in a modern democratic society. Art was certainly not a luxury, but something that any self-respecting advanced society should expect as a mark of its civilized status. It might have seemed to some that receiving a grant from the National Endowment for the Arts in the US, or the Arts Council in Great Britain, or benefiting from state remuneration in Holland upon registering as a professional artist was little more than a sophisticated form of spongeing. A more enlightened interpretation was to recognize it as another responsibility of consensus politics. It was, however, no accident that this state of affairs obtained in the 1970s, precisely that period in which the postwar political consensus was playing itself out prior to the harder, fiscally deregulated realities of the 1980s.

An alternative funding strategy strove for self-sufficiency. In 1971, a group of artists, musicians and dancers including Gordon Matta-Clark (1943–78), Richard Landry (b. 1938), Tina Girouard (b. 1946) and Carol Goodden took over premises in New York's SoHo, refurbished them and opened the restaurant 'Food'. The old warehouses and light industrial buildings of lower Manhattan had been colonized by artists anxious to find cheap but spacious studio accommodation. 'Food' provided not only a service to this growing community, but also work, and therefore a means of financial support to many of its members.

115. **Gordon Matta-Clark**, *Splitting*, 1974. Alice Aycock recalled, 'Starting at the bottom of the stairs where the crack was small, you'd go up, and as you'd go further you'd have to keep crossing the crack. It kept widening as you made your way up the stairs to the top, the crack was one or two feet wide. You really had to jump it. You sensed the abyss in a kinaesthetic and psychological way.'

Matta-Clark's next collaborative project, with some of his 'Food' colleagues but also with Richard Nonas (b. 1936) and Laurie Anderson, was 'Anarchitecture'. The group's aim was to focus on the gaps and undeveloped places within the urban environment: not the buildings so much as 'the places where you stop to tie your shoelaces, places that are just interruptions in your daily movement'. This attitude was taken much further and to striking effect in the sequence of alterations Matta-Clark made to buildings between 1974 and his death in 1978. Cutting deep into their fabric – the first, *Splitting* (1974), involved slicing a house entirely in half – he practised what Dan Graham referred

116, 117. Exterior and interior views of the Museum of Contemporary Art, Chicago with Michael Asher's work installed, 1979

to as 'urban ecology'. He explained, 'His approach is not to build with expensive materials, but to make architectural statements by removing in order to reveal existing, historical aspects of vernacular, ordinary buildings. Thus the capitalist exhaustion of marketable material in the name of progress is reversed.'

While some artists decided that the need for art with a social purpose required them to turn their backs on the galleries, this was by no means a universal conclusion. The norm remained, as with Land and Environmental art, that artists worked in a variety of locations and ways. In addition, of course, the gallery itself was ripe for investigation. Conceptual and post-Minimal practice provided the model for this. Michael Asher's spare installations made the gallery the object of contemplative attention, an 'object' that encompassed the historical, economic, administrative and other institutional dimensions to the built space. For an exhibition at Claire Copley's gallery in Los Angeles in 1973, he removed the dividing wall separating the showing space from the office, making the day-to-day running of the space, the arrangement of future exhibitions, the handling of sales enquiries and the work of publicity into a display. In 1979, invited to make a work for the permanent collection of Chicago's Museum of Contemporary Art, Asher designated a portion of the building's exterior cladding as

the 'work'. While on display, the cladding was removed from the façade and hung on an interior wall. The curatorial decision to exhibit it was therefore not idle, but one that affected the very body of the institution. The museum was, quite literally, shaped by its exhibitions policy. Once its period of display was over, the artwork was put into storage and removed from sight by being replaced on the museum's frontage.

Painting by no means disappeared during the 1970s, although the impact of the new theoretical framework within which art was being produced forced its thoroughgoing critical re-evaluation. For some, enamoured of the critical radicalism of Conceptualism, painting stood, in Victor Burgin's phrase, as 'the anachronistic daubing of woven fabrics with coloured mud'. In this light, though, Conceptualism could only be the academically approved opposition to modernism. If it had something to offer, it was an opening-up of technical and practical possibilities, not a set of aesthetic prescriptions that merely substituted one set of materials and techniques for another. Political or Social art, with its interest in the relationship between the realms of aesthetics and politics, broadened the perspective of this otherwise bland dichotomy. In the 1960s, for followers of Clement Greenberg, the refusal to represent distanced art from sordid reality, while

118. Art & Language, V. I. Lenin by V. Charangovitch (1970) in the Style of Jackson Pollock II, 1980. Charles Harrison wrote. 'The representational materials of the Lenin-Pollock paintings are organized into an allegory of collision. The mythology of individual risk attached to Modernist painting is most compellingly associated with the style of Pollock, while the mythology of historical risk associated with class struggle is a component in the aura of Lenin. To paint the "Portrait of Lenin in the Style of Pollock" was to force these incommensurable mythologies into momentary coexistence upon a single and synchronic surface.'

for Michael Fried's so-called 'literalists' the stamp of 'objecthood' made it a part of reality. Thus, in painting, what in the 1960s had been an argument over the interpretation of abstraction, was transformed in the 1970s into a debate about the apparent significance and political connotations of figurative or non-figurative work.

By the end of the 1970s, Art & Language had begun to work on a series of 'Portraits of Lenin in the Style of lackson Pollock'. The marriage between the quintessentially abstract and the symbol of Socialist Realism – heroic representation subordinated to the political will of the state – would appear to be impossible; as impossible, in fact, as the social realities they represent, the ideological and cultural programmes of capitalism and communism, finding some accommodation between themselves. Yet because, rather than in spite of, this paradox, the paintings work. Pollock's drip technique, perhaps the most individual painterly signature of the century, proves to be easily reproducible and out of its skeins - which seem arbitrary but which must in this instance, of course, be very deliberately placed – drift the familiar features of the father of the Russian revolution. The paintings are both abstract and representational and yet all their elements can be seen to represent something. This understanding that all things connote meaning, whether they happen to resemble something else or not, made art appear to be political whether or not it chose to present itself as such. To eschew political commitment as being outside the proper responsibility of aesthetics, as some painters and sculptors chose to do, could therefore be easily condemned as reactionary because of its furtherance of the traditional, formalist approach to art.

In 1975, Rosalind Krauss and Annette Michelson, two contributing editors of *Artforum*, left the magazine to found a new journal, *October*. The journal was named 'in celebration of that moment in our century when revolutionary practice, theoretical enquiry and artistic innovation were joined in a manner exemplary and unique'. The crude Socialist Realist argument, that a political cause was furthered by its sympathetic representation, was rejected. The editorial of the first issue of *October* proclaimed: 'Art begins and ends with a recognition of its conventions. We will not contribute to that social critique which, swamped by its own disingenuousness, gives credence to such an object of repression as a mural about the war in Vietnam, painted by a white liberal resident in New York, a war fought for

the most part by ghetto residents commanded by elements drawn from the southern lower-middle-class.'

The desire expressed by the editors of October for in-depth theoretical debate across disciplines was symptomatic of the growing acceptance that something really had changed in art. While Pop and Minimalism and their various aftershocks could still be described as responses to, and therefore as part of, late modernism, the kind of 'intertextuality' being propounded here was of a different nature. Beuys's Free International University maintained an avowed revolutionary intent by holding on to the idea that it was possible to imagine a wholly different set of social circumstances and orient oneself towards achieving them. October's intertextuality, drawing on the neo-Marxism of the 1960s revolts, the psychoanalytic analysis of subjectivity and identity in feminism and the phenomenological tradition explored by Minimalism (most fruitfully apparent in the writing of the French philosopher Jacques Derrida whose influence, by the mid-1970s, had transformed critical discourse) was the web of an encompassing and inescapable social reality. The artist was as much a prisoner of this reality - or, at least, the theoretical descriptions of this reality - as anyone else, and the realization of this fact meant that the notion of art as a reflection upon the conditions of the world made from a safe critical distance was now untenable.

Modernism had, in the words of the English historian Perry Anderson, three interrelated elements: a strong sense of the historical progress of the economic, political and social spheres, an academic status quo against which to work and the fruits of considerable technological advance. The first, the idea of progress, was less credible in the wake of successive wars, the repressiveness of communism and the growing realization that what might be considered an advance in the West was often experienced as quite the opposite in some other part of the world. Equally, in the field of ideas, the recognition that research, far from being innocent enquiry, was almost entirely dictated by economic and political circumstances external to its object undermined the thought that the growth of knowledge was in any way directed towards some larger enlightenment. People usually derived knowledge from needing information either to help them build better weapons, or to enable them to patch up those wounded by them more effectively. Lastly, the enquiring character of contemporary art, with its proliferating range of materials and forms, had long ceased to value novelty for its own

sake as a potential weapon, if indeed it ever had. Art's diversity, even in its radical, 'political' forms, became now the academic and institutional norm. The accommodation of public art, artist placement and Performance by state and regional funding bodies was mirrored in education, where colleges expanded their curricula to offer courses not only in painting and sculpture, but also in mural design and other catch-all 'disciplines' such as combined, alternative, or experimental media. Modernism, at least as it had been understood and described from Manet and the Impressionists onward, had, it was thought, reached its terminus; we were now to see the world as postmodern. Utopia had been replaced by dystopia.

Chapter 4: Postmodernisms

Financial deregulation had as great an impact on art as on everything else, and in the 1980s the dealers came back into their own. In 1981, the German-based curator Christos Joachimedes wrote: 'The artists' studios are full of paint pots again.' The remark introduced the exhibition, 'A New Spirit in Painting', held at the Royal Academy of Arts in London, and curated by loachimedes together with Norman Rosenthal of the Royal Academy and Nicholas Serota, then Director of the Whitechapel Art Gallery and subsequently of the Tate. The following year, the Italian critic Achille Bonito Oliva coined the term 'International Trans-avantgarde' as the title of his book proclaiming the re-emergence of painting to pre-eminence in the art world. He wrote: 'The dematerialisation of the work and the impersonality of execution which characterised the art of the seventies. along strictly Duchampian lines, are being overcome by the re-establishment of manual skill through a pleasure of execution which brings the tradition of painting back into art.'

Oliva stressed the passing away of the idea of progress in art. There was no longer one, linear 'story of art', but a multipli-city of attitudes and approaches jostling for attention. One of the consequences of art being released from step-by-step development was a freedom to look anywhere for inspiration: instead of the struggle to develop a current style by carrying forward and responding to the character of the immediately preceding one, Trans-avantgarde art could, or indeed should, quote from any period it liked. Furthermore, it need not now restrict itself to fine or 'high' art but could equally well adopt craft and other 'low' cultural techniques, materials and subject matter where appropriate. Newness could no longer be a criterion of judgment because newness, it was realized, was unattainable, and consequently any claims to originality were downright fraudulent. Everything had already been done; all that remained was for us to take fragments of what was to hand and combine and recombine them in ways that were meaningful. A postmodern culture was one, therefore, of quotation, and viewed the world as a simulacrum. Quotation could appear in a number of guises - as copying, pastiche, ironic reference, imitation, duplication, and so

on – but however striking its effect, it could make no claim to originality. These guises, however, covered a wide spectrum of critical positions. There was undoubtedly an element of nostalgia in the Trans-avantgarde or, as it was widely termed, neo-Expressionism. Count Giuseppe Panza di Biumo, one of the most important collectors of Minimal and post-Minimal art, regarded it as a move backwards rather than forwards, a regression to an art that was easily appreciated after the apparent difficulty of much 1960s and 1970s art. To promote the latest art as essentially a return to painting, particularly the kind of large format, macho gestural painting that had been challenged by feminism, was a marketing exercise, a conservative rejection of Conceptualism's critical enquiry and a capitulation to the insistent demands of the market

There was also a side to postmodernism that relished the unseemliness of an art that made itself by borrowing. Juxtaposing disparate styles and images from different sources did violence to the intentions behind, and the historical integrity of, the original. What could one make, say, of Markus Lüpertz (b. 1941) painting Germany's past as a Surrealist landscape in a pseudo-Expressionistic way: The Triumph of Line III, 'Monument with

120. **Markus Lüpertz**, The Triumph of Line III, 'Monument with Burned Bones', 1979

Burned Bones' (1979)? The unease felt by some at this behaviour led to charges that postmodernism was, simply, devoid of any sense of history, that its products were cynically cobbled together from elements seized because of their superficial visual appeal and that it was therefore itself only an art of surface, lacking substance. In contrast to the negativity of these positions, described by the American critic Hal Foster as 'a postmodernism of reaction', there was also a critical, radical postmodernism. Far from the collapse of the idea of progress leading to a situation of 'anything goes', in which all gestures and interpretations had equal validity, it was possible, having absorbed the lessons of the previous two decades, to question the assumptions behind and meanings of art's borrowings.

As Oliva's book recounts, and as 'A New Spirit in Painting' and Zeitgeist – a subsequent exhibition in Berlin also selected by Joachimedes and Rosenthal - showed, painting was again in the limelight. Notable exponents at this time were: in Italy, Francesco Clemente (b. 1952), Enzo Cucchi (b. 1949), Sandro Chia (b. 1946) and Mimmo Paladino (b. 1948); in Spain, Miguel Barceló (b. 1957) and Ferrán Garcia Sevilla (b. 1949); in France, Gérard Garouste (b. 1946), Jean-Michel Alberola (b. 1953), Jean-Charles Blais (b. 1956), Robert Combas (b. 1957); in Britain, Christopher LeBrun (b. 1951), Paula Rego (b. 1935), Bruce McLean; in Germany, Anselm Kiefer (b. 1945), Georg Baselitz (born George Kern 1938), Markus Lüpertz, Gerhard Richter; in the US, Julian Schnabel (b. 1951), David Salle (b. 1952), Eric Fischl (b. 1948), lack Goldstein (b. 1945); in Denmark, Per Kirkeby (b. 1938); in Holland, René Daniëls (b. 1950); and in Belgium, Narcisse Tordoir (b. 1954). There is no sense in which these artists together constituted any kind of movement - their work was far too varied in appearance and intention for that to be the case, and anyway, postmodernism's pluralism prohibited anything as coherent as a movement - but as much as anything, it was this huge variety that allowed Oliva to bracket them together.

In Italy, Clemente's work was strongly autobiographical, combining images in a rhythmic and free-wheeling way that implied an erotically charged atmosphere without quite suggesting a narrative. One image leads to another and then another, without ever turning out towards the world. Clemente worked in a number of different media, but kept their use segregated according to the country in which he worked. Large paintings in oil on canvas, as in *The Fourteen Stations* sequence (1981–82), were executed in New York. Chia's subject matter played

121. Francesco Clemente, The Fourteen Stations. No. III. 1981–82

in a tongue-in-cheek manner with the fear of not living up to expectations. His overburdened *Water Bearer* (1981) asks how a young artist, working in Italy, a country with such an illustrious cultural heritage, could hope to match the grandeur of past achievement he saw all around him. Cucchi's energetically worked surfaces drew their imagery from themselves, envisaging the act of painting as a continuing process of making, rather than a fixing of representations on canvas. Mimmo Paladino's paintings and his later multi-part sculptural installations disposed figures and props with symbolic and mythic resonance within dramatically depicted spaces. These artists and others – Nicola de Maria (b. 1954), Nino Longobardi (b. 1953), Bruno Ceccobelli (b. 1952), Gianni Dessi (b. 1955) – appeared alongside the older Arte Povera figures Mario Merz, Jannis Kounellis and Pier Paolo Calzolari, rather than supplanting them as the new generation.

In Germany, the imagery of many painters concerned the causes and consequences of postwar division. This was not a new preoccupation, and the predominant figures of the early 1980s, far

from being young unknowns, were artists who had been working for some time: Gerhard Richter and Sigmar Polke from the 1960s and Georg Baselitz, Markus Lüpertz, Jörg Immendorff, Bernd Koberling (b. 1938), Dieter Hacker and K. H. Hödicke (b. 1938) right throughout the 1970s. There was also, in Germany, less of a sense that painting needed to reassert itself. In much of this work clear evidence of the stylistic influence of Expressionism could be seen, and it was generally referred to as neo-Expressionism. Ernst Ludwig Kirchner's work and primitivism were reworked by Helmut Middendorf (b. 1953), and emerged in the febrile sexuality of Rainer Fetting (b. 1949) and Salome (b. 1954), these three being dubbed the Neue Wilde. In the case of Baselitz, Expressionist influence lay in his handling of paint and his acknowledged debt to, and direct quotation from, Nolde. Baselitz, born in East Germany, had painted pioneers from early in his career. Battle-scarred, tattered, and becoming fragmented as the political tutelage of his youth was reconsidered, his work had nevertheless retained a breezy heroicism. In 1967 his work underwent a literal revolution: in Finger Painting I – Eagle – à la (1971–72), he painted his subject matter upside down. To paint abstractly was too nebulous a proposition for Baselitz. He needed an image of some sort to

122. **Georg Baselitz**, Finger Painting I – Eagle – à la, 1971–72

provide a rationale for the laying on of paint, but at the same time did not wish the recognition of that image to obscure an appreciation of the brushwork and colours of the painting itself. Painting upside down – which is to say actually painting upside down, not painting the right way up and turning the finished canvas through 180 degrees – was his solution to this problem. The image was there as an ordering principle for the pigment, but that pigment was able to have its full impact before the image was recognized.

As Hölderlin and Nietzsche had done in the nineteenth century, Kiefer examined critically the mythic and historical dimensions of the German sense of identity and nationhood. More explicitly than most, he focused on the period of Nazism and the Second World War. The 'scorched earth' paintings of 1974, such as Maikäfer Flieg, depicted landscapes blackened either by stubble burning or the depredations of war. The transforming power of fire was repeatedly used by Kiefer as a metaphor for the artistic process. Straw, too, was used as an ironic symbol of the same: a reference to Rumpelstiltskin who span straw into gold. Ironic questions abound. The stairs up to an early studio feature: are they the ascent to a place of spiritual grace? Similarly an artist's palette makes frequent appearances, sometimes with wings: is the vain hope of transcendence held out by art an adequate substitute for lost religious faith? Another studio, a disused brickworks bought in the late 1980s, is pictured again and again in countless manipulated photographs. The photographs are bound, sometimes in huge books with pages of lead. Too

123. **Jörg Immendorff**, Eigenlob stinkt nicht, 1983

124. **Gerhard Richter**, *18*, *Oktober 1977*, *c*. 1988. Asked about the philosophy of the Baader-Meinhof, Richter said: 'I dismissed it as an ideology, as Marxism or the like. I'm interested in something quite different, which I have attempted to transmit, namely the raison d'être of an ideology that sets so much in motion...why we have ideologies, whether they are an inescapable, necessary part of our being – or a superfluous, troublesome, lifethreatening madness.'

heavy for a single human to lift, they lie open on a lectern or are housed in gargantuan shelving units. Kiefer used straw again in a major series of 1981 [125] entitled, after the refrain in the Jewish poet Paul Celan's *Todesfuge*, 'Your golden hair Margarethe/Your ashen hair Sulamith', a reference to the victims of the Holocaust. One or other of the lines is scrawled across each canvas, charging landscape or figure with emblematic significance.

In a different way, Lüpertz's paintings also dealt with myth and reality in German history. He adopted the Nietzschean term 'dithyramb' - Dionysian song - as a generic title. Immendorff continued to make paintings with strong political content. If his work also looked stylistically to earlier German art, it leant towards Neue Sachlichkeit rather than Expressionism. The 'Café Deutschland' series, begun in 1977 and continued in the early 1980s, presented the realities of a divided Germany in bar scenarios. By the later 1980s, as in Nachtmantel (1987), the inhabitants of Immendorff's restaurant and theatre interiors had become the denizens of the art world. His one-time associate and fellow artist A. R. Penck (b. 1939), his teacher Beuys, his colleagues Lüpertz and Baselitz, the art dealers Michael Werner from Cologne and Mary Boone from New York, the American artists Schnabel, Salle and Fischl, the European curators Rudi Fuchs and loachimedes and many more curators, artists, collectors and critics all engaged in the niceties of the social dance.

125. **Anselm Kiefer**, Margarethe, 1981

126. **Julian Schnabel**, Oar: for the one who comes out to know fear, 1981 Richter's output included both abstract and representational paintings, although his method of working meant that it was never easy to say where the dividing line between the two fell. The figurative canvases were always copied from reproductions, photographs, postcards or media images, never from 'real life'. A late-1970s series of abstract canvases, for example, were in fact faithful enlargements made from slides of small oil studies. In 1988, he returned to source material he had kept for over a decade, an exhaustive collection of images documenting the prison suicides of the members of the Baader-Meinhof terrorist group. Wary of possible charges of sensationalism, Richter stipulated that the resultant sequence of grey paintings, collectively titled 18, Oktober 1977 [124], were only to be shown together.

Polke's use of imagery and media was a paradigm of the eclectic nature of 1980s art. His work had a notable influence outside Germany on the painting of Julian Schnabel, whose characteristic early-1980s style was to paint a similarly varied range of imagery – from high art to advertisements and cartoons – on a ground of broken crockery. The paintings, usually large and necessarily bulky in order to support the weight of the ceramics, were spectacular in effect, their forms animated by their fractured surfaces. Subject matter was of a piece with this spectacle: a female crucified Christ in *Vita* (1983), for example, and, on an old piece of haulage lorry tarpaulin covered in grime and bootprints, a bravura blue shape entitled *Portrait of God* (1981). Schnabel's sense of the significance of materials was one he saw himself sharing with both Polke and Kiefer, something that all three ultimately derived from Beuys's example. He wrote: 'A lot of Americans

127. Eric Fischl, Bad Boy, 1981

still don't understand that it was Beuys who instigated this current shift in art. They think it came from reductivism and minimalism and painting being dead and then resurrected – but I'm talking about an involvement with materials.... Even if the materials are manufactured, or they look new, the work has to do with the alchemic and accumulative power of...objects.'

Also in the US, David Salle's paintings fitted more neatly into the notion known as 'appropriation' that was widespread in the early 1980s. Appropriation, the opportune seizing of things for our own use, was the activity to which we were all sentenced by our condition of postmodernity. The flat areas of colour in The Trucks Bring Things (1984), or How to Use Words as a Powerful Aphrodisiac (1982), on which floats a mixture of material culled from many sources, were clear examples of this. Salle's frequent use of soft-porn imagery was read by some as evidence of a backlash against feminist arguments over what could or could not justifiably be represented. Eric Fischl did not so much appropriate as consciously refer to the style of Max Beckmann in his psychological portrayals of leisured existence, such as the deck full of naked figures in The Old Man's Boat and the Old Man's Dog (1982) and the pubescent sexuality of Bad Boy (1981) [127].

The US and Germany were the two poles of the art world in the 1980s, with New York and Cologne as their most important centres. The Cologne dealers had inaugurated a Kunstmarkt (art market) in 1967. Düsseldorf, Cologne's near neighbour, started one five years later. The two alternated thereafter until 1983, by which time the Cologne Art Fair had established itself, along with the more traditional event in Basle, as one of the prime displays of artists' wares in the calendar. There were others of longer or shorter pedigree in Paris, Chicago, Milan and elsewhere. One was set up in the late 1980s, just before the end of the economic boom, in Frankfurt, and another, ARCO in Madrid, enjoyed a period of success in the latter half of the decade as a result of the socialist government's generous arts funding policy.

ARCO was, in fact, just one factor in the much greater international visibility which art from Spain enjoyed from this time onwards. The sculptors Susana Solano (b. 1946), Juan Muñoz (1953–2001) and Cristina Iglesias (b. 1956), and the painter Federico Guzmán (b. 1964) were among those who became more widely known. Muñoz's installations [119] had a theatrical air and were peopled by caricatured and exaggerated figures: dwarfs, puppets and isolated body fragments. In line with his interest in de Maria, Guzmán's painting/objects, which often extended out

from a flat surface into the room containing them, played on the unresolvable relationship between representation and occupying a space. Although very different in look and feel, Iglesias's wall-mounted structures similarly evoked aspects of architectural experience through a mode of visual address appropriate to painting. Solano's welded metal works emphasized the importance of Spain's re-entry into the art world since they reconnected the experimental developments in art since the 1960s to the strong Iberian strand in modernism. A sculpture such as *Thermal Station*, *No. 1* (1987), for example, as the American critic Kim Bradley has noted, certainly acknowledges the direct simplicity of Minimalism, yet its materials and formal allusiveness also place it in a line of sculptural descent from Picasso and Julio Gonzalez through Eduardo Chillida (1924–2002).

In the new deregulated economic circumstances, the business of collecting exerted an enormous influence on art. The new Museum of Contemporary Art, for example, opened in Los Angeles in 1983 with a show of works drawn from eight large private collections including those of Count Giuseppe Panza di Biumo and Peter Ludwig (Haacke's 'Chocolate Master'). Other lenders included Charles and Doris Saatchi, whose collection was founded on the success of the advertising agency Saatchi ran with his brother, Maurice. The Saatchi collection, which included works by Judd, Warhol, Serra, Flavin, Chamberlain and Andre, was showcased in a series of temporary exhibitions at its own venue. Occupying the premises of a former paint factory in north London, the Saatchi Gallery opened in 1984, providing a highprofile base for a rapidly expanding stock of new art. In 1984, a four-volume catalogue of the collection was published under the definitive title, Art of Our Time. As with any other commodity, the consequences of the growth in art buying were predictable. The restricted supply resulted in an increase in value, and new prices would quickly be confirmed, if not improved upon, by purchases from the contemporary sales at the major auction houses. The renewed interest in painting had profound implications for this booming market. An individual's manual skill was reinstated as proof of an object's artistic credentials, and this meant that, instead of being merely analysed as if it were a commodity, art could now properly function as one. Aesthetic pleasure could be marketed just like soap powder and coffee beans.

Embracing the idea that art could and should be publicized, an annual award, the Turner Prize, was instigated by the Tate Gallery in 1984. Initially sponsored by the New York financial

128. **Malcolm Morley**, SS Amsterdam in Front of Rotterdam, 1966

129. **Willem de Kooning**, Untitled XII, 1982

institution Drexel Burnham Lambert, the Turner Prize survived their bankruptcy at the end of the 1980s boom, and still provides contemporary art with a prominent public forum. The US-based English artist, Malcolm Morley (b. 1931), whose photographically accurate paintings of ocean liners had been prominent in the late-1960s Hyper Realist movement, was its first recipient. His 'Day of the Locust' series of the late 1970s, while done in a looser style than hitherto, included direct references to earlier, tightly controlled works, particularly SS Amsterdam in Front of Rotterdam (1966). Morley's example demonstrates that as well as bringing forward the work of many younger artists, the renewed interest in painting also brought back into new focus the careers of an older generation. Barnett Newman and Mark Rothko had both died in 1970, but of the Abstract Expressionists both Willem de Kooning and Philip Guston (1913-80) were still alive and making new work, albeit that de Kooning was working through the increasing effects of Alzheimer's disease up until his death in 1997. Guston had, in fact, ceased to paint in his earlier lyrical abstract style and had begun to portray himself, as in The Studio (1969), as a cowled presence amid the doubts and difficulties of the working

130. Philip Guston, The Studio,1969

environment. Graphic evocations of the Classical civilizations by Cy Twombly (1928–2011) – Hero and Leander (1981–84), Anabasis (1983) – were only the most recent in a career that stretched back to his Abstract Expressionist roots in the 1950s; from Minimalism there were Agnes Martin (1912–2004), Robert Ryman and Brice Marden (b. 1938).

In Britain, the biggest contribution from older generation artists was from Howard Hodgkin (b. 1932), Francis Bacon (1909–92), R. B. Kitaj, Michael Andrews (1928–95) and the painters of the 'School of London', i.e., those artists who were associated with the painterly representational approach of David Bomberg: Frank Auerbach (b. 1931) and Leon Kossoff (b. 1926). There was no shared style in the work of this group: the thickly worked and dribbled paint of Kossoff's *Christchurch Spitalfields*, *Morning* (1990) [132], like that of his portraits, is a long way from the flat, colourful strokes of Hodgkin's *In Bed in Venice* (1984–88).

The market even found a way to bring some parts of public art back into its orbit. The burgeoning in the US of urban graffiti into large-scale, colourful tableaux was recognized as a vivid art form. Using not only walls, but also mobile sites such as railway carriages which took the work from the city to the suburbs and beyond, graffiti art quickly became a pervasive presence throughout the US and Europe. The opportunism of practitioners who used any conveniently available blank surface to spray complex paintings of exuberant expressiveness – provocative

131. **Howard Hodgkin**, In Bed in Venice, 1984–88

132. **Leon Kossoff**, Christchurch Spitalfields, Morning, 1990

DIY murals of greater urgency and immediacy of impact than the polite, democratic products of bona fide community arts projects — was in tune with the newly vitalized market. The tactic, quite simply, was that instead of an exterior wall, the sprayers would be offered a surface inside a gallery on which to paint.

Wary of the exploitation that could occur in such circumstances, Tim Rollins (b. 1955) collaborated with youngsters drawn largely from within the poorer Puerto Rican population of New York who were keen to work creatively, but who, because of circumstances, had had little formal training. Rollins and K. O. S. (Kids of Survival), using literature as a starting point, read a text and discussed imagery that might be appropriate to it. This was then sometimes painted over a canvas on which the pages of the original book had been pasted. In other cases, images were drawn onto the pages of books. The project was educative as well as artistic, growing from the after-hours group 'Art and Knowledge' Rollins had set up in the school where he taught. Texts studied and used in more than one work included Herman Melville's Moby-Dick, Lewis Carroll's Alice in Wonderland and Franz Kafka's Amerika. The presence of text, the grid effect

of the rows of pages underlying what was often predominantly monochromatic painting, and the shared authorship of the works was, for Rollins, a natural development of his background in the political discussions of New York Conceptualism. All participants, however, were adamant about distancing their working pattern from the exploitative relationship that existed between the art world and graffiti. As Rollins said, 'We learned a lot from the situation of what happened to graffiti artists, and how a white audience can treat that work: embrace it with such enthusiasm, and then get rid of it the next year with equal enthusiasm. Particularly with black and Hispanic artists, that tends to be the pattern.'

For Kenny Scharf (b. 1958), Keith Haring (1958–90) and Jean-Michel Basquiat (1960–88) it was the style of graffiti that was put to expressive purpose in their work. Basquiat came to notice as 'SAMO', whose tag, in a well-conceived campaign of self-promotion, appeared on walls outside all the best art-world venues. His paintings were full of words and phrases that had been crossed out, altered and substituted for better versions. Far from signalling nonchalance or thoughtlessness, this pervasive editing represented a struggle to clarify and to communicate. He said, 'I just look at the words I like, and copy them over and over again, or use diagrams. I like to have information, rather than just have a brush stroke. Just to have these words to put in these feelings underneath, you know.'

Cumulatively, Basquiat's paintings conduct a harsh critique of contemporary America and of the position of black people within it: 'Black people are never portrayed realistically, not even portrayed, in modern art, and I'm glad to do that,' he said. Discography two (1983) [135] copies, with deliberate repetitions, emphases and crossings-out, the liner notes for a Bebop LP onto a square, black canvas: the archetypal modernist image, that has already travelled from Malevich to Reinhardt and beyond, is here invested with new significance and sent off in another direction. In 1980, Basquiat stopped using his 'SAMO' tag; he was taken on by the Annina Nosei Gallery in New York and given materials and a basement space to work in. Four years later he was with one of the major and most glamorous New York galleries of the 1980s, owned by Mary Boone, and able to sell his paintings for \$100,000 apiece. The year after that saw a collaboration with Warhol and an appearance on the cover of the New York Times Sunday colour supplement sitting barefoot in his studio wearing an Armani suit. And two years after that he was dead, overdosed, a victim of

133. **Tim Rollins and K. O. S.**, *Amerika VI*. 1986–87

his indulgence in the rewards of the demeaning patronage he had so despised.

Keith Haring's outlined humans and animals cavorted in Day-Glo splendour. They began in the very early 1980s as chalk drawings on black paper pasted over expired posters on subway billboards; his work always retained that connection. He could show paintings and sculptures at the New York galleries of Leo Castelli or Tony Shafrazi, but the instant demotic appeal of his cartoon, stick-figure style meant that it worked equally well on T-shirts, badges, stickers and posters. The 'Pop Shop', which he opened in New York in 1986, sold merchandise bearing his designs, but he would also design for fund-raising and advertising campaigns, particularly those associated with AIDS, of which he died in 1990.

The impact of AIDS on the art world in New York was profound. Act-Up, the organization of artists fighting among other things to promote AIDS awareness and the interests of those who were HIV positive, staged events and demonstrations. The impact of AIDS was clear, too, in the kind of work that drew on 1970s art with a social purpose for its formal and expressive means. The group Gran Fury [139] made informative, educational and forthrightly propagandistic posters, magazine spreads and exhibition displays. On one occasion they mimicked a United Colors of Benetton campaign in a bus advertisement attacking indifference and prejudice. Bureaucratic indifference is also the subject of Arena (1992) [138] by Frank Moore (b. 1953), one of the magical realist canvases which communicate his fury at and sensitivity to AIDS; figures are depicted in the midst of nightmarish medical procedures, toxic waste and chemical pollution. No less direct were the writings and images of David Wojnarowicz (1954–92). 'I'm a blank spot in a hectic civilisation',

134. **Keith Haring**, *Untitled*, 1983

135. Jean-Michel Basquiat, Discography two, 1983

136. Philip Taaffe, Overtone, 1983

he wrote in Memories That Smell Like Gasoline, published in 1992, the year of his death from AIDS: 'I'm a dark smudge in the air that dissipates without notice. I feel like a window, maybe a broken window.' The Sex Series of photomontages (1988–89) used negative imagery from numerous sources to assert, in the face of society's response to AIDS, that 'I will continue to explore my body and the bodies of other men and find the possibilities for pleasure and connection'.

Concern with AIDS is visible in less obvious ways in the abstract painting of the early and mid-1980s. In 1981, Ross Bleckner (b. 1949) exhibited paintings at the Mary Boone Gallery, some of which, like his *Growing Grass* of 1982, copied the illusionistic abstractions of Op art. Two years later, Philip Taaffe (b. 1955) did the same with paintings whose richly decorative surfaces were built up from printed paper pasted onto the canvas. The undulating black-and-white stripes of *Overtone* (1983) were the most obvious reprise of Bridget Riley's earlier work. Shortly thereafter, Peter Schuyff (b. 1958) made some work strongly reminiscent of another Op artist, Victor Vasarely. Considering the general political and economic situation as well as the advent of AIDS – a phenomenon he likened elsewhere to the plague, a

medieval visitation at the heart of the late twentieth century – Ross Bleckner suggested in 1987 that 'people in their early 20s are now thinking about death more'. The use of Op by these artists was a way of dealing with this. Coming as it had at the very end of the modernist trajectory, Op stood as the most played-out, most empty, non-referential, non-art of the entire century. Using this as an 'image' of hopelessness, a hopelessness defied by their continuing to make paintings rather than to capitulate and give up altogether, these artists were able to do in a way what art had always done: to project beyond the present moment. Bleckner's particular quality of light, Taaffe's use of ornament as a means to relieve unremitting circumstance and Schuyff's 'spotlit' grids that might be skin blemished by Kaposi's sarcoma each reintroduce utopia to dystopian reality.

137. **David Wojnarowicz**, Sex Series. 1988–89

138. Frank Moore, Arena, 1992

139. **Gran Fury**, *Untitled*, 1990 (partial view)

Ashley Bickerton (b. 1959) worked in a similar way. His elaborate, box-like, wall-mounted metal units covered in abstract fragments, logos, symbols and stylized lettering, made a display of the method and logic of their construction. They were described by him in suitably bleak terms: 'I'm just kicking the great big, corpulent, cellulitic body of art as it lays there in its deathbed, and creating a sort of perverse poetry out of the whole thing, I guess.' This is a long way from modernism. The startling power of Malevich's Black Square in 1913, the dynamic balance and primary-coloured rhythms of Mondrian's pre-Second World War 'Neo-plasticist' compositions and even the concern with abstraction of Caro, Kelly, Stella and Olitski in the 1960s rested in some degree on the belief that it was possible to make art that was non-representational. By the 1980s, in both chronological and practical terms, painting was post-Conceptual. The compound styles and joky titles - Blobscape (1986), The Big Picture (1988) – of the American Jonathan Lasker (b. 1948), and the Day-Glo renditions by another American, Peter Halley (b. 1953), of Newman-inspired designs showed that they could use the history of abstraction as a painterly vocabulary. Their work

140. **Ashley Bickerton**, Le Art (Composition with Logos 2), 1987

sat comfortably alongside that of an older generation: not only Richter, but also, for example, Olivier Mosset whose abstraction, like that of his early associates Toroni and Buren, was always Conceptual, and Richard Artschwager (1923-2013), whose 1960s work had bridged Pop and Minimalism. The geometrical simplicity, usually rectilinear, of Mosset, Halley, Meyer Vaisman (b. 1960). the Swiss John Armleder (b. 1948), the Austrians Helmut Federle (b. 1944) and Gerwald Rockenschaub (b. 1952), among others, was nicknamed neo-Geo. Not quite new, only neo-, this latest manifestation of abstract painting was taken to be a copy or simulation of the real thing. Halley dubbed the large Day-Glo blocks of colour and connecting black lines in his paintings cells and conduits: Yellow and Black Cells and Conduit (1985), White Cell with Conduit (1986) [143], and so on. These spaces and their interlinkings mapped out the systems of contemporary exchange. Less an agglomeration of private and public terri-tories, our social space was now a collection of nodes within the networks of communication. Halley was greatly influenced in his work by the theories of Jean Baudrillard, whose ideas on 'hyper reality' described a world in which images no longer represented a real object, but referred the viewer to another image, then another, in an endless sequence. It was a world in which simulation was not the pretence of a 'real experience', but was itself the only kind of reality we could ever hope for. The loss of originality meant that everything was a copy, and, without an original, the idea of copying with its pejorative overtones made no sense anyway. By making paintings that replicated those of Picasso, on the other hand, the approach of Mike Bidlo (b. 1953), made perfect sense in a world where advertisements stole from other advertisements. where music pirated snatches from other songs, where films spoofed other films and the lives of characters were prolonged through perpetually extendable series and where the invasiveness and ubiquity of TV erased the boundaries between public and private and between fact and fantasy.

As previously noted, the term widely used to describe the copying of already existing images by Taaffe, Bidlo, Sherrie Levine (b. 1947), Elaine Sturtevant (b. 1926), Jack Goldstein and others was 'appropriation'. For the American art historian Thomas Crow, such imitation was made possible by the fact that 'the authority of art as a category' had ceased to be the matter of contention that it had been throughout the modernist period: 'In narrowing artistic mimesis to the realm of already existing signs, these artists simply accept, with a serene kind of confidence, the

141. Robert Gober, Double Sink, 1984

distinction between what the modern cultural economy defines as art and what it doesn't.'

Postmodern theories that described contemporary culture as one of surfaces and images had a particular appeal in Australia, a country largely 'Western' in its perceptions but geographically guite isolated. Because of that isolation, many artists' understanding of contemporary art was gleaned far more from illustrations in magazines than from seeing the real thing. Imants Tillers (b. 1950) worked with this circumstance, making paintings put together from the images of Baselitz, Kiefer, Schnabel and others mixed in with elements drawn from the work of Aboriginal artists. His paintings were, moreover, done on many small art board panels rather than a single, large canvas with the result that works could be more easily parcelled up for shipment out of the country to an exhibition venue elsewhere. As an ultimate appropriation of the appropriationists, Tillers's Double Covenant (1987), made for his first exhibition in New York, borrows Philip Taaffe's We Are Not Afraid (1985), an image of defiance and hope, which is itself derived from Barnett Newman's 1960s 'Who's Afraid of Red, Yellow and Blue' series, which is a return to the primary directness of late Mondrian after the poetic tonalities of Abstract Expressionism.

Robert Gober (b. 1954) noted on this point that the US 'in particular is nurtured on and transfused with images of duplicity'. His plaster sinks, while referring to Duchamp's readymade Fountain were, like all his work, made by hand. Gober's installations also evoke an ambivalent sexuality, as, occasionally, had some of Duchamp's work. In rooms wallpapered with a forest scene, a penis and vagina motif or a hanged man and sleeping boy

pattern, Gober variously placed his sinks, convincingly fabricated boxes of rat bait and cat litter, wax limbs with protruding candles and inset plug-holes, a hand-sewn wedding dress, bundles of newspaper in which the top story had been mocked up to highlight intolerance and social repression, and a hugely oversized cigar.

The work of Jeff Koons (b. 1955) and Haim Steinbach (b. 1944) was, along with that of Gober and Bickerton, considered to be object-making of a neo-Conceptual kind. Steinbach collected shop-bought products displayed on formica-covered shelf units. Although often quite different kinds of things were placed together, their colours, materials, textures and shapes made

143. **Peter Halley**, White Cell with Conduit, 1986

144. **Haim Steinbach**, related and different, 1985

145. **Jeff Koons**, One Ball Total Equilibrium Tank, 1985

the arrangements coherent in the way that an individual's lifestyle is shaped by his or her particular choices from among the variety of mass-produced goods available. Steinbach's shelves, with such titles as dramatic yet neutral (1984) and related and different (1985) [144], reflected the growing acceptance that while we might all be consuming the same commodities, the way in which each of us does so is quite distinct. Koons's interest in the acceptance of commercial products as art, his employment of skilled workers to make his work for him and his concentration on the infamous - not least himself - as subjects, all marked him out, for some, as the natural successor to Warhol. The displays of upright and wet/dry vacuum cleaners in spotless, fluorescent-lit perspex cases he began in 1980 are perhaps another homage to Duchamp. Bulbous containers, long floppy tubes, rigid upright forms and the tension between dirt and pristine purity rework Duchamp's eroticism and his admiration for American plumbing as the country's one great artwork for a new era. In the mid-1980s, a number of stainless steel casts of a plastic inflatable bunny and a Bourbon decanter shaped like the train on the Jim Beam Bourbon label among other things, reaffirmed the distance between the usefulness of ordinary artefacts and the reflective value of art. The Jim Beam decanter remained art only so long as the seals and the Bourbon it contained were intact. One Ball Total Equilibrium Tank (1985) can be seen as the pared-down expression of art's striving towards perfection and the ideal. A sealed glass tank containing a basketball sits on top of a metal stand. The balance between the weight of the ball and the density of the salt solution surrounding it allows the ball to rest at the exact centre of the container. It is a beautiful illusion - look, no strings, the gravity-defying feat of the body in slow-motion replay as it soars towards the hoop - all the more so because nothing is hidden.

This attitude was what the German critic Wolfgang Max Faust called 'the paradox of an "unbelievable belief" in art'. The same paradox was evident in the work of some Cologne-based artists of the generation after Kiefer. Albert (b. 1954) and Markus Oehlen (b. 1956), Werner Büttner (b. 1954), Georg Herold (b. 1947), Martin Kippenberger (1953–97), Walter Dahn (b. 1954) and Georg Jiri Dokoupil (b. 1954) belonged to this generation. Both Polke and Immendorff had taught many of them, and another important influence on them was the Danish Situationist Asger Jorn. Dokoupil, who changed style for each new batch of work, was, with Dahn and Peter Bömmels (b. 1951), a member of the Mulheimer Freiheit group of neo-Expressionists. Albert Oehlen

146. Martin Kippenberger, With the Best Intentions I Can't Find a Swastika, 1984

and Kippenberger used the Expressionism of the moment to question the orthodoxies it seemed to be reintroducing. Paintings such as Kippenberger's jumble of angular forms titled With the Best Intentions I Can't Find a Swastika (1984) and Oehlen's Kieferaping imagery or his study in red, yellow and blue called Portrait of A. Hitler (1985) parade a cynicism towards the oppressive rectitude of liberal thinking. Herold's sculptures looked like knocked-up affairs, although the wire and underpants of Egypt (1985) from the 'German Speaking Summit' series, the bricks and tights of Hologram (1986) and the cheap wood and cardboard of his constructions, as well as the brief, cryptic words they bear, have a resonance carried over from Beuys and Polke.

Some of the sculptural objects by Rosemarie Trockel (b. 1952), such as Komaland (1988) with its tights stretched by organically inspired plaster forms, had a similar feel to Herold's, with the addition of an awkward sensuousness. As well as these, there was a series of large knitted paintings and wearable garments. Tiny wool marks, hammers and sickles, swastikas or the words 'West Germany' covered jumpers and balaclavas or made up expansive monochrome fields. Another wool 'painting', Cogito, Ergo Sum (1988), had Descartes's dictum across a mainly white surface. It is a post-feminist assertion of female identity, but the area of black in the bottom right-hand corner also echoes Polke's 1969 painting, Higher Powers Commanded: Paint the Upper Right Corner Black! The early sculptures of Katharina Fritsch (b. 1956)

147. **Rosemarie Trockel**, *Cogito*, *Ergo Sum*, 1988

148. **Sigmar Polke**, Higher Powers Commanded: Paint the Upper Right Corner Black!, 1969

149. **Katharina Fritsch**, *Tischgesellschaft*, 1988

excited wonder and controversy in equal measure. The crowd-pulling 1987 Elephant was a full-size green plastic model, cast from a specimen at the Bonn Natural History Museum, and placed on a tall, oval plinth. Fritsch's interest in making copies appeared more explicitly in Tischgesellschaft (Company at Table) evoking society's fear of technological advance. Cloned figures sit on either side of a long table, their identical hands resting on a cloth patterned with a computer-generated design.

The 1980s also saw the emergence in Germany of a substantial group of artist photographers – Thomas Ruff (b. 1958), Thomas Struth (b. 1954), Andreas Gursky (b. 1955) and Candida Höfer (b. 1944) – all of whom had been pupils of Bernhard and Hilla Becher. Ruff made large portraits of his contemporaries in the art world and, with the same typological approach, catalogued the southern sky at night; Struth recorded black-and- white cityscapes, remarkable for their lack of human inhabitants, and made studies in the world's major museums of people looking at

150. Louise Lawler, How Many Pictures, 1989

151. **Candida Höfer**, Natural History Museum, London II, 1990

art. Höfer photographed educational and cultural institutions as a means of representing the values embodied within them, while Gursky's large scenes of activity that are often shot from above — as in the electronics factory, *Karlsruhe* (1991), and the busy stock exchange floor, *Tokyo* (1990) — demand to be viewed almost as paintings. The Canadian Jeff Wall (b. 1946) self-consciously displayed his use of the conventions of photography in setting up his large, back-lit cibachrome images. Wall had participated in Conceptualism in the late 1960s, and a 1980s work such as the sweatshop confrontation *Outburst* (1989), made in that critical spirit, was precisely composed and rehearsed in order to make viewers conscious of the stereotypes they rely upon and the cultural assumptions they make when reading an image.

The feminism of the 1970s appeared in the changed conditions of the next decade in work by Sherrie Levine, Cindy Sherman (b. 1954), Louise Lawler (b. 1947), Barbara Kruger (b. 1945) and Jenny Holzer (b. 1950) that looked critically at the issues of consumption. Levine confronted the power of the male gaze and its presumption of possession, folding it back on itself by paying attention to the products of male creativity. Copying works by Kandinsky, Feininger and others and presenting them as her own (because they were her own) she suggested that the question of originality could not be separated from a consideration of who was allowed to be original. The point was perhaps most clearly made in Levine's photographs 'after' Walker Evans [154] and Edward Weston, retakes of images by two of the pioneers

of American photography, of which the American critic Craig Owens wrote: '[Is] she simply dramatising the diminished possibilities for creativity in an image-saturated culture, as is often repeated? Or is her refusal of authorship not in fact a refusal of the role of creator as "father" of his work, of the paternal rights assigned to the author by law?"

In the spirit of Asher and Broodthaers, Lawler conducted a renewed examination of the ways in which art attains value as it finds its place in the system of exchange and display. How Many Pictures (1989) [150], for example, shows, through the reflection of a Frank Stella painting in a gallery's highly polished floor, how indissolubly linked are work and context. Kruger adopted the techniques of display design in her photo-texts. Stark messages in bold white out of red sit over black-and-white images: We won't play nature to your culture (1983), Your gaze hits the side of my face (1981) and other pronouncements of similar intent questioned the relations of power within our commodity culture.

Sherman's 'Untitled Film Stills' [155] of the late 1970s and early 1980s are, as are almost all of her subsequent works, self-portraits. Endlessly mutable, she appears again and again in different situations. The studied stylistic coherence of each black-and-white photograph makes it resemble a still, around which one could easily dream up a filmic narrative complete with plot and characterization. The lie to one's instinctive grasp of Sherman's identity in these pictures is given by the next in the series, and the next, which each present her as an entirely different person. After the 'Film Stills' and another series in which she parodied

153. Andreas Gursky, Tokyo, 1990

154. **Sherrie Levine**, *Untitled* (After Walker Evans #3 1936), 1981

155. **Cindy Sherman**, *Untitled Film Still*, 1977

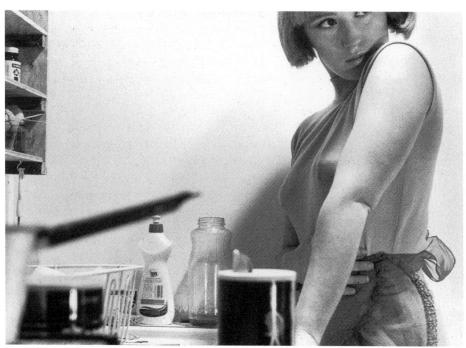

156. **Jenny Holzer**, 'Truism' on T-shirt modelled by Lady Pink, 1983

glamorous magazine poses, her work became somewhat darker featuring monstrous bodies, decay and rotting food shot in rich colour. With her so-called 'vomit pictures' Sherman asked whether it would be possible to take a picture that could overcome the appeal of the medium and be unhangable. Inevitably, the answer was no since, whatever the subject matter, our delight in the seductive nature of photography itself always triumphs. In later work, the characters she adopted, both male and female, were drawn from old master paintings. Here, as much as in the earlier series, Sherman's desire was not so much to become these characters as to efface her own self, becoming blank in a manner reminiscent of Warhol.

Holzer's 'Truisms', short statements with a strong impact but an ambiguous meaning, were fly-posted, stuck up in telephone booths and printed on T-shirts: 'Protect me from what I want', 'Lack of charisma can be fatal.' As the decade progressed, she moved into more officially sanctioned public communication sites, putting her art on illuminated advertising boards in places such as Times Square or Piccadilly Circus. Although her work has been shown to great effect in galleries, most notably at the Guggenheim Museum in New York in 1989 and in Venice the following year where she was the first woman to represent the US, it is in the public arena that they have had most impact.

The Polish-Canadian Krzysztof Wodiczko (b. 1943) co-opted the power and symbolism of public buildings and monuments for his work. Using projectors with tungsten lamps, he treated their façades as screens on which to project images that provided an ironic commentary on their meanings: US and Soviet missiles chained together over the arch of the Soldiers and Sailors Memorial Arch in Brooklyn (1984), a small swastika on the pediment of the South African embassy in Trafalgar Square, London (1987) and Ronald Reagan's hand as he took the oath of allegiance on New York's AT&T building during the 1984 presidential campaign. These, like Holzer's, were temporary displays, gestures that activated an environment without imposing upon it unduly.

Public art in the 1980s was considerably removed from its 1970s beginnings. In the US and Europe, agencies specializing in public art became established as the territory became more and more a part of the development boom. Where building projects required the inclusion of works of art such agencies would oversee the selection and commissioning of an appropriate artist. 'Percent for Art' schemes were also widely introduced, whereby

157. Richard Serra, Tilted Arc, 1981

one percent of the total cost of any development had to be earmarked for expenditure on art. Elsewhere, a developer such as Sir Stuart Lipton, responsible for London's Broadgate Centre, could, as a collector, decide which of his own works he wished to place around the site. Richard Serra, whose Fulcrum (1987) stands at one of the entrances to Broadgate, had been making sculpture for many years that was, in the increasingly popular phrase, site-specific. This meant that what the sculpture was, where it was placed and how it might produce its effect were inextricably linked. Moving such a work even a short distance would result not just in a re-siting, but in the creation of an altogether different sculpture.

The tensions that still existed between the general public and art, ostensibly conceived with the public's well-being uppermost

in mind, were amply demonstrated in the argument over and ultimate fate of Serra's Tilted Arc. commissioned under the US artin-architecture scheme in 1981 for New York's Federal Plaza. The steel sculpture - much taller than human height - cut across the plaza, severely restricting the view and progress of pedestrians. By 1985, protest by those who worked in the surrounding buildings had reached such a pitch that the General Services Administration, the government body that had commissioned the work, stated that it should be moved. A court case ensued, with Serra maintaining that its removal would constitute a violation of his contract and that a proposed relocation to one side of the plaza was of no use, as the work had been conceived for its original position. Any alteration to that would effectively destroy the work. Those speaking in support of Tilted Arc were not above relying on traditional ideas of the artist's integrity in their arguments. They were, in other words, using models of art practice and ideas of what an artist is that were precisely those which work such as that of Serra had been undermining in the preceding decades. It was eventually removed in 1989.

158. **Tony Cragg**, New Stones – Newton's Tones, 1978

While some aspects of public art maintained the separation between the culture of the gallery and the demotic

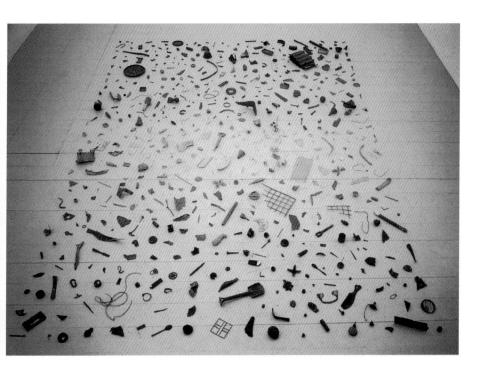

wholesomeness of emancipation from it, there were many more artists whose practice spanned both gallery and public site. Curatorial projects brought this to the fore. In 1986, the Belgian Jan Hoet organized *Chambres d'Amis*, a large-scale project in Ghent that was both public and private. More than forty families submitted parts of their homes to an artist for the duration of the exhibition. The viewer, therefore, had to take a map of all the locations and spend several days moving around the town knocking on doors and ringing bells in order to see the whole show.

In spite of the size of the exhibition, no artists from Britain were invited to participate. Hoet's explanation for this omission was that British artists were more involved in making objects than in the investigation of space and temporality. The artists to whom he was referring were a group of sculptors, many of whom emerged from the Royal College of Art in the mid- to late 1970s: Richard Deacon (b. 1949), Tony Cragg (b. 1949), Antony Gormley (b. 1950), Bill Woodrow (b. 1948), Shirazeh Houshiary (b. 1955), Anish Kapoor (b. 1954), Alison Wilding (b. 1948) and Richard Wentworth (b. 1947). Deacon's sculptures in laminated wood, riveted metal, rubber and plastic combined allusions to both engineered and biomorphic forms, as can be seen in the tongue-in-cheek echoes of everyday objects in his long sequence of small-scale works, the 'Art for Other People' series. Lead casts of his own body, Gormley's sculptures relate the figure and its dimensions to the space around it. Both Cragg and Woodrow used discarded material. Woodrow snipped and folded the casings of consumer durables into new shapes that speak of spectacle,

159. **Richard Deacon**, Art for Other People No. 10, 1984

160. **Reinhard Mucha**, The Figure-Ground Problem in Baroque Architecture, 1985

excitement, danger and the media's treatment of these: the side of a twin tub turns into a guitar, the panel of a car door becomes a gun and a microphone, and the seat of a child's tricycle folds into a tank. At the beginning of the 1980s, Cragg was collecting discarded items in wood or plastic and making arrangements of them on the floor. Exemplary of the approach and of Cragg's position in a sculptural tradition is *New Stones – Newton's Tones* (1978) [158], a rectangular array of plastic fragments arranged à *la* Long and graded to form a spectrum of colour.

In Germany, Reinhard Mucha (b. 1950) and Meuser (b. 1947) were also both recycling the discarded remains of an industrial past. Meuser's compositions of plates and girders left each element as it was, thereby using the 'found colour' in which they were originally painted. Their titles, too, provided a sign of their origin and former function: Metro Station Overkampf, or Krupp (both 1987), for example. Mucha's sculpture was centred on the construction sites, steelworks and extensive railway network around his Düsseldorf home. A large-scale work such as The Figure-Ground Problem in Baroque Architecture (1985), made for the Centre Georges Pompidou in Paris, uses equipment and materials found in the museum itself. Other works incorporate scavenged items, especially old doors, within finely crafted and elaborate framing structures. Mucha's work is autobiographical, rooted in its place of origin, and often makes use of elements from previous works in a continuing recreation of the past: personal, social and artistic.

Chapter 5: Assimilations

Andy Warhol died at the beginning of 1987. His presence had been a profound influence for a quarter of a century. The photoportrait of him by Richard Avedon (1923-2004) showing his bullet scars, taken following Valerie Solanas's unsuccessful assassination attempt the day after Bobby Kennedy was killed in 1968, made him, as the American critic Lisa Liebmann wrote, seem immortal. 'How can he be so right?!' the US art critic Peter Schjeldahl remembered thinking, 'with mingled awe and fury. He even got shot at the historically correct moment, if such is conceivable.' Two days before he died, the 32 Campbell's Soup can paintings that made up his first show at Irving Blum's Los Angeles gallery - all of which Blum had bought and kept together - went on permanent loan to the National Gallery of Art in Washington, D.C. In the light of this, the news of his death seemed for Liebmann to presage something catastrophic. She wrote: 'On the morning of Sunday, February 22 with the news that Andy Warhol was dead, I ran to the window expecting to hear seismic noises coming from the city outside, and to witness a transfiguration, I don't know of what: of the back of the building facing me, of the air quality, of appearances in general - but of something. The shock of so enormous an absence would surely register, it seemed, on reality itself.' The shock of his passing was, however, no more than equal to the impact of his emergence, as the artist Larry Bell wrote on first seeing Warhol's work in 1963: 'Warhol has successfully been able to remove the artist's touch from the art. He has not tried to make a science out of it as Seurat did. but made an anti-science, anti-aesthetic, anti-"artistic" art totally devoid of all considerations that we may have thought of as necessary. He has taken a super-sophisticated attitude and made it art, and made the paintings an expression of complete boredom for aesthetics as we know it.... It is absolute, it is painting, most of all it is art. In any event, and no matter what is finally decided about it, nothing can take away from it the important changes that the work itself has made in the considerations of other artists.'

Two years after Warhol's death, in 1989, the Los Angeles Museum of Contemporary Art staged 'Forest of Signs', an exhibition named after a line in Baudelaire's poem

161. Hans Haacke, Die Freiheit wird jetzt einfach gesponsert – aus der Portokasse (Freedom is now just going to be sponsored – out of pettycash), 1990

162. Judith Barry, Echo, 1986

'Correspondences' that brought together many American neo-Conceptual artists including Koons, Steinbach, Lawler, Levine, Sherman, Judith Barry (b. 1949) and Barbara Bloom (b. 1951). Barry's Echo (1986) investigated the conflict between the liberating promise of modernist architecture and the dehumanizing effect of so much contemporary glass and steel-frame urban design. Bloom contributed an installation entitled The Reign of Narcissism (1988–89), a mock Neoclassical interior in which all busts, wall reliefs, moulding details and vitrine-encased objects bore her silhouette or likeness. 'Forest of Signs' was subtitled by its curator, Mary Jane Jacob, 'Art in the Age of Reagan'. As the painter and critic Jeremy Gilbert-Rolfe (b. 1945) suggested in a lecture given during the exhibition, a better description might have been 'Art in the Age of Andy'. The only European figure of equivalent stature to Warhol throughout this period was Joseph Beuys, and he had died the year before Warhol. These two deaths coincided with a change of circumstance and perception that accompanied the absorption of the lessons of the previous quarter century's experimentation. The popularity of Installation. the maturity of video work, the transformed strategies of public art and the continued relevance of work that specifically addressed the social issues of oppression, racism and sexuality can each be witnessed in several of the major exhibitions since then.

The apogee of generalized postmodern creative practice that sought to draw parallels between various forms was Documenta

VIII in 1987. A large work by Beuys in the main museum's central space acted as a poignant focus for the proceedings. The theme of the Documenta was art and design, and designers and architects were included among the exhibitors along with artists. Ettore Sottsass (1917-2007), Jasper Morrison (b. 1959), Paolo Deganello (b. 1940), Hans Hollein (b. 1934), Haus Rucker Co. (Laurids Ortner, b. 1941), Günter Zamp-Kelp (b. 1941) and Manfred Ortner (b. 1943)), Arata Isozaki (b. 1931) and others bore witness to the fact that many facets of these disciplines had apparently converged. Among the exhibits, the entry of the Iranian-American Siah Armajani (b. 1939) was a design for a footbridge to be installed in the sculpture garden outside the Walker Art Center, Minneapolis, and the construction of the German Thomas Schütte (b. 1954) was a pavilion selling ice cream and drinks, complete with WC. Ange Leccia (b. 1952), a Corsican, presented one of the latest Mercedes Benz cars on a revolving pedestal.

Leccia's 'Arrangements' of manufactured items – anything from Concorde aeroplanes down to radio-cassettes – are one example of art in which the act of display is a central concern. It is central not because it separates the commodity as artwork from its appearance in everyday life, but because it reproduces it. When Warhol showed his Brillo and Campbell's Soup boxes back in 1964, they were, for all the shocking banality of verisimilitude,

163. **Barbara Bloom**, The Reign of Narcissism, 1988–89

artful copies. He used wooden boxes, in effect Minimal sculptures, onto which were pasted silk-screened logos to make them look like the real thing. Leccia used the real boxes. Similarly, *Poison* (1992) by the Swiss Sylvie Fleury (b. 1961) heaps together the smart designer carrier bags from her shopping trips complete with their contents, and the 1986 exhibition at the Cologne Kunstverein of the Belgian Guillaume Bijl (b. 1946) turned the gallery into a functioning menswear store. At first sight, works such as these resemble those of Steinbach and Koons, but there is little irony in them. Rather than using the reflexive criticality of Conceptualism to frame their practice, these artists take its lessons as read.

In 1986, Rebecca Horn, Jannis Kounellis and the German playwright Heiner Müller proposed the staging of an exhibition in Berlin which would include two works by each participant, one to be shown on either side of the Wall. By the time the project was realized in 1990 as Die Endlichkeit der Freiheit ('The Finitude of Freedom'), the Wall had come down and the process of unification was under way. The artists had to adjust to this new reality. The Missing House (1990) by Christian Boltanski (b. 1944) was sited in the gap made in a terrace in the former Jewish quarter of East Berlin by an Allied bomb in 1945. Fixed to the exterior walls of the houses to either side of the space were the names and dates of occupation of former residents. Further detailed documentation was displayed at the now derelict exhibition area that had once housed El Lissitzky's Proun Room at the 1923 Grosse Berliner Kunstausstellung. For his contribution, Hans Haacke [161] used one of the observation towers still standing in the Potsdamerplatz. Once the central

point of Northern Europe, the square had been cut in two by the Wall and was now cleared and whole again prior to being redeveloped. Haacke placed the Mercedes Benz logo, symbolic of the corporate muscle that would dominate the reshaping of the city, on top of the tower, and to one of its sides fixed Goethe's words 'Kunst bleibt Kunst' ('Art remains art'). In both cases, the public nature of the work was able to engage with the historical, political and economic dimensions of the urban context without compromising its artistic qualities.

'The Finitude of Freedom' was symptomatic of the way in which public art, when it was not merely an adjunct to or an aspect of urban planning, had overwhelmingly come to be conceived as a series of temporary interventions. The British agency Artangel commissioned several such short-term projects in the 1990s, notable among which were *Work for the North Sea*

165. **Christian Boltanski**, The Missing House, 1990

166. Rachel Whiteread, Untitled (House), 1993. 'The previous tenants were obviously DIY fanatics. The house was full of fitted cupboards, cocktail bars and a tremendous variety of wallpapers and floor finishes. I was fascinated by their personal environment and documented it all before I destroyed it. It was like exploring the inside of a body, removing its vital organs.'

(1993) by Bethan Huws (b. 1961) and *Untitled (House)* (1993) by Rachel Whiteread (b. 1963). Huws invited the Bulgarian singers, Bistritsa Babi, to sing by the water's edge on a Northumberland beach at high tide on a summer's evening. The 'work' was a coming together of their singing, Huws's choice of time and location, and the unpredictable contributions of the prevailing sea and weather conditions. Whiteread's *House* was a cast of the interior space of a house in east London. The last of a terrace to be demolished to make way for a park, the building's solitary presence stood as a brief monument, a focus for much strong feeling about London's homeless and a trigger for memories of other, long-forgotten dwelling places.

Despite, or perhaps because of, the impending financial strain of German unification and the likelihood that the seat of power at that time in nearby Bonn – would move to Berlin taking much money and cultural activity with it, the mood in Cologne in 1990 was determinedly bullish. Nine dealers in the city pooled their resources and their artists to mount a single group exhibition, 'The Köln Show', that spread throughout their respective venues. 'Nachschub', proclaimed the front cover of the catalogue: supplies, back-up, reinforcements. The military overtones were still there, despite thirty years during which art had undermined the idea of an avant-garde allied to historical progress. It was, nonetheless, an apt tag for those in the show and for some American artists closely associated with them in attitude and spirit: for the performances and videos of Andrea Fraser (b. 1965), in which she acted as a gallery guide, her talks humorously undermining the ostensible messages of the museum's displays; for the investigative analyses and installations of Fareed Armaly (b. 1957) and Mark Dion (b. 1961); the proposals of Peter Fend (b. 1950) for remodelling the earth for sound political, economic and ecological reasons; the laconic and witty wall drawings of Jessica Diamond (b. 1957); and the investigations of sexuality and prejudice by Zoë Leonard (b. 1961) and Larry Johnson (b. 1959). Armaly's Orphée 1990, at the Maison de la Culture, Saint Etienne that year, recreated the design and décor of the building at its opening in the 1960s as part of André Malraux's drive to provide access to culture for all. Dion's elaborate laboratory-cum-attic installation, Frankenstein in the Age of Biotechnology (1991), infused the prospect of genetic research with an excitement akin to the 'Boy's Own' adventuring of nineteenth-century exploration. These and many others of the sixty artists could be seen as working in ways established by Broodthaers, Haacke, Asher,

Smithson, Nauman and Mary Kelly. Diamond's Yes Bruce Nauman (1989) explicitly acknowledged the debt to that artist.

In his catalogue essay, Diedrich Diederichsen looked at the fears that the changes in global power relations had unleashed. 'The misery of being exploited', he said, quoting the musician and writer Mayo Thompson, 'is nothing when compared to the misery of not even being exploited any more.' In looking at the art being made in these new circumstances he suggested new criteria of judgment: 'Pornographic is the adjective that ought to replace the pejorative "decorative" in art criticism. It is a term for work that takes no responsibility for its origin. Trash, in contrast, takes all responsibility.'

Trash and an unimpeachable sense of failure were everywhere present in the performances, videos, objects and installations of Mike Kelley (1954–2012). 'Why I became a performance artist', says one piece showing photographs of naked young women. A series of banners made in 1987 in the colourful style of those designed by the former nun Mary Corita Kent, hold remorselessly nerdish messages: 'I am useless to the culture but God loves me', 'Pants shitter and proud. P. S. Jerk off too (and I wear glasses).' Kelley has often used home-made soft toys, playthings invested with inordinate amounts of love and care with their intended recipients in mind, which, in the dirt of their old age and abandonment, speak of unbearable dereliction and loss. His 'Arenas' and 'Dialogues' of the late 1980s and early 1990s, arrangements of toys scattered on and under knitted blankets. treat this issue of abandonment in formal terms derived from the critical, yet still positive, language of Minimal and post-Minimal sculpture. The 'slacker'-like dysfunctional anomie of Karen Kilimnik (b. 1962), Jack Pierson (b. 1960), Raymond Pettibon (b. 1957) and Sean Landers (b. 1962) ploughs a closely related furrow. Kilimnik's installations such as Mrs Peel ... We're Needed (1992) map the action fantasies of bedroom-bound, TV-addicted youth, while her faux-naïf texts Jane Creep, about an eponymous imaginary friend, hint that it will not take much to tip the mental balance over into psychosis: 'JANE'S BEST FRIEND IS MAKING A JANE DOLL + STICKING PINS IN IT.'

In Britain some of the most interesting art of the late 1980s and early 1990s was associated with London's Goldsmiths College. Julian Opie (b. 1958) and Lisa Milroy (b. 1959) had studied there earlier in the decade. Milroy, in the earlier part of her career, painted things to buy – shoes, shirts, coats and hats – singly or in neat rows. Larger canvases of plates, potsherds,

167. Mike Kelley, Dialogue #2 (Transparent White Glass) Transparent Black Glass), 1991. Kelley has said, 'I've always thought that mixing pop and formalism was a really important part of my work.... My work is really formal, but that formality is never talked about. People always glom right onto its abject nature, or blah blah blah blah blah blah blah.

tyres or lightbulbs relied on the abstract order of the grid to bring cohesion, a sense of a complete picture, to the collected elements. Some, such as Lightbulbs (1988), had the feel of a trade catalogue impassively offering a huge variety of goods to cater for all requirements, except that they were lovingly painted in oils. Opie's sheet metal sculptures from 1983 were painted to mock their own eminent saleability: a cheque-book and pen, five supermarket items, five old masters. Conversely, the next series were abstract forms given titles of socio-political import lifted from newspaper headlines. The work subsequently drew more obviously on Minimal form by parading an absence of function in its likeness to chill cabinets, ventilation ducts and office partitions that stressed the primacy of the visual in art. Milroy and Opie were exhibiting internationally within a very short space of time, and provided a model for those who followed.

While still a Goldsmiths student in 1988, Damien Hirst (b. 1965) obtained the use of a disused building from the Docklands Development Corporation, and, within its generous spaces, put on 'Freeze', an exhibition that included many of his fellow students. Collectively, they were in tune with the

entrepreneurial spirit of the times, and their enterprise in setting up the show and, perhaps more significantly, persuading several important dealers and curators to travel out to see it, paid off. The exhibition was quickly followed by others of a similar nature – such as 'Modern Medicine' in 1990, also co-curated by Damien Hirst – whose participants also supplied the clutch of new private galleries in London owned by non-British dealers. Among those who appeared via this route were Anya Gallaccio (b. 1963), Angela Bulloch (b. 1966), Simon Patterson (b. 1967) and Gary Hume (b. 1962). Gallaccio's installations involve perishable or mutable materials such as flowers, fruit, ice or chocolate arranged and then left over a period of days or weeks to decay and change as circumstances dictate. Stroke (1993) saw the Karsten Schubert Gallery painted with chocolate: 'chocolate box' art with faecal overtones. Visitors licked the walls for a little pleasure if they had the nerve. Bulloch's works in light, sound and other media are sometimes activated randomly, but are more often triggered by the presence of a viewer, as with the drawing machine, Blue Horizons (1990). Another series that collected together rules of conduct posted up in various places – topless bars, hotels and offices - emphasized the universality of the need for human acquiescence if society is to be run smoothly. Patterson finds in names, both famous and unknown, the means to examine value, historical perspective, educational priorities and personal characteristics. The Great Bear (1992) replaced the

168. **Simon Patterson**, The Great Bear, 1992

169. Damien Hirst, I Wanna Be Me, 1990–91

station names on the London Underground map with lists of footballers, comedians, philosophers, newscasters and others to make a quite different but no less readable map of contemporary cultural space. The dimensions of Hume's early gloss-painted abstract works and their placement of circular and rectangular areas of relief were derived from the porthole windows, finger- and kick-plates of hospital doors. He subsequently used figurative motifs which were important as much for formal as for narrative reasons. Hirst's medicine cabinets were fin de siècle wall sculptures reminiscent of Donald Judd, stuffed with the artificial means to achieve the goals announced in their titles: New York (1989), for example, or I Wanna Be Me (1990–91). His pickled specimens – fish, a sheep, a cow and calf, a shark entitled The Physical Impossibility of Death in the Mind of Someone Living (1991) – also dealt with the strength of human desire for and fear of love,

170. Andres Serrano, Piss Christ, 1987

beauty and death, and with our inadequacy in the face of them. Hirst bounces a ping-pong ball on a jet of air, like Koons's floating basketball, and calls it *I* want to spend the rest of my life everywhere, with everyone, one to one, always, forever, now (1991).

The American art world was preoccupied during the summer of 1989 with a debate over censorship. It concerned the work of two photographers, Robert Mapplethorpe (1946–89) and Andres Serrano (b. 1950). Over the preceding decade and a half, Mapplethorpe's figure studies, flowers, portraits and photoconstructions had explored male beauty, homosexual desire and sado-masochism. The tour of his retrospective, 'Robert Mapplethorpe: The Perfect Moment', came shortly after his

death from an AIDS-related illness and the publication of a book of his photographs that was denounced by, among others, Senator Jesse Helms. Serrano had made and was exhibiting a series of photographic studies involving various bodily fluids. One of these, a rich, golden-hued image of Christ on the cross, had been made by photographing a small plastic crucifix in a glass of urine. As the critic David Levi Strauss suggested it was probably less the image - which 'is really quite beautiful' - that upset people than the combination of words in its title, Piss Christ (1987). Both Mapplethorpe's retrospective and Serrano's series had been financed with assistance from public funds, a fact which was loudly deplored by morally outraged members of the Senate and the public. The debate encompassed issues of racism and sexism, as well as blasphemy and homophobia. The immediate result was that the House of Representatives reduced the National Endowment for the Arts's budget by the amount previously disbursed to the two projects, and Washington's Corcoran Gallery, scheduled as the third venue for Mapplethorpe's show, pulled out. Taking a leaf out of Krzysztof Wodiczko's book, Mapplethorpe's supporters staged a demonstration during which they projected slides of his work onto the gallery's façade, forcing it to 'house' the exhibition in spite of itself.

171. Robert Mapplethorpe, Thomas, 1986, 1986

Over the same summer, that of 1989, the Centre Georges Pompidou in Paris held the exhibition 'Magiciens de la Terre'. Containing work from all over the world, it aimed to show something of the heterogeneity of art, but also to answer charges of Eurocentrism by bringing together 'primitive' art and Western new art. New York's Museum of Modern Art had housed 'Primitivism in Twentieth-Century Art' back in 1984. an enterprise that aroused much criticism for its assumptions that art was a Western phenomenon feeding off the exotic and primitive it found elsewhere. The rationale for the MOMA exhibition maintained the notion of primitivism as the otherness to be found exclusively outside Western culture. It was as if the debates on racism, feminism and politics of the 1970s had never taken place, and as if the maturing of these discussions and their extension into other areas of social marginalization – notably those of sexual and gender identity brought to the fore in part by the onset of the AIDS crisis - were not, even then, having their effects. In spreading its curatorial net around the globe 'Magiciens de la Terre' tried to present otherness as the stuff of a more equitable ideological exchange between cultures. Fifty Western and fifty non-Western artists were exhibited, the catalogue entry for each including a map showing their home as the centre of the world. The American critic Thomas McEvilley

172. **Cheri Samba**, Les Capotes utilisées, 1990

173. **Rasheed Araeen**, A Long Walk in the Wilderness, 1991

considered 'PC', the acronymic sign of late-1980s good behaviour, to stand for post-colonialism rather than political correctness. He wrote critically of 'Primitivism' in 1984, and much more supportively of 'Magiciens': 'All the criticism of the show that I have seen fails to confront the monumental fact that this was the first major exhibition consciously to attempt to discover a postcolonialist way to exhibit first- and third-world objects together. It was a major event in the social history of art, not in its aesthetic history.' How far the placing of objects together would lead to a rapprochement remained to be seen. The paintings of Zairean Cheri Samba (b. 1956) defined the size of the problem, their ironic texts remarking on Zaire's continuing economic dependency on France: 'Paris is clean thanks to us immigrants who don't like looking at piss and dog shit.' Le Sida (AIDS) (1989) suggested that while the threat from AIDS might be a global one we can neither afford to ignore the cultural traditions of the various places in which it occurs, nor pretend that the release of resources to combat it is triggered by humanitarian feeling and not political expediency.

In Britain, Rasheed Araeen (b. 1935) had long been similarly critical of the acquisitiveness and suppression of difference that underlay intercultural discourse. A work from the early 1980s, I Love It, It Loves I (1978–83), photographically documented the slaughter of a goat for the Muslim festival of Eid. Both

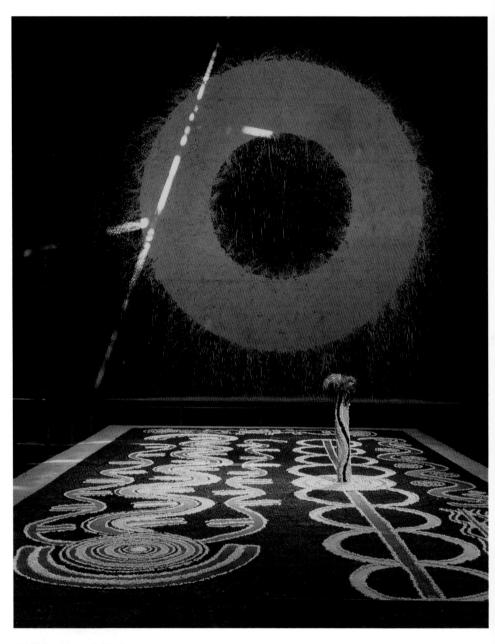

174. **Richard Long**, *Red Earth Circle*, 1989, with, below, ground painting by Yuendumu community, Australia

subject matter and title pointed towards Beuys's *Coyote* and, by extension, the well-intentioned inclusiveness of Beuys's rhetoric expressed in his 'shamanistic' relationship to animals. They – a coyote here, a hare there – were able to comprehend the truths of art because of their proximity to the earth. Araeen's fields of old shoes and trainers [173], in the manner of Richard Long's lines of stones, driftwood, or other materials, questioned the validity of visiting 'other places' (other people's homes) merely in order to walk on them in the name of art. The shoes, too, had in all probability been made thanks to exploited third world labour.

As if in illustration of this tension, on the wall of the second site of 'Magiciens' at La Villette, a large circular drawing executed in red mud by Richard Long is juxtaposed with a floor-painting in pigment on similar-coloured earth by the Yuendumu community of Alice Springs. Aboriginal paintings by artists including Michael Jagamarra Nelson (b. 1949) and Clifford Possum Tjapaltjarri (1932–2002) from Papunya had become familiar during the 1980s because designs traditionally executed in sand were worked on canvas, often in acrylic paints, for exhibition and sale within the gallery system. In Australia, at least, this work was not an ethnographical curiosity but, as in the fish, rippling water and protruding sandbanks of Tjapaltjarri's Fish Dreaming (1986), or

175. Michael Jagamarra Nelson, Five Dreamings, 1984

the peopled landscape of lagamarra's Possum Dreaming (1985). remained a distinct and distinctive means of conceptualizing and representing the world in visual terms. The landscapes of Tim Johnson (b. 1947) showed its influence, particularly in his Antipodean Manifesto (1986), and its imagery made frequent appearances, along with appropriations from Kiefer and others. in the paintings of Imants Tillers. While he was happy that more people could now see his designs, lagamarra was convinced that their creation only remained possible because he and others who still lived outside the cities had not lost their culture: 'not like those people living in Sydney. They've lost all their culture, they just follow the European way,' he would say. Those in the cities, such as the painters Robert Campbell Inr (b. 1944) and Gordon Bennett (b. 1955), and the photographer Brenda Croft (b. 1964), may well have adopted modes of image-making more generally familiar in the art world, but they used them in a trenchant critique of the colonialist appropriation of their continent.

Adrian Piper and David Hammons (b. 1943), who had been dealing with black nationalism since the early 1960s, continued at the same time to provide dextrous manipulation of Minimal and Conceptual strategies with a keen polemical edge. Both showed work in New York at the Museum of Modern Art's 1991 Installation exhibition 'Dislocations'. The white, Minimal terracing around the walls in Piper's What It's Like, What It Is #3 (1991–92) turned the room into an arena, in the centre of which was a tall

176. **Adrian Piper**, What It's Like, What It Is #3, 1991–92

177. David Hammons, Yo-yo,

column supporting a four-square arrangement of video monitors. On these a black man, periodically turning through ninety degrees, insistently informed the spectator what he was not, stripping away one stereotype after another. Hammons's Public Enemy (1991) showed photographs of an equestrian statue of Theodore Roosevelt flanked by walking Native Americans. These were defended by a ring of sandbagged gun emplacements, the whole being heaped with piles of dead leaves and old party streamers as a warning to those looking forward to celebrating the anniversary of Columbus's landing the following year. Hammons was also a participant in the concurrently running Carnegie International in Pittsburgh which that year was also devoted to installation. The separate walls of Yo-yo (1991) had on them a delicately painted stencil pattern redolent of yuppy domestic interior décor, and the random marks made by a thrown ball. In the centre of the room a basketball, gripped by the arms of a paint-mixing machine, vibrated to the music of James Brown. Others who showed in Pittsburgh included Juan Muñoz, Louise Bourgeois, whose cell-like rooms made of movable screens carried forward her obsession with lairs, the French artist Sophie Calle (b. 1953) and the Russian Ilya Kabakov (b. 1933). Calle had previously gained notoriety for work which purported to involve exploitation of an innocent public. The photo-text work Suite Vénitienne (1983) narrates

178, 179. Exterior and interior views of Ilya Kabakov's *The Toilet*, 1992

180. **Sophie Calle**, Last Seen: A Lady and Gentleman in Black by Rembrandt, 1991

how she stalks a chance acquaintance whom she has overheard planning a trip to Venice. But this, like all her work, is a product of memory and imagination, concerned with desire and loss. Last Seen: A Lady and Gentleman in Black by Rembrandt (1991) was an attempt to retrieve through photographs and personal accounts the thirteen works of art, some by Vermeer and Rembrandt, which were stolen without trace from Boston's Isabella Stewart Gardner Museum in 1990. The critic David Deitcher's comment on the exhibition as a whole can be considered to be appropriate to Calle's work. 'Installation art,' he wrote, 'whether site-specific or not, has emerged as a flexible idiom; so flexible in fact that it can function all at once as a means of deconstructing the museum and of reconstructing it.' Unlike Vitali Komar (b. 1943) and Alexander Melamid (b. 1945), who left the Soviet Union for the US in the 1970s, following the bulldozing of an unofficial, open-air exhibition of their work, Kabakov had stayed in Russia, working largely in secret until the collapse of communism. His installation at the Carnegie was the recreation of an old school complete with proudly displayed work by the pupils and meticulously kept records of attendance and achievement. The school now, though, was empty following instructions that staff and pupils were to be moved to another, as yet unspecified, location. With this and other installations, such as the peasant home masquerading as a urinal he built behind Kassel's main museum for 1992's

Documenta IX, Kabakov questions the wisdom of simply jettisoning seventy years of endeavour and expertise in obeisance to the West's superior economic wisdom.

Some of the art which made the biggest impact at Documenta IX was the video work of Matthew Barney (b. 1967), Tony Oursler (b. 1957), Bill Viola (b. 1951), Gary Hill (b. 1951) and Stan Douglas (b. 1960). Visitors to a small storage space, deep in an underground car park, found OTTOshaft (1992): a large rubber mat, several prosthetic objects and other props together with two ceiling-mounted video monitors. The tape, which had been shot in the car park, featured Barney and others using the assembled props. Barney could also be seen on the tape climbing naked up the lift shaft with the aid of mountaineering tackle. Oursler's multi-part The Watching (1992) spanned the Museum Fridericianum's stairwell from top to bottom. Shapeless bundles of material and clothes with stuffed cloth heads make up Oursler's dummies and effigies. The blank heads act as screens onto which videoed faces are projected, making them come to life as disturbing versions of the internal voices and media presences with whom we continually converse in our own heads. Viola showed The Arc of Ascent (1992), a huge, slow-motion projection

181. **Tony Oursler**, Sexplotter (from The Watching), 1992 (detail)

182. **Stan Douglas**, Hors-champs, 1992

of a man in loose clothing jumping into and floating around in a pool before, tape reversed, gathering all the air bubbles to himself and shooting off screen into darkness and silence. Our understanding of the body is a fundamental factor in Viola's art. It is 'the neglected key of our contemporary lives', and its trajectory from cradle to grave is pictured in his Nantes Triptych (1992) [183] in which a similar floating figure is flanked on the left by film of Viola's wife giving birth to their son, and on the right by his mother, nearing death, lying on a hospital bed. Hill's Tall Ships (1992) [184] is a broad, blacked-out corridor from the ceiling of which a line of video projectors cast silent black-andwhite images obliquely down onto the walls. The films were of people approaching, looking with varying degrees of fascination at something – an object, scene or person, perhaps – and retreating from it, the whole being at once the provocation for, an echo of, and a response to the viewer's behaviour. Hill described the work as bringing, in both a literal and figurative sense, 'slow illumination': 'As the figures come forth they provide the light in the space. Silhouettes of other viewers begin to appear.... It's very subtle, but the viewers begin to mix with the projections.' For

183. **Bill Viola**, Nantes Triptych, 1992

184. Gary Hill, Tall Ships, 1992

the filming of *Hors-champs* (1992) [182], Douglas recreated a 1960s French TV studio setting for a free jazz improvisation featuring four black American musicians who had been based in Paris during that period. By editing between shots from two cameras, a 'broadcast' and an 'out-take' version of the session were obtained and projected onto either side of a screen suspended diagonally across the gallery. Neither version gave a full picture, and only one could be seen at a time.

The aesthetic and political resonance of the freedom exercised by black jazz musicians in their improvisations was also referred to by Lorna Simpson (b. 1960) in her installation for the 1993 Whitney Museum of American Art Biennial in New York. A wall of lips formed part of *Hypothetical*, a reflection on the implications and aftermath of the case in which police officers were prosecuted for beating up Rodney King. The *Village Voice* critic Greg Tate said of it: '*Hypothetical* invokes cuts like the [Miles] Davis Quintet's version of Herbie Hancock's "Riot" on 1967's *Nefertiti*. America's on fire and Miles and the crew are in

185. **Sue Williams**, The Yellow Painting, 1992

some posh studio hideaway saying, Let's meditate on this in a succinct manner shall we?' Visitors to the 1993 Whitney Biennial were presented with a work by Daniel J. Martinez (b. 1957), a lapel badge bearing the slogan 'i can't imagine ever wanting to be white'. It introduced an exhibition which consciously set out to emphasize, in the words of the curator Elizabeth Sussman, works that 'confront such dominant current issues as class, race, gender, sexuality and the family'. A quarter of a century after the agitational activities and protests of the Art Workers' Coalition, this would still lead the New York Times to conclude that such a show 'neglects painting', a verdict, as the critic Laura Cottingham suggested, that is equivalent to a charge of the absence of beauty and pleasure. The work of Sue Williams (b. 1954), one of the selected painters, suggested otherwise. Domestic and sexual drudgery, rape and physical violence against women are Williams's subject matter. Her images and words are treated in a raw illustrational and graphic style that owes a debt both to the crude directness of lavatory wall graffiti and the gestural discursiveness of Jackson Pollock. 'It's a new age and it's hot', paints Williams across The Yellow Painting (1992) [185]. 'One thing I've gotten with age, is free to choose.' And, over to one side, she has written: 'This is (art) not social commentary.'

Robert Gober's Door with light bulb installation (1992) containing his self-penned stories highlighting oppression and discrimination was also included at the 1993 Whitney Biennial and resurfaced as part of the 'Rites of Passage' exhibition at the Tate Gallery in 1995. The show's centrepiece was Beuys's Terremoto in Palazzo (Earthquake in the Palace) [188], the recreation of a 1981 installation that included a sawing horse precariously balanced on four glass jars. Broken glass covered the floor replicating the original occasion on which the jars Beuys was using to make the work fell and shattered. The exhibition's theme was the provisional and fragile nature of the body: photographic selfportraits of his ageing, naked body by John Coplans (b. 1920); Susan Hiller's An Entertainment (1990), which explored the brutally aggressive gender lessons taught by the children's Punch and Judy show; a Newton's cradle using glass ampoules filled with chlorine instead of the usual metal spheres by Hamad Butt (1962-94) and hugely extended, open-bottomed bird cages by Pepe Espaliú (1955-93), who, like Butt, had recently died from AIDS. Corps Etranger (1994) by Mona Hatoum (b. 1952) in which the video of an endoscopic journey through Hatoum's body is projected on the floor of a circular cubicle makes the viewer feel

186. Pepe Espaliú, The Nest, 1993

187. **Mona Hatoum**, Light Sentence, 1992

188. **Joseph Beuys**, Terremoto in Palazzo (Earthquake in the Palace), 1981

at once spectacularly intimate and at the same time distanced by the camera's dispassionate eye. A similarly disturbing effect had earlier been created by the changing size of the shadows in her Light Sentence (1992) [187]. The 'Passage' of the show's title is here between the solidity and certainty of the object and its dissolution into the flux of process. Art struggles to hold its place on the indeterminate ground that separates the two extremes.

What then of Williams's 'new age' and her status as someone 'free to choose'? At the 1993 'Aperto', the international exhibition for younger artists at the Venice Biennale, Rirkrit Tiravanija (b. 1961) installed tables and chairs and, with water boiled by two large gas burners, provided visitors with pots of instant noodles to eat. The title of the piece, Untitled (Twelve Seventy One), referred to the year Marco Polo set off from Venice to visit China, the ultimate source of the food. Tiravanija set up a bar the following year in the window of the SoHo gallery Metro Pictures. It dispensed free water rather than expensive coffee to those who wished to sit and watch the world go by. Noting a distinction between these gestures and the social utopianism of Matta-Clark's 'Food' restaurant, the critic Dan Cameron described them as: 'More ephemeral, less contained by the intricate relationships found in community infrastructures.... Their particular nature as events arises from the placement of the spectator at the centre of the piece, allowing each one to determine the duration and nature of their interaction with the work at hand.' Viewers also find that they are unable to duck their responsibilities when confronting the work of Felix Gonzalez-Torres (1957-96). Gonzalez-Torres,

189. Felix Gonzalez-Torres, 'Untitled' (Lover Boy), 1990

who died of AIDS in 1996, spread sweets in a square on the floor, or heaped them like a Minimalist corner piece in the angle of a room, and invited visitors to take one and eat it. His stacks of paper, equally Minimal in their formal derivation, induce more tension. 'Untitled' (Lover Boy) (1990) is blue paper – blue for a boy, blue skies, heavenly blue – art still deals with beauty and longing and transcendence. You are allowed, if you wish, to take a sheet from the top of the pile, to consume not only the body of art, but also the body of the artist. The overtones are religious, sacramental, since the stack, constantly replenished, will not be exhausted. But what could you do with that piece of paper once you got it home to keep it as open and full of possibility as it was in the stack?

190. Matthew Barney, CREMASTER 5: her Giant, 1997

Chapter 6: Globalization and the Post-Medium Condition

The previous chapter draws an overview of artistic practice from a number of large-scale exhibitions. This approach is indicative of a trend - in some respects, deriving one's ideas about what is going on in the world of art from such events is an increasingly common practice among curators, dealers and critics. In the early nineties, the word Biennale was associated with only a small number of places: Venice, which celebrated its centenary in 1997, São Paulo, which had begun in 1951, Sydney, and the rather different domestic show at the Whitney Museum of American Art in New York. By the end of the century, the assiduous art traveller could spend much of the time flitting not only between these established venues, but also between Johannesburg, Kwangju, Istanbul, Delhi, Melbourne, Havana and Berlin, in addition to the homes of other new and long-standing shows such as Documenta, the Carnegie International, Manifesta, and so on. What we see in this growth in the exhibition calendar is that the changes within art that had attempted to take account of a multiplicity of viewpoints, of cultural contexts and priorities, of the potential within a variety of forms and materials, are part of a more comprehensive globalization of art. Not just in the works, then, but in the network of galleries and auctions, in the critical discourse as it appears in numerous journals, and in the geographical dispersal of art events, one sees evidence of this spread. Whether it can be seen as a true globalization, which is to say an expansion to accommodate different, often conflicting, attitudes to art, its market and the manner in which it functions socially, or whether it is more properly identifiable as an expansion of a Western model of art into new market areas, is debatable. As a way of posing this question, Rirkrit Tiravanija inaugurated a Thai pavilion at the 1999 Venice Biennale [191] by planting a specimen of a native Thai tree rather than building an art space similar to those belonging to all the other participating countries

In the course of reviewing a whole rash of exhibitions celebrating 'multiculturalism' that took place across Europe in 2000, an outbreak symptomatic of a more widespread

191. **Rirkrit Tiravanija**, *dAPERTutto*, 1999. Installation at the Venice Biennale.

phenomenon, curator Richard Hylton noted that in 'Abstraction and Tradition' at the Musée d'Art Moderne et d'Art Contemporain, Liège, 'whereas Yang Jiechang's label read "Foshan, China 1956/ Paris, Heidelberg" that for Gauguin (who spent many years living in the French colony of Tahiti) read simply "Paris 1843-1903".' It still seems that in its desire to address issues of otherness, the foreign and the exotic, as evident in the response to 'Primitivism in Twentieth-Century Art' at MOMA New York in the early 1980s, 'Magiciens de la Terre', held at the Centre Georges Pompidou in Paris at the end of that decade, and everywhere since, the art world has yet to recognize that this requires an examination of attitudes to Europeans as much as to non-Europeans. It is undoubtedly true that visitors to those many large-scale international exhibitions are, alongside US and European art, just as likely to see work by Zhang Huan, Zhao Bandi and others from China, Lee Bul and Kim Sooja from Korea, Doris Salcedo from Columbia, William Kentridge from South Africa, Ghada Amer from Egypt, Shirin Neshat from Iran, and so on. It remains equally true, however, that many artists continue to move within the US-European ambit. Both Amer and Neshat, for example, now live in New York.

The exhibitions mentioned in the last chapter were organized according to disparate agendas, curated with differing intent.

Taken all in all, however, they demonstrate the extent to which the lines of aesthetic enquiry pursued during the preceding quarter of a century, far from trailing off or petering out,

192. Kim Sooja, Cities on the Move - 2727 Kilometers Botari Truck, 1997. Of the cloth used to make her botari, or bundles, Kim Sooja says, 'One day while sewing a bedcover with my mother, I had a surprising experience in which my thought, sensibility and action at that moment all seemed to converge. And I discovered new possibilities for conveying buried memories and pain, as well as life's quiet passions. I was fascinated by the fundamental orthogonal structure of the fabric, the needle and thread moving through the plane surface, the emotive and evocative power of colourful traditional fabric."

became the essential vectors of art at the turn of the twenty-first century. Two events in 1996 demonstrate this well. The first was 'L'Informe: mode d'emploi', a historical survey exhibition conceived by Rosalind Krauss and French art historian Yve-Alain Bois for the Centre Georges Pompidou in Paris. Taking as its starting point an idea from the writings of Georges Bataille, the exhibition offered a view of the changes in twentieth-century art that contrasted significantly with the traditional account of modernist development. The four main organizational categories within the show - Base Materialism, Pulse, Horizontality and Entropy - would be unthinkable without the practical and theoretical shifts of the previous three decades. The second event, mounted at the Louisiana Arts Centre in Denmark and overseen by its then director, Lars Nittve, was 'NowHere', which consisted of several independent shows, running concurrently, each assembled by one of an international group of young curators. In his catalogue introduction, Nowhere but NowHere, Nittve states: 'I was frightened, but also tempted. How to organise an exhibition that would acknowledge the changes of the last few decades, that would recognise an absence of structure, and that would work with small stories, with local language games and contexts?... Might it be possible to make an exhibition a playground in which the difference – political, aesthetic, you

193. **Vanessa Beecroft**, *VB43*, 2000. Performance at the Gagosian Gallery, London.

name it – among the positions of contemporary artists and curators would be brought to the fore?'

Bataille's 'informe', an untranslatable word whose meaning lies somewhere between formless and formlessness, was described by Bois as an anti-concept: 'Were you to define it as a concept it would be the concept of undermining concepts, of depriving them of their boundaries, their capacity to articulate the world.' There is something essentially postmodern in an idea such as this, which can be traced back to the Nietzschean wish to re-evaluate all values. Likewise, Nittve's talk of small stories and local language games taking over from the overarching, all-inclusive narratives and theories associated with modernist progress reiterates the arguments of French philosopher Jean-François Lyotard in his writings on the postmodern condition. If there is anything like a maturing of the postmodernist sensibility at work here, or a shift in awareness of what the implications of experiencing the postmodern condition might be, it is evident in the wish to avoid merely substituting one account of art for another. This was even, or especially, the case with respect to the term abjection, which was being increasingly used in referring to work by those artists such as Mike Kelley, Tony Oursler, John Miller (b. 1954) or Paul McCarthy (b. 1945) that concerned the impossibility of successful communicative or expressive action. Work dealing

with the pathologies of the fractured psyche attempting to come to terms with an equally incoherent world, however interesting and relevant this condition may be, was not to be thought of as the new norm, but as one of the many themes being explored within art practice as a whole. In his performances, tableaux, videos and installations, on his own and in collaboration with others including Kelley and Jason Rhoades (b. 1965), McCarthy had, since the late 1960s, been combining actions, objects, toys, dolls, masks, sausages and plenty of tomato ketchup in a manner that brought the rude, the popular, the banal, the trashy, the stupid, the pornographic and the scatological into humorous juxtaposition within an artistically knowing context. Even in the early performance *Plaster Your Head and One Arm into a*

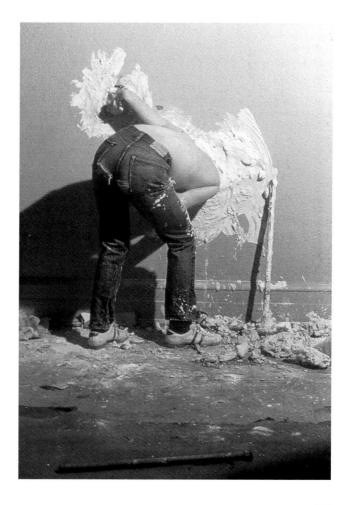

194. Paul McCarthy, Plaster Your Head and One Arm into a Wall, from 'Instructions', a performance in Pasadena, California, 1973.

Wall (1973), the farcical reference to process work in general, and Bruce Nauman's body cast, From Hand to Mouth (1967), in particular, seems deliberately perverse in the light of post-Minimalism's general honesty and truth to materials. 'To minimise referentiality,' writes German critic Tom Holert, 'to ultimately dispel it from art-critical reading, proves so difficult in McCarthy's case that "failure" is certain from the beginning.'

The lesson that there are, indeed, many incommensurable stories within art is reinforced by the critical significance not only of McCarthy's work, but also of other practices as disparate, for example, as South African William Kentridge's (b. 1955) animated charcoal drawings, Swiss artist Dieter Roth's (1930–98) daily struggle to wrestle some sort of small order out of the chaos of the world's materials, the visually dense, symbolically ambiguous *Cremaster* films of Matthew Barney [190], the German Gregor Schneider's (b. 1969) continual remodelling of the Mönchengladbach house in which he lives, Italian Vanessa Beecroft's (b. 1969) live tableaux [193] involving rows of nearnaked models, or the poeticized observations of nomadic artists such as Mexican Gabriel Orozco (b. 1962) or the Mexicodomiciled Belgian Francis Alÿs (b. 1959).

One thing that is clear is that there now exists a greater freedom with respect to the materials, media and techniques used by artists. While the range of such things had not necessarily expanded – with the possible exception of a growing interest in computer and web-based work – the implications of a choice

195. Dieter Roth, Solo Scenes (Solo Szenen), 1997–98. These 128 videos show Roth in his studio apartment sorting, ordering, tidying, mending – in short, living and working: 'I would call myself an inventor of machines', he said, 'that are meant to entertain (or inspire) feelings (or thoughts) that help to digest this Central European civilisation wading in junk.'

196. **Gregor Schneider**, Haus u r, Rheydt, 1985–2001

197. **Francis Alÿs**, *Zocalo*, 20 May 1999. Single-screen DVD projection with soundtrack.

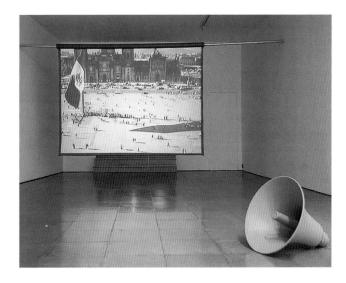

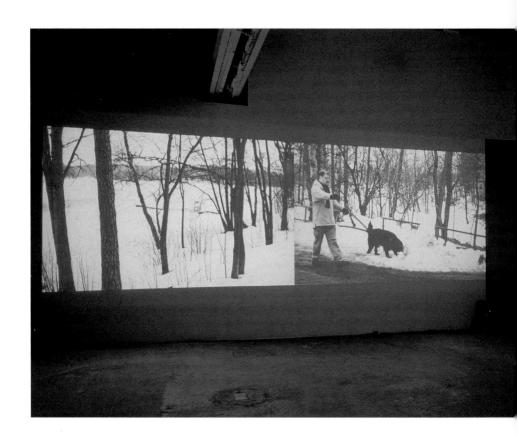

198. Eija-Liisa Ahtila, Consolation Service, 1999. Installation at Klemens Gasser & Tanja Grunert, Inc., New York. 'The chosen form of the installation - the separation of the story into two adjacent images - evolved out of the theme: a torn relationship, two people, an end, a beginning.... Because of its experimental, non-realistic style of narrative and the deliberate disruption of narrative continuity, the experience conveyed to the viewer is ultimately more realistic and powerful.'

from within that range had. Previously, the decision to use video or photography spoke implicitly, however unintentionally, of a position being taken vis-à-vis established forms such as painting and sculpture. Similarly, the decision to paint was a decision to continue doing something that had a history in the knowledge that whatever one did would be seen in ironic relation to that history. The problematic nature of representation within traditional media has become less of an issue in recent years, and we are now in what Krauss has identified as a 'post-medium condition'. It is a condition in which the presence of so much photographic and video work in today's art has more to do with the ubiquity of those media in the culture generally, and with the ways in which we read the imagery around us than with anything else.

The point is made by the critic Maria Lind when she says of fellow Swede Annika von Hausswolff's (b. 1967) photographs that 'they are our visual culture in all its glory. It is a culture in which

the image is central, in which the picture gives us experiences and conditions the eye.' Wolfgang Tillmans (b. 1968) moves easily in such a culture between fashion shoots, magazine features and fine-art photography. If any distinction exists between these areas, it lies less in the images themselves, than in the choice of where and how they are to be published or displayed. Uta Barth's (b. 1956) photographs contain little in the way of what would conventionally be described as subject matter, but as we are all now able to grasp the significance of technical qualities and to recognize that how an image is constructed matters a great deal, they are far from empty. Choices of framing, depth of field or location, together with the information they do offer as to time of day, season, quality of light and so on, make it clear that what we are seeing is something like the act of seeing itself. The longexposure night-time shots of Rut Blees Luxemburg (b. 1967), who, like Tillmans, is a German artist based in the UK, create silent cityscapes that, although empty of people, seem loaded with narrative possibility. Norwegian Knut Åsdam's (b. 1968) night time is altogether more disturbing, making reference as it does to the French Surrealist writer Roger Caillois's idea that darkness permeates us, rendering our sense of self radically unstable. The psychological and physical struggles of adolescence, as it senses impending adulthood, are visible in the stark portraits of Dutch photographer Rineke Dijkstra (b. 1959) and the psychologically charged scenes of British artist Sarah Jones (b. 1959).

Complex multi-screen installations by many artists, including Doug Aitken (US), Eija-Liisa Ahtila (Finland), Ann-Sofi Sidén (Sweden), Marejke van Warmerdam (Holland), Pierre Huyghe (France), Candice Breitz (South Africa), Shirin Neshat and Pipilotti Rist (Switzerland) also attest to the liberation of the medium from any need to play a part in what is now an entirely outdated dialogue between high and low, avant-garde and kitsch, or art and the everyday. Rist's [199] playful takes on power and gender relationships are quite detached from the theoretical discourse that underpinned earlier feminist work. Ahtila's mix of drama, reality and internal narrative require the viewer to construct his or her own version of what they are witnessing, and to question where, if anywhere, the borders between the normal and the pathological, and between dream, fantasy and the real exist. In Sidén's videos [201], the camera as recording device is recognizable sometimes as the coldly distant observation of a surveillance mechanism, at other times as the embodied eye of the emotionally and physically engaged onlooker, but in neither

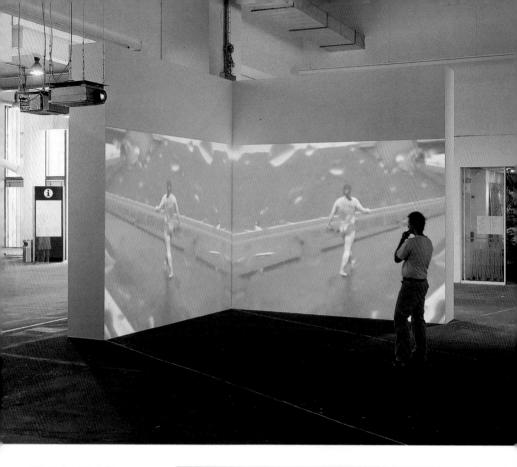

199. **Pipilotti Rist**, *Cinquante Fifty*, 2000. Video installation, Art
Unlimited, Basel, 2001.

200. **Doug Aitken**, Electric Earth, 1999

201. **Ann-Sofi Sidén**, still from *QM, I Think I Call Her QM*, 1997. Sidén's 'Queen of Mud' is a character that she originally developed in performances. Naked and caked in mud, she appeared in various anomalous public locations, such as at the perfume counter of a department store.

instance is any moral judgment attached to the way of seeing. Aitken's [200] editing of both visuals and sound together with his screening techniques relate closely to the experiences to which they refer – hip-hop dancing or Bollywood films, for example - and with which the viewer will be familiar from elsewhere. Neshat, an Iranian who has lived in the US for some years, has used the camera to speak of social and religious circumstances that limit the possibilities of expression in her native country. Turbulent (1998) [202, 203] projects a man and a woman onto opposite walls of a gallery. The man sings a well-known traditional Iranian song in front of an all-male audience, while the woman, veiled, remains silent. When the song is over, she, in turn, sings, only this time to an empty auditorium as she is not allowed to perform in public. Her only audience is us in the gallery and the males on the opposite screen, forced through the work itself to watch and hear.

202, 203. **Shirin Neshat**, *Turbulent*, 1998. Video still.

Painting, too, has moved beyond its critical dependence on the strong belief that a Greenbergian modernist orthodoxy needed to be challenged. Reviewing Homemade Aesthetics, a collection of Greenberg's writings published in 1999, Belgian art historian Thierry de Duve began: 'At long last, Clement Greenberg has become readable again.... Most artists and critics who came of age in the '80s were fed a caricature of Greenberg - a foil, more precisely, against which the then-dominant antiaesthetic discourse stood for the truth.' Within this changed atmosphere, the figurative exaggerations of Americans John Currin (b. 1962) and Lisa Yuskavage (b. 1962) exist comfortably with the Greek Miltos Manetas's (b. 1964) paintings of his games consoles, Thai artist Udomsak Krisanamis's (b. 1966) collaged surfaces referring to his struggle to come to terms with US culture and language, US Elizabeth Peyton's (b. 1965) pretty but contaminated landscapes, Neo Rauch's (b. 1960) examination of the aesthetic and political legacy of his native German Democratic Republic, and US Sarah Morris's (b. 1967) portraits of buildings and people, each rectangle of their gridded images looking like an overblown pixel. In the case of Belgian Luc Tuymans (b. 1958), experience gained during a short spell as a film maker in the

1980s has influenced the way in which he crops and reframes the photographic images used as the sources for his paintings. The generally muted colours of Tuymans's [204] canvases give an initial feeling of quiet pleasure that is soon undercut by the more disturbing nature of the imagery and its implications — a diseased body, a gas chamber, or a bed used in a pornographic shoot, for example.

The surface of a painting by US artist Laura Owens (b. 1970) [205] can happily be acknowledged to contain a mix of representational and abstract elements. Neither mode needs to be seen as critically dependent on the other for its authentication. The painting as a whole can, furthermore, be understood as a discrete object, in relation to another canvas on which a detail of its surface appears, and as a participant within a gallery installation. This is far away from, say, the abstraction in Jonathan Lasker's or Peter Halley's paintings being recognizable as representing the idea of abstraction rather than being the real thing. 'I think', says Owens, 'that a lot of artists use a painting to point out a reference – a quote, an anecdote, or an idea – and that reference becomes more interesting than the work. I'd much rather have a reference generate a painting.' In the wake of this alteration of attitude,

204. **Luc Tuymans**, *Maypole*, 2000. The photograph from which this painting is derived, depicting a group dressed in traditional South German costume erecting a maypole, was printed in a Nazi propaganda magazine published in Belgium during the Second World War.

paintings as disparate as the abstractions of Californians Monique Prieto (b. 1962) and Ingrid Calame (b. 1965), and Gary Hume's figurations drawn from fine art and popular media have had the description 'colour field' applied to them without embarrassment, self-consciousness or irony. Furthermore, it has been possible for an older artist such as Bridget Riley, the look of whose 1960s Op art paintings had been appropriated by Philip Taaffe and Ross Bleckner in the 1980s, to find audiences no longer encumbered by the need to approach her work through those later pastiches.

In addition to the proliferation of major temporary exhibitions, the 1990s also saw a continuing expansion in the number of museums devoted to contemporary art. The year after 'NowHere', Lars Nittve was appointed as director of the new Tate Modern in London. Housed in a former power station, the museum opened in the spring of 2000 to become the latest addition to a string of such enterprises. Most famously, the

Guggenheim's plan of opening satellite spaces in other cities – it had already set up a second New York space in SoHo some years before – resulted in the building of the Bilbao Guggenheim in Spain (1997). The startlingly innovative design of this museum by Frank Gehry prompted several critics to suggest that it would necessitate a concomitant change in art making. In an enthusiastic response to Gehry's building, Peter Schjeldahl spoke of the way in which it does not just catch up with the aesthetic attitudes apparent in recent art movements, but rushes on ahead: 'The building's romance will exacerbate boredom with that old stuff and help to bring about marvellous new stuff soon.' Besides Bilbao there were other projects, such as Richard Meier's Museum of Contemporary Art (MACBA) in Barcelona (1995), and Steven Holl's Kiasma in Helsinki (1998). As with Gehry's Bilbao

205. **Laura Owens**, installation at Sadie Coles HQ, London, November 1999

206. **Tadashi Kawamata**, *Bridge Walkway*, 1996. Installation at MACBA, Barcelona

Guggenheim, Meier's MACBA was not a stand alone project, but formed part of much more ambitious plans to improve the city's infrastructure, leisure facilities and attractiveness to tourists. Set in a newly cleared plaza, the building prompted artists in one early exhibition to make works that attempted to maintain some continuity between the new museum and the tenement blocks that had formerly occupied the site. Japanese artist Tadashi Kawamata (b. 1953), for example, constructed a walkway that extended out from a first floor window of the museum almost as far as the balcony of the adjacent apartment block. The new could not be reconnected in any simple physical way, but what could be allowed was the imaginative grasping of historical embeddedness.

This piece by Kawamata, like his other work, renders many boundaries indistinct. While it is certainly a work of art, to assert that it is such a thing does not in any way prevent it from being other things as well. That it is art, for example, does not condemn it to being merely a representation of a walkway. It

207. **Jorge Pardo**, 4166 Seaview Lane, 1998

208. Martin Creed, Work No. 225: Everything Is Going To Be Alright, January 2000. Times Square, 42nd Street and 8th Avenue, New York.

209. **Tobias Rehberger**, *nana*, 2000. In works such as this, in which well-known, classic designs are sketched from memory and remade, Rehberger states that his chief interest is in the idea of translation: 'My pieces are about seeing things in new ways – a bit like Jorge Pardo's works. He shows a sailboat in a museum, I present a vegetable garden as art.'

210. **Liam Gillick**, Prototype design for the conference room, with joke by Matthew Modine. Arranged by Marcus Weisbeck, 1999.

really is a walkway and functions adequately as such. Refusal to think in either/or terms – either art or design, either art or craft, either art or architecture, etc. - is a trait visible in the work of many artists of widely differing ages. German Tobias Rehberger (b. 1966) designs and plants a vegetable garden, or commissions African craftsmen to make classics of modernist furniture from his quick sketches. Dan Peterman (b. 1960) uses reconstituted plastic blocks to make an installation, the dimensions of which relate to the amount of packaging consumed annually by the average household. Fellow American Jim Isermann's (b. 1955) meditations on art, architecture, interior design and craft result in paintings, rugs, wall decorations, stained-glass panels and furniture. Kai Althoff (b. 1966) from Germany and Martin Creed (b. 1968) from the UK are both artists and members of bands. Briton Liam Gillick (b. 1964) designs books, posters, logos, furniture, and much else besides. In the course of his career as an artist, Frenchman Fabrice Hybert (b. 1961) has set up and made live broadcasts from a radio and television studio. And LA-based Cuban Jorge Pardo (b. 1963) [207] reconfigures a yacht before placing it in an art gallery, brightens up a motorway service station, alters the seating in a restaurant or the lighting in a museum lobby, conceives a jetty for a lake in a park, and even designs his own house.

All these artists in their different ways reject any oppositional distinction between art and other areas of endeavour. They are not setting up a series of one-to-one dialogues between art and other disciplines such as design, craft or science in order to offer a critique of them. To do so would be to adopt, somewhat presumptuously, a position of superiority in relation to those disciplines. As Rehberger maintains, though, his pieces are more about seeing things in new ways: 'Jorge Pardo shows a sailboat in a museum, I present a vegetable garden as art. Similar questions are being asked. I myself don't know much about growing things. But I don't know much about design either. There's not much difference between my letting a gardener grow vegetables and my asking an African carpenter to produce a copy of a Le Corbusier object.' A traditional way in which the relationship between art and other practices, and for that matter, between contemporary art and its historical precedents, has been viewed is as that between model and response, or example and critique. This implies that, one way or another, the historically prior phenomenon is exerting an influence. Gillick, however, stresses that while his aluminium and plexiglass screens and ceilings may bear some resemblance to Minimal art, he is not working as someone influenced by the 1960s movement. He is, rather, reframing Minimalism. Such reframing affects what Minimalism might mean for us - what it stood for, what it opened up and made possible - as much if not more than our knowledge of Minimalism is able to steer an interpretation of Gillick's work. 'If one assumes that art is autonomous,' says Carsten Höller, 'one may try to build a bridge between two spheres: art and fashion, art and science. That kind of dualism and its supposed dialectical outcome, in a chic "autonomy is over" attitude, is not valid. I prefer the "and...and" model to the banality of duality. It's true that I have worked as a scientist, and that clearly has influenced me and what I do. But I have also been a child, a driver, and many other things.' This view echoes the notion put forward by Robert Venturi in his late 1960s book Complexity and Contradiction in Architecture that what was interesting was not either/or, but both/and. It is, too, in tune with the philosophical theories of Gilles Deleuze and Félix Guattari that have been so influential in recent years.

In collaboration with Rosemarie Trockel, Höller (b. 1961) made A House for Pigs and People for Documenta X in 1997. The pigs could be seen from the outside by onlookers who would also see themselves reflected in the mirrored wall of the pig sty

211. Rosemarie Trockel and Carsten Höller, A House for Pigs and People, 1997. Installation at Documenta X. Kassel.

beyond. Inside the house, the wall is revealed as a two-way mirror through which the audience can watch pigs and onlookers unseen. With this house, according to critic Daniel Birnbaum, Trockel and Höller do not 'actively renegotiate the traditional notion of humanism, but their exposure of the very line of demarcation forces the viewer to ask the same questions over and over: What is an animal? What is Man?' Documenta X as a whole was an extended effort to reassess both recent art and the political context in which it appeared. Alongside the artworks on show, a series of daily lectures throughout the exhibition's three-month run aimed to elaborate and articulate this context. The show was a self-consciously intellectual experience as well as an affective one, or perhaps an event which demonstrated that the intellectual and the affective are inseparable aspects of experience. Back in the 1970s, as noted earlier, the catalogue to 'Art into Society/ Society into Art' held at the ICA in London had provided a reading list for those who wished to make further study. The catalogue to Documenta X, running to considerably more than 800 pages, contained a montage of innumerable key texts plus extensive interpretative material. For director Catherine

212. **Maurizio Cattelan**, *Bidibidobidiboo*, 1995

David, while the montage approach was necessary as a means to represent the diversity of contemporary art, its disparate nature was also useful in countering the false coherence of the world reflected in the media: 'Can an exhibition like documenta – somewhere between an experimental space and an arts bazaar – propose a model capable of confronting the complexity of aesthetic experience today?... The exhibition system, considered as a medium in its own right, is increasingly inflected by the logic of the media, and threatened with a drift toward the spectacular.'

This drift toward the spectacular was much in evidence in the 1990s. Although not confined to Britain – it can be seen,

for example, in the joky tableaux of Italian Maurizio Cattelan (b. 1960) - it was particularly noticeable there. Gillick, like the others mentioned above and many more including the French artists Philippe Parreno (b. 1964), Dominique Gonzalez-Foerster (b. 1965) and Pierre Huyghe (b. 1962), is not using art as an opportunity to play at doing some other job. He is always making art, precisely because it is the fact of being an artist that allows the freedom to do all of those other things. This attitude, which, as the short list of those given here suggests, finds many like minds in continental Europe and the US, is quite unlike the ironically media-savvy stance associated with much other British art of the 1990s. There were others – Angela Bulloch, Merlin Carpenter (b. 1967), Ceal Floyer (b. 1968), for example - who avoided the promotional hype surrounding 'Britart' during this period, but they tended to be the exceptions rather than the rule. One obvious consequence of their avoidance was that they remained less visible in Britain than elsewhere.

The British collector, Charles Saatchi, had sold much of his art during the economic downturn at the very end of the 1980s. Including examples of work by the leading figures of Pop and Minimalism, as well as much Neo-Expressionist painting, this 'first' collection had been publicized in a four-volume catalogue, Art of Our Time, in 1984. When rebuilding his collection following those sales, he concentrated largely on work by younger British artists, and it was a selection of this work that was shown at the Royal Academy of Arts, London, in 1997 under the title 'Sensation'. The name of the exhibition was a self-conscious reference to an earlier show of British art at the Walker Art Center in Minneapolis entitled 'Brilliant!'. 'Sensation' was the highpoint of the yBa phenomenon – the young British artists, whose frequent appearances in the media made it easy for people to accept their work as a collective expression of the fashionconscious cultural climate. This overall image tended to obscure the very real differences between the ideas and attitudes of the artists, and made it hard to think of their work as being more than symptomatic of the grind of the media machine. One could look more closely, for example, at Richard Billingham's (b. 1970) striking, but humorous and sympathetic photographs of his family - the dog eating spilt peas off the kitchen floor, his drunken father, his mother doing jigsaws, or at Darren Almond's (b. 1971) [213] videos, photographs and objects exploring his interest in the relationships between places, and in how the body can experience itself as historically present within that relational structure, or

213. **Darren Almond**, *Traction*, 1999. Three-part video installation.

214. **Tracey Emin**, Everyone I Have Ever Slept With, 1963–1995, 1995

215. Jake and Dinos Chapman, Rhizome, 2000. The French philosopher and psychoanalyst Gilles Deleuze and Félix Guattari, to whose ideas the title of this model of a McDonald's outlet refers, write, as if defining postmodernism: 'The rhizome is antigenealogy. It is a short term memory, or antimemory. The rhizome operates by variation, expansion, conquest, capture, offshoots.... A rhizome has no beginning or end.'

at Jake (b. 1966) and Dinos Chapman's (b. 1962) [215] clusters of merged mannequins with anuses and penises instead of mouths and noses testifying to the impossibility of feeling oneself to be a discrete, self-sufficient identity in today's world. The work of each of these artists would repay that closer look. What transpired more often than not, however, was the dominance of a more generalized story of shock and outrage, a circumstance that was only heightened further in the case of artists such as Damien Hirst and Tracey Emin (b. 1963) for whom the operations of the media provided an essential part of the work's subject matter.

The most obvious instance of manufactured outrage was the way in which the 'Sensation' exhibition was appropriated during both its London and New York runs. In London the work that caused the greatest public outcry was Marcus Harvey's (b. 1963) portrait of Myra Hindley (1995). The famous image of the Moors murderer, familiar from countless reproductions in the British press since her trial over thirty years ago, was rendered as just that, a media image, each of the 'pixels' or screen dots were made using a stamp in the shape of a child's handprint. Hindley's

past deeds and her face are more or less unknown in New York, and when the exhibition transferred there in late 1999 (after showing in Berlin, where there was no 'sensation' at all) it was, instead, Chris Ofili's (b. 1968) *Holy Virgin Mary* (1996) that provided the focus of attention. Incorporating not only the balls of elephant dung familiar in many of his works, but also collaged images of black women taken from pornographic magazines, the painting was branded obscene by New York mayor Rudolph Giuliani in what seemed an overt piece of electioneering aimed at securing the Catholic vote. Asking himself what anyone might think of 'Sensation' as an exhibition, one critic was forced to the conclusion that 'the question is probably moot, for when New York mayor Rudolph Giuliani threatened to evict the museum and cancel the city's \$2.7 million subsidy, discussion of aesthetic or intellectual worth receded in the face of principle.'

216. Franz West, Haider haidert, 2001. Secession Façade Project, Vienna, 28 February to 13 March 2001.

The short-lived furore over the fate of 'Sensation' in New York provided an echo of the censorship debates of a decade earlier over the work of Mapplethorpe and Serrano. A potentially more serious cultural debate occurred during the spring of the next year, following the entry of the right-wing Freedom Party (FPÖ) into the coalition government of Austria. Throughout the 1990s, the FPÖ had, in addition to its verbal attacks on immigrants and refugees, spoken out against aspects of Austrian culture with which it disagreed. These pronouncements had been directed at, among others, the writer Elfriede Jelinek and one of Hermann Nitsch's OM Theatre (Orgy Mystery Theatre) actions. While not calling for a cultural boycott by artists from other countries, Austrians themselves protested in various ways. Valie Export, for example, refused to accept what is in monetary terms the country's biggest art award, the Oskar Kokoschka prize, from a government member. The sculptor Franz West (1947–2012) installed a large poster on the façade of the Vienna Secession, proclaiming, 'Der Kunst ihre freiheitliche, der Zeit ihre Kunst' (To art its freedom party, to the time its art). The text was a play on the Secession's motto, 'To each time its art, to art its

217. **Manfred Pernice**, *Klagenfurt u. A.*, 1999. Installation at Galerie Nächst St Stephan, Vienna.

freedom.' In a less direct, but equally telling way, the German sculptor Manfred Pernice (b. 1963) made a reference in the title of one of his spatial constructions to Klagenfurt. His more general investigations into the social and political dynamics of constructed space, be it domestic, public or institutional, were thereby set in relation to the political debate centred on the chief town of FPÖ leader Jörg Haider's province of Carinthia.

Just as the various media used in the making of art have gradually freed themselves from the dominant presumptions about them that prevailed in various ways from the 1960s through to the 1980s, so the arguments over the relationship between art and politics have moved on. When Icelandic artist Olafur Eliasson (b. 1967) empties green dye into the river that runs through Stockholm, it is the response of the authorities to that action, and their silences and evasions in the face of a curious or worried public, that reveals the specific qualities of the place and its cultural climate. In 2000, Swiss artist Thomas Hirschhorn (b. 1957) built a temporary walkway across the alley separating the Whitechapel Art Gallery in London from the anarchist press

218. **Olafur Eliasson**, *Green River*, 2000. Stockholm, Sweden.

and bookshop next door. On other occasions he has provided quantities of theoretical and philosophical texts, news reports and other material as part of his installations that would take weeks to read thoroughly. More quirkily, German Andreas Slominski (b. 1959) has, among other things, extracted water from camels' humps and introduced it into a gallery's heating system, built a device for scratching car doors, and arranged for a golfer to hit a ball over Mies van der Rohe's Museum Haus Esters in Krefeld [220]. If any of these works are political, they are so through the negotiations, actions and decisions of the viewer finding meanings in objects and materials that exist within a necessarily political context, rather than because they offer fixed opinions about that context from a detached, aesthetic environment. Finding an old film of his mother giving a speech as the youth leader of Albania's Marxist ruling party, film maker Anri Sala (b. 1974) [221] asked lip readers to reconstruct what she was saying and then confronted her with the evidence of her former self. Her puzzled, confused and disbelieving response speaks of all those ambiguities that exist in the exchange between reality and fantasy, memory and history, in the contemporary world and which we see playing out again and again in today's art.

219. **Thomas Hirschhorn**, *Public Works – The Bridge*, 2000. Whitechapel Art Gallery, London.

220. Andreas Slominski, Golfball-Aktion, 1995. Installation at Museum Haus Esters, Krefeld, 11 March 1995. Though the outcome – a single golf ball on the floor of an otherwise empty gallery – is minimal, its achievement involves a great deal of time, effort and expenditure. The place of art in real life, and the relationship between art and work are thereby thrown into relief.

221. **Anri Sala**, *Intervista*, 1998. Still from colour video.

The problem, then, of what to do with the individual sheets of Gonzalez-Torres's stack of paper is ultimately one of responsibility. One is not confronted with the extreme and spectacular demands of the performances of Marina Abramovic, Vito Acconci, Gina Pane, Chris Burden and others, but the issue of the mutual obligations that exist between artist and spectator is equally present. To look at art is not to 'consume' it passively, but to become part of a world in which both that art and the spectator belong. Looking is not passive; it does not leave things unchanged.

The efforts of the 1960s and 1970s – when artists sought to establish the political parameters of the artwork, to adapt the social marginality of modernist avant-garde practice into a means of voicing the experience of cultural marginality or of giving a voice to those who are, for various reasons, excluded from mainstream cultural experience – have by now been assimilated as significant factors in art's production and reception. There is

a pulse in Warhol's imagery which is the pulse of the everyday, and there is a poetry in materials which Beuys and those who have come after him accept is inextricably bound up with the context of its utterance. How the artwork functions politically is not a question that can be answered independently of any consideration of its artistic merit. It is, rather, central to the way in which the work is able to exercise any aesthetic hold on the viewer at all. Art is a continuing reflective encounter with the world in which the work, far from being the end point of that process, acts as an initiator of and focus for the subsequent investigation of meaning.

Throughout the period covered here it has never been the case that perennial concerns for beauty, for the affecting qualities of form and for the search for a significance which appears to reach forward beyond the immediate present have been rejected. The struggle, rather, has been to find means to address those concerns that are appropriate to the character of contemporary life, irrespective of traditional, canonical forms of address and established hierarchies of media.

Chapter 7 Art After 2000

To launch the new art season in the autumn of 2007, two leading Western contemporary art magazines, Artforum and Frieze, chose the same photograph for the cover of their September issue. It was one of those years in which the art world's planets fall into alignment and the Venice Biennale, Documenta and Sculpture Projects Münster – the ten-yearly exhibition of public sculpture in the German city of Münster – all took place. As the emblematic image from this heavyweight summer, both publications opted for a shot of Bruce Nauman's Square Depression [222]. Nauman had proposed this work for the inaugural Münster show in 1977, but at the time the necessary permissions could not be obtained and the plans were shelved. Three decades later the invitation to resurrect the plans was accepted and the project, a 25 × 25 m pyramidal indentation in the ground in front of one of the University of Münster's science buildings, was constructed. The decision by the two magazines not only to illustrate the same work from amongst the hundreds on show that summer, but also to use the same photograph of that work, could be dismissed as nothing but an amusing coincidence. Yet the conjunction seemed more significant than that. In the years since Nauman had worked on the original plans for the sculpture, the generation to which he belonged had been shaping the kind of art that was exhibited in the galleries and museums and setting the parameters for what was taught in art schools. That generation was now approaching the age of retirement, and its members would soon need to make way for others with different agendas. In joining together to look with one eye and speak with one voice it appeared that the two journals were signalling both the consummation and the conclusion of the artistic narrative that had developed out of the Pop, Minimalism and Conceptualism of the 1960s and early 1970s. It was as if they were saying, 'This is where art has come to; this is what it is.' And if that was the message, then the response must be to pose the question: Where is it going now? If the old criteria, which focused on a critique of the efficacy of the modernist avant-garde, were no longer credible, then what might take their place?

'Nothing has changed, but everything is different', according to writer François Piron. 'For a generation born in the 1970s, the

222. **Bruce Nauman**, *Square* Depression, 1997–2007. Installation for Sculpture Projects Münster 07.

223. **Seth Price**, Hostage Video Still with Time Stamp, 2012. The screen-printed image is grabbed from a video posted online by Jihadist kidnappers, taken as they executed their hostage. The works in this series can be installed in any configuration, provided each polyester sheet is sufficiently folded and crumpled for the image to appear distorted from every angle.

museum is no longer considered a totemic foe.' He was writing about Saâdane Afif (b. 1970), whose 2010 exhibition 'Anthologie de l'humour noir' at the Centre Georges Pompidou in Paris included texts written by his friends and a Ghanaian coffin in the shape of the museum itself. Roman Ondák (b. 1966) asks people to stand in a line as if waiting for something, though in reality they are queuing for nothing; or he might have museum guards mark the height and name of each visitor on the gallery walls, thereby creating an ever-thickening, cloudy tidemark that is both the act of making the exhibition and a recording of those who have seen it. Visitors to Tino Sehgal's (b. 1976) exhibitions could also find themselves greeted by a guard, this time speaking the words of a headline from one of that day's papers, or could be engaged in conversation by another gallery-goer with an urgent tale to tell of a long wait for a visa, or encouraged by a group of schoolchildren to join them in playground games. Are works such as these, or perhaps that of Martin Creed setting the lights to go on and off every five seconds in an empty gallery, delivering what Piron sees as the coup de grâce to the overt critique of art's institutions, one delivered most notably by Andrea Fraser in the 1990s?

In his influential 2002 essay 'Dispersion', the post-Conceptual artist Seth Price (b. 1973) [223] had suggested that while art and its viewers may have followed the path that leads from Duchamp to the exuberance of Pop and the investigations of Conceptualism, what was needed now was that they turn their backs on that story. 'The last thirty years', he wrote, 'have seen the transformation of art's "expanded field" from a stance of stubborn discursive ambiguity into a comfortable and compromised situation in which we're well accustomed to conceptual interventions, to art and the social, where the impulse to merge art and life has resulted in lifestyle art, a secure gallery practice that comments on contemporary media culture, or apes commercial production strategies.' The al-Qaeda terrorist attacks of September 11 2001; the subsequent protracted wars in Afghanistan and Iraq; the worldwide grip of neoliberal economic policy that led inexorably to the global financial crash of 2008; the Arab Spring of 2011 that saw political upheaval across North Africa and the Middle East; the rebalancing of power through the rise of the BRIC economies (Brazil, Russia, India and China); the increasing impact of global warming on our climate and environment – these are just some of the events forcing the realization that the old narratives could no longer suffice.

However much the attitudes and practices associated with those earlier tendencies continued to shape present-day art, the fact was that by the start of the new century many artists were too young to have had any direct experience of them. Critic Dieter Roelstrate recognized the significance of this generational shift, referring to it as a 'historiographic turn' in art, and identifying its features as an 'obsession with archiving, forgetfulness, memoirs and memorials, nostalgia, oblivion, re-enactment, remembrance, reminiscence, and retrospection.' This range of features, indicative of a desire to build a new relationship with the past, is evident in the work of artists as diverse as the Polish Goshka Macuga (b. 1967), whose complex installations might include her own Constructivist-inspired sculptures in conversation with existing works from a museum or gallery's collection, in Cypriot Haris Epaminonda's (b. 1980) film archive of images that prompt a reframing of antiquity, in Paul Sietsema's (b. 1968) films of constructed objects and sets, in Matthias Poledna's (b. 1965) reworked cinematic moments, in Gerard Byrne's (b. 1969) multi-screen investigations into aspects of modernist thought and practice, and in Luke Fowler's (b. 1978) films reappraising the work and ideas of 1970s anti-psychiatrist

224. Jeremy Deller, The Battle of Orgreave, 2001. Performance view. Deller likened his re-enactment of this major incident from the UK miners' strike of 1984–85 to digging up a corpse in order to give it a proper burial. The film includes testimony from many of those involved in the original event, including miners, their wives, police, union leaders and politicians.

R. D. Laing. It can also be seen in the work of German Felix Gmelin (b. 1962), Lithuanian Deimantas Narkevicius (b. 1964) and Briton Jeremy Deller (b. 1966). In his large-scale event The Battle of Orgreave (2001) [224], Deller restaged an incident from the 1984 UK miners' strike. Some of Deller's cast were seasoned battle re-enacters, but others were former miners and policemen who had been involved in the original incident. Just as Deller here revisits and re-examines the major confrontation between the government of Margaret Thatcher and unionized labour, a confrontation marking the demise of the country's heavy industry and its associated work patterns, Narkevicius has explored the ending and the legacy of the Soviet Union. The film Once in the XX Century (2004) [225] is assembled from existing footage showing the removal of a sculpture of Lenin from a prominent position in Vilnius, Lithuania. As well as material from the Lithuanian National TV archive, Narkevicius obtained video recordings of the event from a freelance cameraman. Through editing together elements of these two different perspectives, and manipulating the footage, Narkevicius constructed a narrative that effectively reverses time. Instead of seeing Lenin's removal, we see a crowd of onlookers apparently assembled to witness the installation of the statue on its waiting plinth. Already, Narkevicius observes, Communism is coming to be regarded by the younger generation as something exotic, rather than an ideology of imperial domination that resulted in a state of terror for individuals. In the double video projection Farbtest, Die Rote Fahne II (Colour Test, The Red Flag II) (2002) [226], Gmelin recreates a film made by his father in 1968 in which a series of runners carried a red flag through the streets of Berlin before the person on the

225. **Deimantas Narkevicius**, *Once in the XX Century*, 2004. Still from colour video.

final leg ran into the town hall and draped the flag over the first-floor balcony. One of the participants in the original film went on to become part of the Baader-Meinhof terrorist group, and Gmelin's re-creation, actually filmed in Stockholm, omits the final display of the flag, as if to confirm that the ideal of revolutionary social transformation must now be well and truly abandoned.

Yet there is no shortage of art produced that faces the profound socio-political and economic tensions of the new century. Deeparture (2005) [227] by Romanian Mircea Cantor (b. 1977) shows a wolf and a deer in an otherwise empty white gallery space. The animals do not interact directly with one another, but instead sit, walk and stand around in the space, all

226. Felix Gmelin, Farbtest, Die Rote Fahne II (Colour Test, The Red Flag II), 2002. After Gerd Conradt's Farbtest, Die Rote Fahne, 1968. Still from colour video.

227. **Mircea Cantor**, *Deeparture*, 2005. Stills from colour video.

the time wary of each other's presence. Something could be about to happen, but because the film is on a loop, any potentially violent coming together of the creatures is endlessly deferred. There will be no resolution to the conflicts through which we are living; we are doomed to a life in endless tension and anticipation. In Repetition (2005) [228], Artur Żmijewski (b. 1966) re-created a famous psychological experiment conducted at Stanford University in 1971 in which volunteers were randomly assigned the role of either prisoner or guard, and were subsequently observed assuming the behavioural characteristics of their given status. Likewise, Aernout Mik (b. 1962), constructor of scenarios in which actors frequently adopt aggressive or submissive roles, says of his work, 'My pieces are about political or social events, but they are not direct images of those events. They act a bit like flashes which you can recognize but not precisely locate.' His films stage situations of stress and conflict that are played out in silence and without resolution. Three of Mik's works from 2006 address the issue of imposing order upon chaos within social and political structures. Scapegoats shows people assembled in a large sports hall. Soldiers are present, too, making somewhat half-hearted attempts to organize and 'process' these people. Are they refugees? Captives? The boundary between those trying to establish order and those resisting it remains blurred, so that when, for example, one of the soldiers puts down his gun, he is

228. Artur Żmijewski, Repetition. 2005. Still from colour video. Żmijewski has stated that doing something only once is as good as not doing it at all. Here he restages Philip Zimbardo's famous 1971 prison experiment, using unemployed Polish men in place of students. As the power dynamics develop, the behaviour of the 'prisoners' seems guided less by their immediate circumstances than by the more deeply ingrained lessons learned under the repressive Communist regime in Poland.

swiftly set upon and transformed into a member of the marshalled mob. *Training Ground* [229] appears to show a group of refugees or asylum seekers being processed, having been apprehended by the authorities, while truck drivers – perhaps those caught trying to transport them – look on. The third work, *Raw Footage*, is a two-screen projection assembled from Reuters and ITN news footage shot in the former Yugoslavia during the civil wars of 1991–2001. Unlike Mik's films featuring fictional narratives, this work has sound, although without the guiding, shaping voiceover of the war correspondent telling us what we are looking at, these scenes of military engagement in lush countryside, and of the collecting of corpses following battle, can give no larger political sense of what is going on.

For a number of compelling reasons the world in the early years of the third millennium was changed from what it had been in the final years of the second. The terrorist attacks that took place on September 11 2001 in New York, Washington and Pennsylvania triggered a protracted and pervasive political response. However abstract or nebulous the term 'war on terror' may be, the many, often brutal consequences of

229. **Aernout Mik**, *Training Ground*, 2006. Still from two-channel video installation.

September 11 have been far-reaching, and artists have struggled to make work that responds adequately to their ugly realities. Discussing this problem in 2008, Cuban–American artist and writer Coco Fusco (b. 1960) wondered whether the 2001 attacks and the subsequent wars in Afghanistan and Iraq had really been properly and directly examined, or whether the subject had instead been approached obliquely, for example through

230. **Paul Chan**, Baghdad in No Particular Order, from the Tin Drum Trilogy, 2002–5. Still from colour video.

'nostalgic looks at the Vietnam era', such as when Mark di Suvero and Rirkrit Tiravanija collaborated in rebuilding, for the 2006 Whitney Biennial, the Peace Tower that Di Suvero had first constructed forty years earlier in protest against the Vietnam war. One artist who did tackle the subject was Paul Chan (b. 1973), whose Tin Drum Trilogy of films (2002-5) [230] addressed the wars from various perspectives. The first film, RE: The Operation (2002), imagined the members of George W. Bush's cabinet as enlisted soldiers in Afghanistan writing letters home. Baghdad in No Particular Order (2003) comprised a sequence of scenes filmed by Chan on a visit to the city in the months before the declaration of war, and the final film, Now Promise Now Threat (2005), saw the artist returning to his home state of Nebraska to interview people in the US's staunchly Republican heartland. Chan has said that all of his work is made in the shadow of the Iraq war, suggesting that whatever an artist might say about its specific relevance, the conflict will inevitably affect what he or she does. Vietnamese-American Danh Vo (b. 1975) says of his project We The People (2010–13) [231], a multi-part, life-sized replica of the Statue of Liberty, that although it is not directly about September 11, it is essentially that event and its aftermath that provides the work's context. Similarly, while the films of Omer Fast (b. 1972) cannot usually be understood as commentaries on any specific conflict, their mix of factual information with fictional, often futuristic narratives allows them to reflect more generally upon the wars and occupations of the Middle East, Afghanistan and elsewhere since the turn of the millennium.

The rapidly developing nature of the digital environment and the manner in which it has affected so many aspects of our lives has had significant implications for the art of the early twenty-first century. The online, open-source encyclopaedia Wikipedia was launched in 2001, and a string of social media sites appeared over the following half-a-dozen years – Second Life (2003), Myspace (2003), Vimeo (2004), Facebook (2004), YouTube (2005), Twitter (2006) and Tumblr (2007). There are several characteristics visible in the art of the century's early years that appear closely related to these and other digital developments such as the widespread rise of blogging and file sharing and the culture of open-source data. These developments provided a virtual though nonetheless real space that artists, like everyone else, could explore, exploit and colonize. As well as a space to occupy, the internet is also a resource, research library, workshop, laboratory and a network for communication, distribution and display. Artists have made

work reflecting all aspects of the digital environment, embracing its unparalleled ability to enable interaction of many kinds – social, economic and informational. Working first with the phenomenon of 'cosplay' – acting in real life in the costume of fantasy superheroes – Cao Fei (b. 1978) invented the alternative persona China Tracy, who lived in Second Life and went on to plan and build her own Second Life metropolis, RMB City (launched in 2008) [232]. The artist referred to this as both an act of 'sampling' and a 'superficial' city in that it 'appropriates and duplicates a lot of surfaces from reality, yet it is not simply a representation that follows reality'. For his work *Dorm Daze* (2011), Ed Fornieles (b. 1983) gathered a cast of people who assumed fictional

231. **Danh Vo**, We the People, 2011–13, detail.

232. Cao Fei/China Tracy, RMB CITY: A Second Life City Planning, 2007. Still from 3D video game.

identities on Facebook, their communications and interactions over time building the narrative of a kind of soap opera. Similarly, in Fornieles's Ivy Pink (2012) [233], the central screen displays a stream of all the images uploaded onto Tumblr sites that carry one of a set of prescribed tags. Once again there is a collaborative dimension to this work, as there is, for example, with a project such as Miranda July (b. 1967) and Harrell Fletcher's (b. 1967) Learning to Love You More (2001-4). Here, a website suggested activities for users to do, inviting them to then post the results on the site. Cory Arcangel (b. 1978) is a creature of the internet by his own admission, surfing it incessantly throughout each day and leaving what he calls a 'trail of breadcrumbs' to indicate where his curiosity has taken him. In keeping with this behaviour his works use material culled from the web, computer games, records and elsewhere, reframed in ways that can involve collage, editing, or recoding. Two works from 2002 found Arcangel hacking early computer games, reworking them to create a humorous homage to Andy Warhol. 'I am interested in how a given technology's time might be over', he says. 'I fill a gap in the history of technology and culture, doing things people didn't actually do

233. Ed Fornieles, Ivy Pink, 2012

when these systems were in use.' A Couple of Thousand Short Films About Glenn Gould (2007) comprises YouTube clips of individual musical notes being played on a variety of instruments by people (and pets), edited together to form a rendition of Bach's Variation No. 1 from his Goldberg Variations (1741).

At the opposite end of the temporal scale, collaging of this kind is also used by Christian Marclay (b. 1955) in *The Clock* (2010) [235], a 24-hour sequence of film clips, each of which contains a clock or watch showing the correct time. Jon Rafman (b. 1981) began his ongoing online work 9 Eyes of Google Street View [234] in 2009. Named after the vehicles each mounted with nine cameras that had travelled many of the world's streets capturing

panoramic views, the piece consists of images of scenes happened upon during this process. A butterfly with wings fully spread flutters down the road in front of the camera; a handcuffed man lies in the back of a police truck; a figure strolls across a street in Rapid City, Dakota, carrying a machine gun; and prostitutes wait for trade in all corners of the world. What is also frequently picked up are the moments when people moon or give the finger to the camera in quiet objection to having their space and lives invaded, stored and catalogued.

234. **Jon Rafman**, 9 Eyes of Google Street View: Calle de Osona, Santa Perpetua de Mogoda, España, 2010

235. **Christian Marclay**, *The Clock*, 2010. Video installation view.

236. Ai Weiwei, Sunflower Seeds, 2010

Another key figure in the creative use of digital technology is Chinese artist Ai Weiwei (b. 1957). Ai started a blog in 2005, and has expressed his belief that the changes that have taken place in art thanks to digital technology can only continue 'more extensively and more aggressively in the future'. Ai's work as an artist since his return to China in 1993 – after spending more than a decade in the US – has been inseparable from his status as a challenging presence in Chinese political life. Whether gathering 1001 people from all over China for a trip to Kassel as part of Documenta 12, employing hundreds of workers to handcraft millions of porcelain sunflower seeds for an installation in Tate Modern's Turbine Hall [236], smashing a 2000-year-old Han Dynasty urn in a gesture aimed at questioning the culturally destructive effects of China's rapacious urbanization, or making a sculpture from steel rebar pulled from a shoddily constructed

school building destroyed in the 2008 Sichuan earthquake, Ai consistently asserts the right to freedom of expression in the restrictive political environment he inhabits. Painter and film maker Liu Xiaodong (b. 1963) also refers to the Sichuan earthquake in Out of Beichuan (2010), a large canvas depicting a group of young women standing amidst the rubble of their destroyed town. Elsewhere in his paintings Liu has focused on the social impact of the population displacement made necessary by the Three Gorges Dam project for China's Yangtze River, and on the pollution of water resources due to the lack of environmental oversight on the part of the chemical industry [237]. In contrast to such overt concern with politics, critic Pauline Yao cites artists associated with the 1999 Beijing exhibition 'Post-Sense, Sensibility, Alien Bodies and Delusion' such as Liu Wei (b. 1972), Wang Jianwei (b. 1958) and Song Dong (b. 1966), highlighting the manner in which they 'embraced irrationality, improvisation, and intuition', sharing as they did a 'distaste for the political idealism and rational leanings of their predecessors'. We could also mention here collaborators Sunyuan (b. 1972) & Pengyu (b. 1974), film maker Yang Fudong (b. 1971) and photographer and film maker Qiu

237. **Liu Xiaodong**, Into Taihu, 2010

238. **Sunyuan & Pengyu**, Old People's Home, 2007

Zhijie (b. 1969). Sunyuan & Pengyu's installation *Old People's Home* (2007) [238] is an arena in which motorized wheelchairs carrying life-sized mannequins looking like wizened world leaders move jerkily and unpredictably, forever bumping into one another: world politics as a geriatric dodgem ride.

The manner in which social media have been utilized outside of the art world – such as in the organization and documentation of anti-government protests across North Africa and the Middle East – has had repercussions within it. Rabih Mroué's (b. 1967) The Pixelated Revolution (2012) [239] intercuts footage shot on a mobile phone by someone pinned down in their apartment by a sniper with the artist's meditation on the implications of our being able to record and disseminate such material. Mroué is one

of many artists from the Middle East and North Africa whose work has grown out of, and which consequently reflects, the conditions there. In his two-part film Cabaret Crusades (2010–12) [240], Egyptian artist Wael Shawky (b. 1971) tells the story of the crusades from the Arab perspective in an elaborate puppet show. setting the context for Egypt's more recent political tensions. Since 2007, Lebanese artist Rayyane Tabet (b. 1983) has made work in a variety of media on the subject of the Trans-Arabian Pipeline that was established in 1946 to pump oil from Saudi Arabia to the Mediterranean but was subsequently abandoned due to conflict in the region [241]. Walid Raad (b. 1967) worked under the pseudonym The Atlas Group between 1999 and 2004. The aim of this fictitious collective was 'to research and document the contemporary history of Lebanon, with particular emphasis on the wars of 1975-90'. The Group's My Neck is Thinner Than a Hair purports to be culled from the notebooks kept by Dr Fadl Fakhouri, an eminent Lebanese historian, about his country's civil conflicts, in which he documented the many different makes, models and colours of the vehicles used in all the car bombs during the war years. Fakhouri's existence, however, is purely fictional, and though the photographs that appear in his documents feature car makes and models that may well have been used for some actual bombings, the images were all in fact shot more recently by Raad in Beirut's streets. In another work the Group documented the videos taken by a

239. Rabih Mroué, The Fall of a Hair Part 1: The Pixelated Revolution, 2012. Video stills. Mroué refers to the mobile phone footage taken by Syrians being subjected to sniper fire as a 'double shooting' – by both sniper and target. In this lecture/performance, he selects, analyzes and attempts to interpret this material, finding that it defies resolution since the closer he looks, the more the imagery dissolves into abstract pixelation.

240. **Wael Shawky**, Cabarét Crusades: The Path to Cairo, 2010. Still from colour video.

soldier whose task it was to note any suspicious person on the Beirut Corniche, but who chose instead to turn his camera out. to see and film the sunsets. Since 2007, Raad has worked on a project entitled Scratching on Things I Could Disavow: A History of Art in the Arab World. Raad's work deals with the difficulties of acting in circumstances that lie beyond what Lebanese film-maker and writer Jalal Toufic has called the 'surpassing disaster'. Such traumas – invasions, brutal repressions, displacements and other civil devastations - lead to a radical loss of tradition. All the things that confirm the existence of that tradition, and which allow access to it - artworks, documents, archives, and so on - are destroyed, and what remains is the task of reconstruction. 'We do not go to the West', writes Toufic, 'to be indoctrinated by their culture, for the imperialism, hegemony of their culture is nowhere clearer than here in developing countries. Rather, we go to the West because it is there that we can be helped in our resistance by all that we do not receive in developing countries: their experimental films and video art, their ontological-hysteric theatre, their free improvisation, etc; and because we can there meet people who can perceive, read or listen, and genuinely use pre-surpassing-disaster art, literature, music and thought without having to resurrect them.' Palestinian Emily Jacir (b. 1970) works with this same sense of loss. For Where We Come From (2001-3) she asked Palestinians living abroad and in the Occupied Territories 'If I could do anything for you, anywhere in Palestine,

241. Rayyane Tabet, Steel Rings, from the series The Shortest Distance Between Two Points, 2013. The rings are the exact diameter of the 1213 km pipeline proposed in 1946 by the Trans-Arabian Pipeline Company to connect Dhahran in Saudi Arabia to Haifa in Israel. The pipe was originally designed to run in a straight line, but the Partition Plan for Palestine enforced a dog-leg redirecting it to Zahrani, Lebanon. Each ring is engraved with the distance from the pipe's starting point and its corresponding map co-ordinates.

what would it be?' Being in possession of a US passport (until Israel revoked her freedom of movement in 2004), Jacir was able to undertake each wish, and to bring back documentation to show that it had been fulfilled. Playing football with the first Palestinian boy she saw in Haifa, drinking water in a mother's village, photographing a family, including a brother and his children, taking flowers to a mother's grave and praying – all everyday, personal activities that under normal circumstances would not be given a second thought, yet in these circumstances were demonstrably unachievable. Applying something of a reverse perspective, Israeli Yael Bartana's (b. 1970) trilogy of films, And Europe Will Be Stunned (2007–11), imagines a movement devoted to the repatriation of Jews from Israel to Poland.

The internet's achievement in making vast quantities of material readily available to anyone and everyone has had a profound effect upon the way in which art can address history. Although quality has gradually improved, a great deal of the film and still imagery to be found online is of fairly low grade. In satisfying a desire for accessibility, detail and focus are regarded as a small price to pay. This 'poor imagery', to use the term given to it by the German–Japanese video artist Hito Steyerl (b. 1966), is all-encompassing. Commercial Hollywood film, home videos, news and archive footage, TV programmes from every period,

242. Camille Henrot, Grosse Fatigue, 2013. Still from colour video. Described by Henrot as an 'intuitive unfolding of knowledge', Grosse Fatigue mixes imagery of items from the collection of Washington's Smithsonian Institution with material found on the internet and scenes filmed by Henrot. The soundtrack by electronic musician Joakim is a long poem that knits together the history of science and stories of the creation from different religions.

pornography and everything in between are equally present, and as a result the previous distinctions between high and low art, between avant-garde and kitsch, or between a position that is either complicit with or in opposition to the prevailing political norms, can no longer be sustained in the same way. As Steyerl says, 'while the territory of poor images allows access to excluded imagery, it is also permeated by the most advanced commodification techniques. While it enables the users' active participation in the creation and distribution of content, it also drafts them into production. Users become the editors, critics. translators, and (co-)authors of poor images.' A growing number of artists such as Mark Leckey (b. 1964), Ed Atkins (b. 1982), Helen Marten (b. 1985), Jordan Wolfson (b. 1980), Elizabeth Price (b. 1966) and Camille Henrot (b. 1978) [242] are producing films that could only come from the kind of polyvalent, visually excessive environment Steyerl describes, and the same can be said of the exuberant scenarios of Laure Prouvost (b. 1978), Ryan Trecartin (b. 1981) and Marvin Gaye Chetwynd (b. 1973; formerly known as Spartacus Chetwynd). The mixed character of material Steyerl uses in her own films obliterates easy distinction in just this way. In Lovely Andrea (2007) [243], we see the artist searching the photographic studios and porn archives in Tokyo in an effort to track down an image of herself taken when she worked there as a bondage model in the late 1980s. Whether or not this happened in real life remains beside the point; what is

of much greater importance is the juxtaposition of the bondage images she finds with, on the one hand, film of Iraqis being abused by US military personnel in Baghdad's Abu Ghraib prison, and on the other, the cartoon exploits of Spiderman. The ready availability of so much material means that categories become porous; things can no longer be compartmentalized because anything can imply any possible meaning. Such blending of fact and fiction allied to the conscious shaping of historical account through personal storytelling can also be found in the films and installations of artists such as Bulgarian Nedko Solakov (b. 1957), German Clemens von Wedemeyer (b. 1974), Israeli Keren Cytter (b. 1977), Irish artist Duncan Campbell (b. 1972) and the Indian group Raqs Media Collective (formed 1992).

Much of the art mentioned thus far in this chapter is film, video or installation work, but the characteristics of the art of the new millennium are no less evident in painting. In his 2009 essay 'Painting Beside Itself', historian and critic David Joselit wrote of the manner in which painting in the early twenty-first century explicitly visualized the network of distribution and exhibition within which it was produced and displayed. Furthermore, it could not be critically engaged with except as a part of that network. With this pronouncement we have travelled as far as it is possible to get from Greenberg's idea that painting asserts its autonomy through a progressive realization of the specific qualities of the medium. While the initial reference point for Joselit's claim was the work of Martin Kippenberger who, at the start of the 1990s, had emphasized the importance of this network for any understanding of contemporary art, the argument had particular force in a period in which our understanding of networks had

243. **Hito Steyerl**, *Lovely Andrea*, 2007. Still from video installation.

244. **R. H. Quaytman**, Passing Through the Opposite of What It Approaches, Chapter 25 (after James Coleman's slide piece), 2012

changed markedly. Joselit identified in particular the work of German painter lutta Koether (b. 1958) as exemplifying this characteristic, but it can also be seen in the films and performances of Loretta Fahrenholz (b. 1981), in the painterly installations of Kerstin Brätsch (b. 1969) and Jana Euler (b. 1982), and in the works in various media of Tauba Auerbach (b. 1981). R. H. Quaytman (b. 1961) and Amy Sillman (b. 1955). Quaytman has said that 'the stance of the painting is the profile', a reference to the way in which viewers catch her multi-panel works in their peripheral vision as they walk past, rather than by looking at them head on [244]. Just as the gallery architecture and the movement of the spectator become factors in the exploration of meaning, so too do Quaytman's artistic influences, photographs of whom are silkscreened into her compositions. Euler, too, has included the likenesses of well-known art world figures in her paintings [245]. Aping the hard stare of Neue Sachlichkeit portraiture, these contributions to Euler's installations – which also include large-scale canvases on the themes of gender and power, sculptures, and translucent screens that both restrict and tantalize the spectator - insist on the impossibility of viewing the world innocently. The system that delivers a painting to our eye must always be acknowledged for the influence it has on what

245. Jana Euler, Whitney, 2003

we see. Auerbach's ostensibly abstract paintings, while full of illusion and trompe-l'oeil effect, are at the same time literal records of the crumpling, flattening and spraying of the canvas of which they are constituted [246]. The exuberant figuration and abstract gesture of Sillman's painting revisits the heroism of the Abstract Expressionists, 'not in order to emulate them, but because I didn't like them'. Alongside these paintings, she makes videos and writes and draws cartoons, publishing the latter in magazines with small print runs. Kerstin Brätsch calls her paintings - with their imagery culled from logos, patterns, online sources and elsewhere - 'corporate abstraction'. In its visual reference to a wide range of modern artistic styles, her work exemplifies what curator Massimiliano Gioni has dubbed 'Painting in the age of Wikipedia', which he describes as 'a surfeit of information, maximum superficiality, minimum knowledge - history as assemblage'. In 2007, together with fellow artist Adele Röder (b. 1980), Brätsch set up DAS INSTITUT, a kind of mock marketing company whose air of fake goods dealing and cheap import/ export activities embraces the realities of a climate in which authority and authenticity are questioned. In a similar manner, Xu Zhen (b. 1977) announced in 2009 that he had exhausted the possibilities of his individual identity, and established Madeln, a

246. **Tauba Auerbach**, *Untitled* (Fold), 2013

notional production and advertising company that would, for example, make works masquerading as Middle Eastern objects as a means of unsettling the bipolar cultural dynamic that more usually simply pits China against the West.

The exhibition of Koether's work to which Joselit refers in his essay was held at the New York gallery Reena Spaulings. The gallery took its name from the eponymous heroine of a 2005 novel that was 'written' by the group Bernadette Corporation. The group began in 1994, the form of a corporation being 'the perfect alibi for not having to fix an identity'. Organizing parties, making films, designing and marketing a line of women's fashion, running a style magazine entitled Made in USA, as well as producing the novel, Reena Spaulings, that was collaboratively written by a group of around twenty people, Bernadette Corporation describe themselves as 'emulating a corporate image through "joke" forms of business that are serious'. Their 2003 film Get Rid of Yourself [247] used footage of the demonstrations at the G8 summit in Genoa in the summer of 2001, mixing testimony from the anarchist Black Bloc group with shots of model Chloë Sevigny attempting to learn and repeat the activists' words. By

247. **Bernadette Corporation**, *Get Rid of Yourself*, 2003. Still from colour video.

248. Paweł Althamer, Common Task (Brussels), 2009. For this collaborative project, Althamer worked with fellow residents of his Warsaw neighbourhood of Bródno. Conceived as a 'science fiction film in real time', it involved the gold-clad participants ('aliens') staging events in Brasilia, Oxford, Mali and at the site of the 1958 World's Fair in Brussels

the time the film was edited, the events of September 11 had occurred, and it is kaleidoscoped images of the World Trade Centre's Twin Towers on the verge of collapse that begin the film. Bernadette Corporation's multifarious activities, some of which would hitherto not necessarily be understood as art, bring into sharp focus the question of what that term can now be taken to encompass. Bookending the twentieth century, both Oscar Wilde and Sol LeWitt had offered the opinion that all art is useless, but while this view of art's essential detachment from politics and the pragmatics of everyday life may have held throughout the last hundred years, the recent suspicion that art can be anything raises the possibility that it might, sometimes. be useful too. Between 1999 and 2013 Thomas Hirschhorn constructed a series of monuments to key thinkers, creating them in collaboration with the local communities in a number of cities. Each of these hybrid structures were at one and the same time meeting space, event facility, coffee bar, TV studio, discussion forum, exhibition stand and much more. Similarly, the environmental projects of Tue Greenfort (b. 1973), the community activities of Theaster Gates (b. 1973), the films,

seminars and events staged by the Russian collective Chto Delat? (What is to be Done?) (formed 2003) and Paweł Althamer's (b. 1967) design for a children's playground, the pottery classes he ran for the other residents of the apartment block where he lives in Warsaw, or *Common Task* (2009) [248], his nomadic science fiction production made in collaboration with his neighbours, might all be taken as confirmation of this idea.

Brazilian theorist Suely Rolnik has discussed the degree to which the focus on identity, autonomy and self-sufficiency seen in the art of the later twentieth century was always subject to the homogenizing force of Western economic and cultural interests. Globalization might have spread to all parts of the world, but this reach had been brought about through what she referred to as the 'suppression of the resonant body'. Wherever it was encountered, difference always spoke its truths with the same Westernized voice. Art since the turn of the millennium has shown strong evidence that this situation has shifted somewhat. This evidence can be found in much of what has been touched on in this chapter as well as, for example, in the long term community project Immigrant Movement International, set up and run by Cuban Tania Bruguera (b. 1968) in Queens, New York; in an installation by Thai Pratchaya Phinthong (b. 1974) that scrutinizes the interdependence of Western scientific discourse and the colonization of Africa: in Benin artist Romuald Hazoumé's (b. 1962) use of plastic jerry cans in sculptures and installations that link the modern exploitation of West African oil resources with the history of the slave trade; in the silhouettes of slaves and slave owners in Kara Walker's (b. 1969) humorously excoriating plantation scenes; in Nigerian El Anatsui's (b. 1944) sumptuous fabrics fashioned from flattened beer bottle tops; in Glenn Ligon's (b. 1960) darkened neon signs that both withhold and reveal their texts; in Damián Ortega's (b. 1967) VW Beetle, disassembled into its constituent parts and suspended from the gallery ceiling not long after production of the twentieth-century design classic was shifted from Germany to Mexico [249]; and in Amalia Pica's (b. 1978) use of the Venn diagram, the inclusion of which in mathematics text books was banned in the period of Argentina's military rule because it illustrated the existence of difference [250].

Since the turn of the millennium, while art has in many ways continued to be amenable to the demands of the market, the galleries, and a sensation-hungry media, it has also become more difficult to reconcile its forms, its expressive means, its focus and its frames of reference with traditional expectations. Spanish

249. Damián Ortega,

Cosmic Thing, 2002.
Cosmic Thing gives us an exploded view of the Volkswagen Beetle: a life-sized, 3D realization of an instruction manual diagram.
Originally introduced in Nazi Germany and now manufactured under licence in Mexico, the fragmented form reveals its workings as a car, but must leave unanswered any questions concerning the anatomy and the fate of its classic status.

250. Amalia Pica, Venn Diagrams (under the spotlight), 2011. Installation view as part of 'ILLUMinations', Venice Biennial, 2011. curator Chus Martínez talks of a 'disowning of knowledge', which is to say, a suspension of reliance on established assumptions about the world and the way in which it works. To a significant extent, art has become embedded within academia since the 1960s. It is now possible to study criticism, curating and even the making of art to doctoral level in many of the world's universities. Notwithstanding this apparent assimilation by socially orthodox structures, the vastly enhanced ability to access visual and textual material of all kinds, and to manipulate, share and disseminate it widely for little cost, has been seized upon and exploited to full advantage by artists. In the 1980s and 1990s, amid postmodernism's preoccupation with the collapse of the grand narratives of historical and theoretical judgment, the primary force of the Western perspective remained largely secure and unchallenged. The plurality not only of voices, but also of positions, viewpoints, procedures and rationales seen in the art of the twenty-first century offers the possibility of that dominance becoming vulnerable to change.

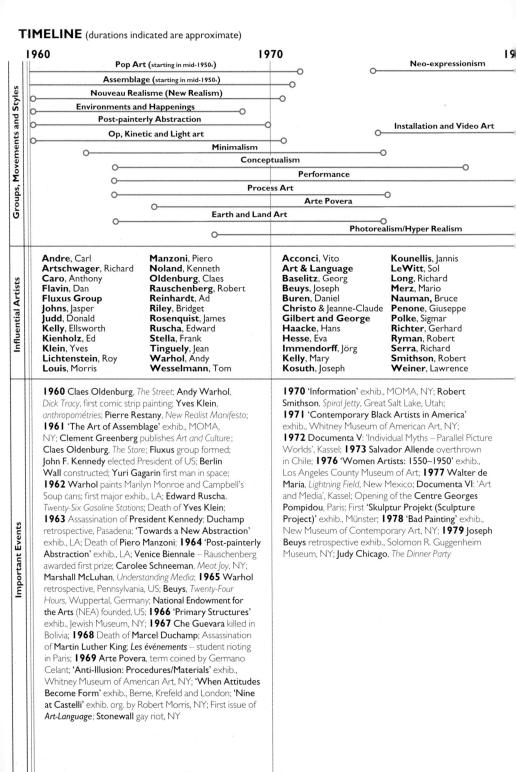

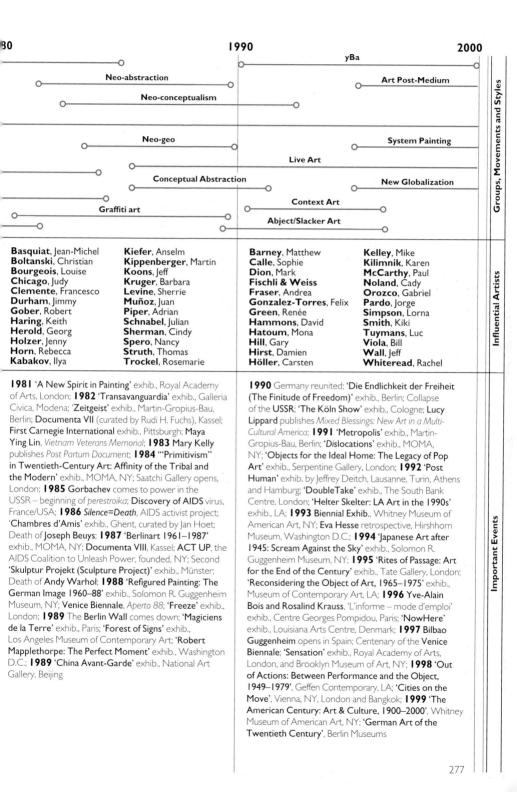

Art Post-Medium	
Art using th	ne Archive
Installation ar	nd Video Art
System Painting	
Live	Art
New Glob	alization
Art using Social Media	
Ai Weiwei Alÿs, Francis Bernadette Corporation Breitz, Candice Bruguera, Tania Chan, Paul Hazoumé, Romuald Hirschhorn, Thomas Huyghe, Pierre Kentridge, William Koether, Jutta Leckey, Mark	Althamer, Paweł Arcangel, Cory Cao Fei Fast, Omer Marclay, Christian Mroué, Rabih Raqs Media Collective Sehgal, Tino Sillman, Amy Trecartin, Ryan Vo, Danh
2000 Tate Modern opens in London; 'Force Fields: Phases of the Kinetic' exhib., Barcelona and London; 'After the Wall: Art and Culture in Post-Communist Europe' exhib., Stockholm; 'Media_City Seoul 2000' exhib., Seoul; 'Fuck Off' exhib., Shanghai; 2001 9/11 attacks in New York, Washington and Pennsylvania; 2002 US invades Afghanistan; 'No Ghost, Just A Shell: The Ann Lee Project' exhib., Zürich; 'Cher Peintre, Lieber Maler, Dear Painter' exhib., Paris; 2003 Second Gulf War in Iraq; 2004 'A Minimal Future? Art as Object' exhib., MoCA, LA; 'Between Past and Future: New Photography and Video From China' exhib., New York, Chicago, Seattle, Berlin and Santa Barbara; 'Cut / Film as Found Object in Contemporary Video' exhib., Miami, Milwaukee, and Tulsa; 2005 'Uncertain States of America' exhib., Astrup Feamley Museum of Modern Art, Oslo; 'Part Object Part Sculpture' exhib., Columbus, Ohio; 'The Wall: Reshaping Chinese Contemporary Art' exhib., Beijing and Buffalo; 2006 Saddam Hussein executed; Manifesta 6 cancelled in Nicosia, restaged as experimental school, 'unitednationsplaza', Berlin; 2007 'WACK! Art and the Feminist Revolution' exhib., MoCA, LA; 'Global Feminisms' exhib., Brooklyn Museum, New York; 'Death of Sol LeWitt; 2008 World financial crisis; 'theanyspacewhatever' exhib., Gugenheim Museum, New York; 'Political/Minimal' exhib., Berlin and Lodz; Death of Robert Rauschenberg: 2009 'Altermodern' exhib., Tate Britain, London; 'The Generational: Younger Than Jesus' exhib., New Museum, New York; 'Modernologies: Contemporary Artists Researching Modernity and Modernism' exhib., MACBA, Barcelona	2011 Arab Spring and Libyan civil war; Muammar Gaddafi killed; Occupy protests begin on Wall Street; September 11' exhib., PS1, New York; Death of Cy Twombly; 2012 'The Ungovernables' exhib., New Museum, New York; dOCUMENTA (13) in Kassel, Cairo, Kabul and Banff; Death of Mike Kelley; 2013 'When Attitudes Become Form: Bern 1969/Venice 2013' exhib., Fondazione Prada, Venice

Select Bibliography

1960s

Baker, K., Minimalism: Art of Circumstance, N.Y., 1988 Battcock, G., ed., Minimal Art: A Critical Anthology, N.Y., 1968. Includes Michael Fried's 'Art and Objecthood', Richard

Wollheim's 'Minimal Art' and Robert Morris's 'Notes on Sculpture' Colpitt, F., Minimal Art: The Critical Perspective, London and Seattle, 1993

Fried, M., Three American Painters, Cambridge, Mass., 1965

Garrels, G., ed., The Work of Andy Warhol, Discussions in Contemporary Culture 3, Seattle, 1989

Hendricks, J., ed., Fluxus Codex, Detroit and N.Y., 1988

Kellein, T., and J. Hendricks, Fluxus, London and N.Y., 1995

Lippard, L. R., Pop Art, London and N.Y., McShine, K., ed., Andy Warhol: A

Retrospective, N.Y. and Boston, 1989 Restany, P., 'Le Nouveau Réalisme à la Conquête de New York', in Art International, January 1963

Russell, J., and S. Gablik, Pop Art Redefined, London and N.Y., 1969

Spoerri, D., An Anecdoted Topography of Chance, N.Y., 1966; London, 1995 Swenson, G., What is Pop Art?, in Art News, November 1963 and February

Warhol, A., The Philosophy of Andy Warhol: From A to B and Back Again, London and N.Y., 1975

1960s-1970s

Alberro, A., and B. Stimson, Conceptual Art: A Critical Anthology, London and Cambridge, Mass., 1999

Aliaga, J. V., and J. M. Cortes, eds, Arte Conceptual Revisado (Conceptual Art Revisited), Valencia, 1990

Battcock, G., The New Art: A Critical Anthology, N.Y., 1966

Battcock, G., ed., Idea Art: A Critical Anthology, N.Y., 1973. Includes Joseph Kosuth's 'Art After Philosophy'

Buchloh, B., ed., Broodthaers: Writings, Interviews, Photographs, London and Boston, 1988

Celant, G., Arte Povera: Conceptual, Actual or Impossible Art?, London and Milan,

Celant, G., The Knot: Arte Povera at P.S.I. N.Y., 1985

Christov-Bakargiev, C., ed., Arte Povera, London, 1999

Concept Art, Minimal, Arte Povera, Land Art, Stuttgart, 1990

Godfrey, T., Conceptual Art, London, 1998 Goldstein, A., and A. Rorimer, eds, Reconsidering the Object of Art: 1965-1975, L.A. Museum of Contemporary Art, London and Boston, 1995

Harrison, C., Essays on Art & Language, Oxford and Cambridge, Mass., 1991 Holt, N., ed., The Writings of Robert Smithson, N.Y., 1979

Kosuth, J., Art After Philosophy and After: Collected Writings 1966-1990, London and Cambridge, Mass., 1991

Lippard, L. R., Six Years: The Dematerialisation of the Art Object from 1966 to 1972, London, 1973

McShine, K., ed., Information, N.Y., 1970 Meyer, U., Conceptual Art, N.Y., 1972

Morgan, R. C., Art Into Ideas: Essays on Conceptual Art, Cambridge, N.Y. and Melbourne, 1996

Szeeman, H., Live in Your Head - When Attitudes Become Form: Works, Concepts, Processes, Situations, Information, Bern,

1970s

Baker, E., and T. Hess, eds, Art and Sexual Politics: Women's Liberation, Women Artists and Art History, London and N.Y., 1973. Includes Linda Nochlin's 'Why Have There Been No Great Women Artists?'

Battcock, G., ed., Super-Realism, N.Y., 1975

Battcock, G., ed., New Artists Video: A Critical Anthology, N.Y., 1978

Battcock, G., with R. Nickas, eds, The Art of Performance: A Critical Anthology, N.Y., 1984

Beardsley, J., Earthworks and Beyond, N.Y., 1989

Benamou, M., and C. Caramello, eds. Performance in Postmodern Culture, University of Wisconsin, Milwaukee,

Broude, N., and M. D. Garrard, eds. The Power of Feminist Art, London and N.Y., 1994

Chicago, J., Through the Flower: My Struggle as a Woman Artist, N.Y., 1975 Chicago, J., The Dinner Party: A Symbol of

Our Heritage, N.Y., 1979 Cockroft, E., J. Weber and J. Cockroft,

Toward a People's Art: The Contemporary Mural Movement, N.Y., 1977 Goldberg, R., Performance Art, London

and N.Y., 1988 Lippard, L. R., Eva Hesse, N.Y., 1976

Lippard, L. R., From the Center: Feminist Essays on Women's Art. N.Y., 1976

Lippard, L. R., Overlay: Contemporary Art and the Art of Prehistory, N.Y., 1983 Lippard, L. R., Get the Message? A Decade

of Art for Social Change, N.Y., 1984 Nochlin, L., 'Why Have There Been No

Great Women Artists?' in Women, Art, and Power and Other Essays, London and N.Y., 1989

Parker, R., and G. Pollock, Old Mistresses: Women, Art and Ideology, London and N.Y., 1981

Popper, F., Art, Action and Participation, Paris and N.Y., 1975

Sayre, H., The Object of Performance: The American Avant-Garde Since 1970, London and Chicago, 1989

Sonfist, A., ed., Art on the Land: A Critical Anthology of Environmental Art, N.Y.,

Tisdall, C., Joseph Beuys, London and N.Y., 1979

1980s

Cameron, D., NY Art Now: The Saatchi Collection, London, 1988

Chadwick, W., Women, Art, and Society, London and N.Y., rev. edn, 1996

Crimp, D., and A. Rolston, AIDS Demo Graphics, Seattle, 1990 Gudis, C., ed., A Forest of Signs: Art in the

Crisis of Representation, London and Boston, 1989

Hoet, J., Chambres d'Amis, Ghent,

Joachimedes, C., ed., A New Spirit in Painting, London, 1981

Joselit, D., and E. Sussman, eds, Endgame: Reference and Simulation in Recent Painting and Sculpture, London and Boston, 1986

Levin, K., Beyond Modernism: Essays on Art from the '70s and '80s, Cambridge and N.Y., 1988

Livingstone, M., Pop Art: A Continuing History, London and N.Y., 1990

Magiciens de la Terre, Centre Georges Pompidou, Paris, 1989

McEvilley, T., Art and Otherness: Crisis in Cultural Identity, N.Y., 1992

Michelson, A., et al., eds, 'October': The First Decade, London and Boston, 1987 Modern Dreams: The Rise and Fall and Rise

of Pop, London and Cambridge, Mass., Oliva, A. B., La Transavanguardia Internazionale (The International

Transavant-garde), Milan, 1982 Owens, C., Beyond Recognition: Representation, Power, and Culture, Oxford and Berkeley, 1992

Pollock, G., Vision and Difference: Femininity, Feminism and the Histories of Art, London and N.Y., 1988

Saltz, J., ed., Beyond Boundaries: New York's New Art, N.Y., 1986

Tomkins, C., Post to Neo: The Art World of the 80s, N.Y., 1988

Wallis, B., ed., Art After Modernism: Rethinking Representation, N.Y. and Boston, 1984

Wallis, B., ed., with T. Finkelpearl, eds, This is Tomorrow Today: The Independent Group and British Pop Art, N.Y., 1987

Weyergraf-Serra, C., and M. Suskirk, eds, The Destruction of Tilted Arc, London and Boston, 1991

Zeitgeist, Berlin, 1982

Cooke, L., and M. Francis, Carnegie International 1991, N.Y., 1992 Deitch, I., et al., The Dakis Joannou Collection, N.Y. and Ostfildern, 1996

Krauss, R., et al., eds, October: The Second Decade, 1986-96, London and Cambridge, Mass., 1998

McEvilley, T., The Exile's Return: Toward a Redefinition of Painting for the Postmodern Era, Cambridge, 1993

Oliva, A. B., ed., *Ubi Fluxus Ibi Motus* 1990–1962, 44th Venice Biennale, Milan, 1990

Popper, F., Art of the Electronic Age, London and N.Y., 1993

Stallabrass, J., High Art Lite: British Art in the 1990s, London and N.Y., 1999

Wallis, B., ed., If You Lived Here: The City in Art, Theory, and Social Activism, Discussions in Contemporary Culture 6. Seattle. 1991

2000s

Belting, H., A. Buddensieg and P. Weibel, The Global Contemporary and the Rise of New Art Worlds, Cambridge, Mass., 2013

Birnbaum, D., I. Graw and N. Hirsch, eds, Thinking through Painting: Reflexivity and Agency beyond the Canvas, Berlin, 2012

Cotter, S., et al., Contemporary Art in the Middle East, London, 2009

Demos, T. J., Return to the Postcolony: Specters of Colonialism in Contemporary Art. Berlin, 2013

Gao, M., Total Modernity and the Avant-Garde in Twentieth-Century Chinese Art, Cambridge, Mass., 2011

Heiser, J., All of a Sudden Things that Matter in Contemporary Art, Berlin, 2008

Joselit, D., After Art, Princeton, 2012 Lee, P. M., Chronophobia: On Time in the Art of the 1960s, Cambridge, Mass., 2004

Lütticken, S., History in Motion: Time in the Age of the Moving Image, Berlin, 2013

Merewether, C., The Archive (Documents of Contemporary Art), London, 2006

Pontbriand, C., The Contemporary, the Common: Art in a Globalizing World, Berlin, 2013

Raqs Media Collective, Seepage, Berlin, 2010

Schwabsky, B., Words for Art Criticism, History, Theory, Practice, Berlin, 2013

WACK! Art and the Feminist Revolution, Los Angeles and Cambridge, Mass., 2007

Weiss, R., et al., Making Art Global Part I: The Third Havana Biennial 1989, Vienna, Eindhoven and London, 2011

Yao, P. J., R. Ho and W. Wei, 3 Years: Arrow Factory, Berlin, 2011

General

Bois, Y.-A., Painting as Model, Boston, 1990

Bois, Y.-A., with R. Krauss, L'Informe: mode d'emploi, Centre Georges Pompidou, Paris, 1996

Buchloh, B. H. D., Neo-Avantgarde and Culture Industry: Essays on European and American Art from 1955 to 1975, Cambridge, Mass., 2001

Crane, D., The Transformation of the Avant-Garde: The New York Art World: 1940–1985, Chicago, 1987

de Oliveira, N., N. Öxley, M. Petry, with texts by M. Archer, *Installation Art*, London and Washington D.C., 1994 Foster, H., ed., *The Anti-Aesthetic: Essays in*

Postmodern Culture, Seattle, 1983 Foster, H., ed., Recodings: Art, Spectacle, Cultural Politics, Seattle, 1985

Foster, H., ed., Discussions in Contemporary Culture I, Seattle, 1987 Foster, H., ed., Vision and Visuality,

Discussions in Contemporary Culture 2, Seattle, 1988

Foster, H., The Return of the Real: The Avant-Garde at the End of the Century, London and Cambridge, Mass., 1996 Frascina, F., ed., Pollock and After: The

Critical Debate, London and N.Y., 1985 Geldzahler, H., New York Painting and Sculpture: 1940–1970, N.Y., 1969

Graham, D., Rock My Religion: Writings and Projects 1965–90, Boston, 1993 Greenberg, Clement, Homemade

Esthetics: Observations on Art and Taste,
Oxford and N.Y., 1999

Hertz, R., ed., Theories of Contemporary Art, London and N.J., 1985 Judd, D., Complete Writings 1959–75, Nova Scotia and N.Y., 1975 Krauss, R., Passages in Modern Sculpture,

London and N.Y., 1977 Krauss, R., A Voyage on the North Sea: Art

in the Age of the Post-Medium Condition, London and N.Y., 2000 Kuspit, D., The Cult of the Avant-Garde

Artist, Cambridge and N.Y., 1996
Kuspit, D., Signs of Psyche in Modern and

Postmodern Art, Cambridge and N.Y., 1996 Littlefield Kasfir, S., Contemporary African

Art, London and N.Y., 1999 Newman, A., Challenging Art: Artforum, 1962–1974, N.Y., 2000

O'Doherty, B., Inside the White Cube: The Ideology of the Gallery Space, London and San Francisco, 1986

Out of Actions: Between Performance and the Object, 1949–1979, London and N.Y., 1998

Pincus-Witten, R., Postminimalism into Maximalism: American Art, 1966–1986, Ann Arbor, 1987

Powell, R. E., Black Art and Culture in the Twentieth Century, London and N.Y., 1997

Refigured Painting: The German Image 1960–88, Solomon R. Guggenheim Museum, N.Y., 1988

Rorimer, A., New Art in the 60s and 70s: Redefining Reality, London and N.Y., 2001

Rush, M., New Media in Late 20th-Century Art, London and N.Y., 1999

Sandler, I., Art of the Postmodern Era: From the Late 60s to the Early 90s, N.Y., 1996 Stiles, K., and P. Selz, Theories and

Documents of Contemporary Art: A Sourcebook of Artists' Writings, London and Berkeley, L.A., 1996 Waldman, D., Collage, Assemblage and the

Found Object, London and N.Y., 1992 Warr, T., and A. Jones, eds, *The Artist's Body*, London, 2000

List of Illustrations

Measurements are given in centimetres, followed by inches, height before width before depth, unless otherwise stated

I Gerhard Richter 256 Colours 1974 (repainted 1984). Enamel paint on canvas, 222 × 414 (87½ × 163). Städtisches Kunstmuseum, Bonn. Richter no. 352/3. © Gerhard Richter; 2 Mierle Ukeles Touch Sanitation 1978–80. Courtesy Ronald Feldman Fine Arts, New York. Photo Marcia Bricker; 3 Robert Rauschenberg Bed 1955. Combine painting; oil and pencil on pillow, quilt, and sheet on wood supports, 191.1 × 80 × 20.3 (75½ × 31½ × 8). The Museum of

Modern Art, New York. Gift of Leo Castelli in honor of Alfred H. Barr, Jr. Photo @ 1997 The Museum of Modern Art, New York. © Robert Rauschenberg/DACS, London/VAGA, New York 2002; 4 Jean Tinguely Homage to New York 1960. Mixed media, destroyed. Photo © David Gahr 1960. © ADAGP, Paris and DACS, London 2002; 5 Robert Rauschenberg Buffalo II 1964. Oil and silkscreen ink on canvas, 243.9 × 182.9 (96 × 72). Private collection. © Robert Rauschenberg/DACS, London/ VAGA, New York 2002; 6 Roy Lichtenstein I Know How You Must Feel, Brad 1963. Oil and magna on canvas, $168.9 \times 95.9 (66\frac{1}{2} \times 37\frac{3}{4})$. The Ludwig Collection, Wallraf-Richartz Museum, Cologne. © Roy Lichtenstein/ DACS 2002; 7 Jasper Johns Flag 1954-55;

dated on reverse 1954. Encaustic, oil and collage on fabric mounted on plywood, 107.3 × 153.8 (421/4 × 605%). The Museum of Modern Art, New York. Gift of Philip Johnson in honor of Alfred H. Barr, Jr. Photo © 1997 The Museum of Modern Art, New York. © Jasper Johns/DACS, London/VAGA, New York 2002; 8 James Rosenquist F-111 1965. Oil, canvas and aluminium, 3.05 × 26.21 m (10 × 86 ft). Private collection. Photo Rudolf Burckhardt. © James Rosenquist/ DACS, London/VAGA, New York 2002; 9 Andy Warhol Brillo Boxes 1964. Silkscreen ink on wood, each box, 43.5 × 43.5 × 35.6 (171/8) \times 17 $\frac{1}{8}$ \times 14). Installed at the Stable Gallery, 1964. Photo John Schiff. Courtesy The Andy Warhol Foundation for the Visual Arts, Inc. © ARS, NY and DACS, London 2002; 10

Andy Warhol Do-It-Yourself (Flowers) 1962. Synthetic polymer paint, type and pencil on canvas, 175 × 150 (69 × 59). Private collection. Photo courtesy Alesco AG, Zurich. @ ARS, NY and DACS, London 2002; II Roy Lichtenstein Little Big Painting 1965. Oil and magna on canvas, 172.7 × 203.2 (68 × 80). Whitney Museum of American Art, New York. Photo Rudolf Burckhardt. © Roy Lichtenstein/DACS 2002; 12 Claes Oldenburg The Store, 107 East Second Street, New York, December 1961 (interior view). Courtesy the artist; 13 Tom Wesselmann Great American Nude No. 54 1964. Museum Moderner Kunst Stiftung Ludwig, Vienna, formerly Hahn Collection, Cologne. © Tom Wesselmann/DACS, London/VAGA, New York 2002; 14 Ed Kienholz Roxy's 1961. Mixed media assemblage, various dimensions. Courtesy L. A. Louver Gallery, Venice, California; 15 Edward Ruscha Actual Size 1962. Oil on canvas, 170.2 × 182.9 (671/16 × 721/16). Los Angeles County Museum of Art, Anonymous Gift through the Contemporary Art Council; 16 David Hockney Doll Boy 1960-61. Oil on canvas, 122 × 99 (48 × 39). Hamburger Kunsthalle. © David Hockney; 17 Jesús Rafaël Soto Cube of Ambiguous Space 1969. Plexiglass and paint, 250 × 250 × 250 (981/2 × 981/2 × 981/2). Soto Foundation, Soto Museum, Ciudad Bolívar, Venezuela. Courtesy the artist; 18 Victor Vasarely, plate 2 from the portfolio Planetary Folklore 1964. Serigraph, printed in colour, composition: $62.7 \times 60 (24^{11}/_{16} \times 23^{5/8})$. The Museum of Modern Art, New York. Larry Aldrich Fund. Photo © 1997 The Museum of Modern Art, New York, © ADAGP, Paris and DACS, London 2002; 19 Bridget Riley Twist 1963. Emulsion on wood, 121.9 × 116.2 (48 \times 45 $\frac{3}{4}$). Courtesy the artist; 20 Günther Uecker Kreis, Kreise 1970, Painted nails on wood, 149.9 × 149.9 (59 × 59). Stiftung Ludwig Roselius Museum, on loan to the Neues Museum Weserburg, Bremen. Photo © Jörg Michaelis, Bremen; 21 Michelangelo Pistoletto Two People 1962. Painted tissue paper on mirrored stainless steel, 200 × 120 (783/4 × 471/4). Private collection, New York. Photo P. Bressano, Turin. Courtesy Maria and Michelangelo Pistoletto; 22 John Chamberlain Miss Lucy Pink 1963. Painted steel, 119.4 × 106.7 × 99.1 (47 × 42 × 39). Photo courtesy Pace Wildenstein, New York. @ ARS, NY and DACS, London 2002; 23 César (César Baldaccini) The Yellow Buick 1961. Compressed automobile 151.1 × 77.7 × 63.5 $(59\frac{1}{2} \times 30\frac{3}{4} \times 24\frac{7}{8})$. The Museum of Modern Art, New York. Gift of Mr and Mrs John Rewald. Photo © 1997 The Museum of Modern Art, New York. @ ADAGP, Paris and DACS, London 2002; 24 Jacques de la Villegé Angers, 21 Septembre 1959 1959. Décollage on canvas, 162 × 130 (633/4 × 51 1/8). Musée d'Art et d'Histoire, Geneva. © ADAGP, Paris and DACS, London 2002; 25 Yayoi Kusama Air Mail Stickers 1962. Collage on canvas, 181.6 × 171.5 (711/2 × 671/2). Whitney Museum of American Art, New York. Gift of Mr. Hanford Yang, Acc. No. 64.34. Photo © 1996 Whitney Museum of American Art, New York. Photo Pierre Dupuy, Stamford, Connecticut; 26 Arman

(Armand P. Arman) Arteriosclerose 1961. Accumulation of forks and spoons in a box, $47.5 \times 72.5 \times 7.5 (18\frac{1}{4} \times 28\frac{5}{8} \times 3)$ © ADAGP, Paris and DACS, London 2002; 27 Piero Manzoni making The Artist's Breath 1961; 28 Yves Klein Celebration of a New Anthropometric Era 1960. Paint on canvas, life-size bodyprints. Courtesy Galerie Karl Flinker, Paris. Photo Jean Dubout, Paris. © ADAGP, Paris and DACS, London 2002; 29 Gerhard Richter Olympia 1967. Oil on canvas, 200 × 130 (783/4 × 511/4). Private collection; 30 Konrad Lueg and Gerhard Richter A Demonstration for Capitalist Realism, Bergeshaus, Flingerstraße II, Düsseldorf, II October 1963. Photo courtesy Konrad Fischer, Düsseldorf; 31 Sigmar Polke Moderne Kunst 1968. Acrylic and oil on canvas, 150 × 125 (59 × 491/4). Courtesy René Block, Berlin; 32 Colin Self Two Waiting Women and B58 Nuclear Bomber 1963. Oil on board, 119 × 181.5 (47 × 711/2). Photo courtesy the artist. © Colin Self 2002. All Rights Reserved, DACS; 33 Wolf Vostell Berlin-Fieber V 1973. 130 × 120 (511/8 × 471/4). Photo courtesy Galerie Inge Baecker, Cologne. © DACS 2002; 34 Andy Warhol Silver Disaster: Electric Chair 1963. Acrylic and silkscreen on canvas, 100 × 150 (39 × 60). Sonnabend Collection, New York. @ ARS, NY and DACS, London 2002; 35 Morris Louis Omicron 1961. Synthetic polymer paint on canvas, 262.3 × 412 (1031/4 × 1621/4). Photo Waddington Gallery, London; 36 Kenneth Noland Song 1958. Synthetic polymer, 165.1 × 165.1 (65 × 65). Whitney Museum of American Art, New York. © Kenneth Noland/DACS, London/VAGA New York 2002: 37 Ellsworth Kelly Orange/ Green 1966. Oil on canvas, 223.5 × 165.1 (88 × 65). Courtesy Sidney Janis Gallery, New York; 38 Richard Smith Tailspan 1965. Acrylic on wood, 119.9 × 212.7 × 90.2 (471/4 × 833/4 × 351/2). © Tate Gallery, London; 39 Anthony Caro Prairie 1967. Steel painted yellow, 96.5 × 581.7 × 320 (38 × 229 × 126). Private collection. Courtesy the artist; 40 Phillip King Genghis Khan 1963. Purple reinforced plastic, 213.4 × 365.8 (84 × 144). Private collection. Courtesy the artist; 41 Robert Morris Untitled (Slab) 1968 (reconstruction of first version in plywood 1962). Painted steel, 243.8 × 243.8 × 20.3 (96 × 96 × 8), © ARS, NY and DACS, London 2002; 42 Donald Judd Untitled 1965. Galvanized iron and aluminium, 83.8 × 358.1 × 76.2 (33 × 141 × 30). Private collection. Photo Rudolf Burckhardt, © Estate of Donald Judd/DACS, London/VAGA, New York 2002; 43 Frank Stella Getty's Tomb, II 1959. Enamel on canvas, 213.4 × 243.8 (84 × 96). Los Angeles County Museum of Art, Los Angeles, California (purchased with Contemporary Art Council funds). © ARS, NY and DACS, London 2002; 44 Barnett Newman Who's Afraid of Red, Yellow and Blue III 1966-67. Oil on canvas, 243.8 × 543.56 (96 × 214). Stedelijk Museum, Amsterdam. Photo courtesy The Barnett Newman Foundation, New York; 45 Dan Flavin The Nominal Three (To William of Ockham) 1963. Fluorescent light, overall size, 182.8 × 133.3 (72 × 521/2). Solomon R. Guggenheim Museum, New York. Photo David Heald © The Solomon R. Guggenheim Foundation,

New York. FN 91.3698. © ARS, NY and DACS, London 2002; 46 Donald Judd's permanent installation of works, East Building, La Mansana de Chinati, Marfa, Texas. Photo courtesy Donald Judd Estate. © Estate of Donald Judd/DACS, London/VAGA, New York 2002; 47 Donald Judd Untitled 1968. Amber, plexiglass and stainless steel, 83.8 × 172.7 × 121.9 (33 × 68 × 48). Photo courtesy Donald Judd Estate. © Estate of Donald Judd/ DACS, London/VAGA, New York 2002; 48 Frank Stella Delaware Crossing from 'Benjamin Moore' series 1961. Alkyd on canvas, 195.6 × 195.6 (77 × 77). Private collection. © ARS, NY and DACS, London 2002; 49 Carl Andre Equivalents I-VIII 1966. Sand-lime bricks, each $6.4 \times 11.4 \times 22.9$ ($2\frac{1}{2} \times 4\frac{1}{2} \times 9$). Installed at Tibor de Nagy Gallery, New York, 1966. Photo courtesy Paula Cooper Gallery, New York. © Carl Andre/DACS, London/VAGA, New York 2002; 50 Carl Andre 37 Pieces of Work Fall 1969. Aluminium, copper, steel, lead, magnesium and zinc; total size 10.97 × 10.97 m (36 × 36 ft): 1296 units, 216 of each metal, each unit 30.5 × 30.5 × 1.9 (12 × 12 × 3/4). Collection Dwan Gallery, New York. As installed for the exhibition 'Carl Andre' on the rotunda floor of the Solomon R. Guggenheim Museum, New York. Photo Robert E. Mates and Paul Katz. Photo © The Solomon R. Guggenheim Foundation, New York. © Carl Andre/DACS, London/VAGA, New York 2002; 51 Robert Morris Untitled 1965. Plexiglass mirror on wood, four pieces each 71.1 × 71.1 × 71.1 (28 × 28 × 28). Installed at Green Gallery, New York, February 1965. © ARS, NY and DACS, London 2002; 52 John McCracken There's No Reason Not To 1967. Wood and fibreglass, 304.8 × 45.7 × 8.9 (120 × 18 × 31/2). Nicholas Wilder Gallery, Los Angeles; 53 Richard Serra One Ton Prop (House of Cards) 1968-69. Lead plates each 139.7 × 139.7 (55 × 55). Private collection. @ ARS, NY and DACS London 2002; 54 Eva Hesse Hang Up 1966. Acrylic on cloth, wood and steel, 182.8 × 213.3 × 198.1 (72 × 84 × 78). The Art Institute of Chicago. © Estate of Eva Hesse. Courtesy Robert Miller Gallery, New York; 55 Eva Hesse Accretion 1968. Fibreglass and polyester resin, 50 units each 148.6 × 6.3 (581/2 × 21/2). Kröller-Müller Museum, Otterlo, The Netherlands. © Estate of Eva Hesse. Courtesy Robert Miller Gallery, New York; 56 Bruce Nauman Composite Photo of Two Messes on the Studio Floor 1967. Gelatinsilver print, 102.9 × 312.4 (401/2 × 123). The Museum of Modern Art, New York, Gift of Philip Johnson. Photo © 1997 The Museum of Modern Art, New York. @ ARS, NY and DACS, London 2002; 57 Lynda Benglis For Carl Andre 1970. Pigmented polyurethane foam, 142.9 × 135.3 × 118.11 (561/4 × 531/4 × 461/2). Collection of the Modern Art Museum of Fort Worth, Fort Worth, Texas. Museum purchase, The Benjamin J. Tillar Memorial Trust. © Lynda Benglis/DACS, London/ VAGA, New York 2002; 58 Robert Ryman Winsor 6 1965. Oil on linen, 192.5 × 192.5 (753/4 × 753/4). Private Collection; 59 Barry Flanagan four cash 2'67, ring/1'67, rope (gr 2sp 60) 6'67 1967. Cloth, 32 × 52 × 48 (121/2 × 201/2 × 19). Arts Council Collection, London: **60** Sol LeWitt Four basic kinds of straight lines and their combinations 1969. Courtesy Lisson

Gallery, London. © ARS, NY and DACS, London 2002; 61 Sol LeWitt Four basic colours and their combinations 1971. Courtesy Lisson Gallery, London, © ARS, NY and DACS, London 2002: 62 Niele Toroni Présentation: imprints of a no. 50 brush repeated at regular intervals of 30 cm 1966-96. Courtesy the artist; 63 Daniel Buren Opéra from Legend I April 1970. Photograph album, Warehouse Publications, London 1973. © Daniel Buren, 1973. © ADAGP, Paris and DACS, London 2002; 64 Hanne Darboven Untitled 1968, Ink on graph paper, 28×21.5 (11 × $8\frac{1}{2}$). Wadsworth Athenaeum, Hartford, Connecticut. LeWitt Collection. Courtesy Sperone Westwater, New York; 65 On Kawara I am still alive and a response from Sol LeWitt. Projects for Lucy R. Lippard's contribution to July/August Exhibition Book, organized by Seth Siegelaub and presented in Studio International (July-August 1970), pp. 36-37; 66 Lawrence Weiner A 36" × 36" removal to the lathing or support wall of plaster or wallboard from a wall 1968. Collection of the Siegelaub Collection & Archives. Installation photo at the exhibition 'January 5-31, 1969'. Exhibition organized and published by Seth Siegelaub. Photo by Seth Siegelaub. Courtesy of The Seth Siegelaub Collection & Archives. © ARS, NY and DACS, London 2002; 67 Douglas Huebler Site Sculpture Project, 50 Mile Piece. Haverhill, Mass. - Putney, Vt. - New York City 1968. Private collection. Installation photo at the exhibition 'January 5-31, 1969'. Exhibition organized and published by Seth Siegelaub. Photo by Seth Siegelaub. Courtesy of The Seth Siegelaub Collection & Archives. © ARS, NY and DACS, London 2002; 68 Joseph Kosuth One and Three Chairs 1965. Wooden folding chair, photographic copy of a chair, and photographic enlargement of a dictionary definition of a chair; chair 82 × $37.8 \times 53 (32\frac{3}{8} \times 14\frac{7}{8} \times 20\frac{7}{8})$; photo panel 91.5×61.1 (36 × 24 /₈); text panel 61 × 61.3 (24 × 241/8). The Museum of Modern Art, New York. Larry Aldrich Foundation Fund. Photo © 1997 The Museum of Modern Art, New York, © ARS, NY and DACS, London 2002; 69 John Baldessari Everything is purged from this painting but art; no ideas have entered this work 1966-68. Acrylic on canvas, 172.7 × 143.5 (68 × 561/2). The Michael and Ileana Sonnabend Collection. Photo courtesy Sonnabend Gallery, New York; 70 Robert Barry All the things I know but of which I am not at the moment thinking - 1:36 pm; June 15, 1969 1969. Courtesy the artist; 71 Terry Atkinson and Michael Baldwin Map to not indicate 1967. 50.8 × 62.9 (20 × 243/4). © Tate Gallery, London; 72 Art & Language Index 01 1972. Eight filing cabinets, forty-eight photostats, and one text in frame. Each cabinet 23 × 29 × 62.5 (9 × $11\frac{3}{8}$ × $24\frac{5}{8}$); text 75 × 53 (291/2 × 207/8). Private collection. Installed at 'L'Art Conceptuel, une Perspective', Musée d'Art Moderne de la Ville de Paris, 22 November 1988-18 February 1989. Participating members for this work: Terry Atkinson, David Bainbridge, Michael Baldwin, Ian Burn, Charles Harrison, Harold Hurrell, Joseph Kosuth and Mel Ramsden; 73 Dan Graham Schema 1966. Private collection, Brussels, Photo Gareth

Winters, London, Courtesy Lisson Gallery. London; 74 Marcel Broodthaers Museum of Modern Art, Eagles Department, Section des Figures (The Eagle from the Oligocene to the Present) (detail) 1972. Städtische Kunsthalle. Düsseldorf. Photo @ Gilissen. @ DACS 2002; 75 Jannis Kounellis Horses 1969. Installed at L'Attico Gallery, Rome. Photo courtesy Visual Arts Library, London; 76 Giuseppe Penone Twelve Metre Tree: Ich werde eine Aktion ausführen, die 15 bis 20 Tage dauert. Ich werde ein Holzbrett in die Zeit zurückbringen in der es ein Baum war und zwar in eine Zeit des Baumes, die ich an Ort und Stelle festsetze (I will perform an action which lasts between 15 and 20 days. I will take a plank of wood back to the time when it was a tree and, indeed, to a time whose site and position I will specify) 1970. Wood, 1213 × 25 (4771/2 × 97/8). Moderna Museet, Stockholm. © BUS; 77 Michelangelo Pistoletto Venus of Rags 1967. Cement, mica, rags 180 × 130 × 100 (70% × 51 1/8 × 393/8). Collection Peppino di Bernardo, Naples. Photo courtesy Visual Arts Library, London, Photo © G. Colombo, Milan; 78 Giovanni Anselmo Untitled 1968-86. Granite, lettuce and copper wire, $70 \times 25 \times 25 (27\frac{1}{2} \times 9\frac{7}{8} \times 9\frac{7}{8})$. Private collection, Photo courtesy Visual Arts Library, London; 79 Mario Merz Igloo de Giap 1968. Metal, plastic bags, earth, H 120 (471/4). Musée National d'Art Moderne, Paris, Photo courtesy Visual Arts Library. London; 80 Richard Long Walking a Line in Peru 1972. Photograph. Collection of the artist. Courtesy Anthony d'Offay Gallery, London: 81 Robert Smithson Gravel Mirror with Cracks and Dust 1968, 12 mirrors with gravel, $91.4 \times 548.6 \times 91.4$ (36 × 216 × 36). Estate of Robert Smithson, courtesy John Weber Gallery, New York; 82 Robert Smithson Spiral Jetty, Great Salt Lake, Utah, April 1970. Coil 457.2 m (1500 ft) long and approximately 4.57 m (15 ft) wide. Black rock, salt crystals, earth, red water (algae). Estate of Robert Smithson, courtesy John Weber Gallery, New York; 83 Bernhard and Hilla Becher Typology of Water Towers 1972 (detail). Six suites of nine photographs each, Each photograph 40 × 29.8 (153/4 × $11\frac{3}{4}$); overall 132.4×101.8 (52 $\frac{1}{8} \times 40\frac{1}{16}$). The Eli and Edythe L. Broad Collection, Santa Monica: 84 Ian Hamilton Finlay with Alexander Stoddart Apollon Terroriste, by the Upper Pool, Little Sparta, 1988. Resin and gold leaf. Photo courtesy Ian Hamilton Finlay and Victoria Miro Gallery, London; 85 Walter de Maria Lightning Field 1971-77. 400 stainless steel poles, with solid stainless steel pointed tips, arranged in a rectangular grid array (16 poles wide by 25 poles long) spaced 67.06 m (220 ft) apart, average pole height 6.27 m (20 ft 7 in) but rising to form an even plane. Courtesy Dia Center for the Arts, Corrales, New Mexico, Photo John Cliett, New York; 86 Alice Aycock A Simple Network of Underground Wells and Tunnels, Merriewold West, Far Hills, New Jersey, 1975. Concrete, wood, earth, c. 8.53 × 15.24 \times 2.74 m (28 \times 50 \times 9 ft), destroyed. Courtesy John Weber Gallery, New York; 87 Mary Miss Untitled, Battery Park, New York City, 1973. Wood, 3.66 × 1.83 m (12 × 6 ft); sections at 15.24 m (50 ft) intervals. Courtesy the artist; 88 Bruce Nauman Green

Light Corridor 1970-71. Wallboard and fluorescent light, variable dimensions. Giuseppe Panza di Biumo, Milan. © ARS, NY and DACS, London 2002; 89 Dan Graham Present Continuous Past(s) 1974. Video camera, video tape, video monitor, mirrors, Musée National d'Art Moderne, Paris. Installed at Projekt, Kunsthalle, Cologne, 1974; 90 Bruce Nauman Self-Portrait as a Fountain 1966-70. Photograph, 50.2 × 57.8 (193/4 × 223/4). Photo courtesy Leo Castelli Gallery, New York. © ARS, NY and DACS, London 2002; 91 Gilbert and George Singing Sculpture 1970. Photo courtesy Nigel Greenwood Inc.; 92 Vito Acconci Trappings 14 October 1971. Performance/installation, Warehouse, Mönchengladbach, Germany. A programme of simultaneous performances. Duration 1 hour. Courtesy Barbara Gladstone Gallery, New York; 93 Valie Export Tapp und Tast Kino (Touch Cinema) 1968. Expanded cinema. street action, mobile film, body action, social action. Photo Werner Schulz, Munich. © DACS 2002; 94 Marina Abramovic Rhythm 0 1974, Performed at Studio Mona Gallery. Naples. Duration 6 hours. Courtesy Sean Kelly, New York; 95 Joseph Beuys How to Explain Pictures to a Dead Hare 1965. Presented at the Galerie Schmela. Düsseldorf, Photo Ute Klophaus, Wuppertal. © DACS 2002; 96 Joseph Beuys Coyote, 'I like America and America likes Me' 1974. René Block Gallery, New York, Photo Caroline Tisdall, © DACS 2002: 97 Hans Haacke Shabolsky et al. Manhattan Real Estate Holdings, a Real-Time Social System, as of May 1, 1971 1971. 2 maps, 142 black-and-white photographs with typewritten data sheets framed in 23 sets of 6 per frame and 1 set of 4 per frame, 6 charts and explanatory panel (ed. 2). Maps: each 61 × 50.8 (24 × 20); photographs and data sheets: each 50.8 × 19.1 (20 × 71/2) (framed sets, 23 at 53.3 × 110.5 [21 × 43½] and one at 54.6 × 76.2 [21½ \times 301); charts: each 61 \times 25.4 (24 \times 10); panel: 61 × 50.8 (24 × 20). Collection the artist. Photo Hans Haacke. Courtesy John Weber Gallery, New York. © DACS 2002; 98 Leon Golub Interrogation II 1981. Acrylic on canvas, 304.8×426.7 (120 × 168). The Art Institute of Chicago. Gift of the Society for Contemporary Art, 1983.264. Photo © 1996, The Art Institute of Chicago. All Rights Reserved; 99 Judy Chicago The Dinner Party 1974-79. Mixed media, 14.33 × 14.33 × 14.33 m (47 × 47 × 47 ft). Photo Michael Alexander, courtesy Through The Flower Corporation; 100 Monica Sjoo God Giving Birth 1968. Oil on hardboard, 183 × 122 (72 × 48). Museum Anna Nordlander, Skellefteå, Sweden. Photo courtesy the artist; 101 Eva Hesse Accession V 1968. Galvanized steel and rubber tubing, $25.4 \times 25.4 \times 25.4$ (10 × 10 × 10). LeWitt Collection, on loan to the Wadsworth Atheneum, Hartford, Connecticut. © Estate of Eva Hesse. Courtesy Robert Miller Gallery, New York: 102 Louise Bourgeois Fillette 1968. Latex, L 59.7 (231/2). © Louise Bourgeois. Courtesy Robert Miller Gallery, New York; 103 Nancy Graves Paleo-Indian Cave Painting, Southwestern Arizona (To Dr. Wolfgang Becker) 1970-71. Steel, fibre glass, oil paint, acrylic and 3 wood boards, 396.2 × 274.3 × 228.6 (156 × 108 × 90). Neue Galerie der Stadt, Aachen.

Sammlung Ludwig. Gift of the artist. Photo Ann Münchow. © Estate of Nancy Graves/ DACS, London/VAGA, New York 2002; 104 Harmony Hammond Presence IV 1972. Cloth and acrylic, 208.3 × 73.7 × 35.6 (82 × 29 × 14). Collection Best Products, Inc. Photo Dale Anderson; 105 Louise Bourgeois Femme Couteau 1969-70. Pink marble, L 66 (26). © Louise Bourgeois. Courtesy Robert Miller Gallery, New York; 106 Adrian Piper I Am the Locus #2 1975. Oil crayon drawing on photograph, 20.3 × 25.4 (8 × 10). Courtesy John Weber Gallery, New York; 107 May Stevens Rosa from Prison from the Ordinary/Extraordinary series 1977-80. Mixed media, 76.2 × 114.3 (30 × 45). Private collection. Courtesy Mary Ryan Gallery, New York; 108 Nancy Spero Torture of Women 1976 (detail; panel 10 of 14 panels). Handpainting and typewriter collage on paper, 0.51 × 38.1 m (1 ft 8 in × 125 ft). Courtesy of the Jack Tilton Gallery, New York and P. P. O. W., New York; 109 Mary Kelly Post Partum Document, Documentation VI 1978-79. 15 slate and resin units, each 35.6 × 27.9 (14 × 11). Arts Council Collection, London; 110 Rebecca Horn Unicorn 1970-72. Fabric and wood, dimensions variable. Appears in the eponymous film, 1970, and in the film Performances II 1973. © DACS 2002; III, 112 Susan Hiller Dedicated to the Unknown Artists 1972-76. Postcards, charts and maps mounted on boards; 14 panels, each 69.5 x 109.2 (273/8 × 43). Installed size variable; book of 56 photographs (Rough Sea) and notes. Courtesy the artist; 113 Christo (Javacheff) and Jeanne-Claude (de Guillebon) Wrapped Coast, Little Bay, Australia 1969. One million square feet of Erosion Control fabric and 36 miles of polypropylene rope. The coast remained wrapped for a period of 10 weeks from 28 October 1969, then all materials were removed and the site returned to its original condition. Copyright Christo 1969. Photo Harry Shunk; 114 Maya Ying Lin Vietnam Veterans Memorial 1982. Washington Convention and Visitors Association; 115 Gordon Matta-Clark Splitting 1974. Black-and-white photocollage, 101.6 × 76.2 (40 × 30). Collection of Jane Crawford; 116, 117 Exterior and interior views of the Museum of Contemporary Art, Chicago with Michael Asher's work installed, 8 June-12 August 1979; 118 Art & Language V. I. Lenin by V. Charangovitch (1970) in the Style of Jackson Pollock II 1980. Enamel and cellulose paint on canvas, 239 × 210 (941/8 × 825/8), Courtesy Lisson Gallery, London; 119 Juan Muñoz Wasteland 1986. Installation at the Galleria Marga Paz, Madrid. Mixed media, ceramic tile floor, 35 × 35 m (115 × 115 ft). Private Collection; 120 Markus Lüpertz The Triumph of Line III, 'Monument with Burned Bones' 1979. Oil and mixed media on canvas, 200 × 162 (783/4 × 633/4). Courtesy of Michael Werner Gallery, New York and Cologne. Photo Whitechapel Art Gallery, London; 121 Francesco Clemente The Fourteen Stations, No. III 1981-82. Encaustic on canvas, 198 × 236 (78 × 93). Private collection; 122 Georg Baselitz Finger Painting I - Eagle - à la 1971-72. Oil on canvas, $200 \times 130 (78\frac{3}{4} \times 51\frac{1}{8})$. Neue Galerie, Staatliche und Städtische

Kunstsammlungen Kassel, private loan; 123 Jörg Immendorff Eigenlob stinkt nicht 1983. Oil on canvas, 150 × 200 (59 × 78³/₄). Courtesy of Michael Werner Gallery, New York and Cologne; 124 Gerhard Richter 18, Oktober 1977 c. 1988. Museum Haus Esters 29 April-4 June 1989, Krefelder Kunstmuseen, Krefeld. © Krefelder Kunstmuseen. Photo Volker Döhne; 125 Anselm Kiefer Margarethe 1981. Oil and straw on canvas, 280 × 380 (110 × 150). Courtesy Anthony d'Offay Gallery, London, by permission of the artist; 126 Julian Schnabel Oar: for the one who comes out to know fear 1981. Oil, crockery, car body filler paste, wood on wood, 322.6 × 444.5 × 33 (127 × 175 × 13). Private collection; 127 Eric Fischl Bad Boy 1981. Oil on canvas, 168 × 244 (66 × 96). Private collection; 128 Malcolm Morley SS Amsterdam in Front of Rotterdam 1966. Acrylic on canvas, 157.5 × 213.4 (62 × 84). Private collection; 129 Willem de Kooning Untitled XII 1982. Oil on canvas, 177.8 × 203.2 (70 × 80). Private collection. © Willem de Kooning Revocable Trust/ ARS, NY and DACS, London 2002; 130 Philip Guston The Studio 1969, Oil on canvas, 121.9 × 106.7 (48 × 42). Private collection. Courtesy McKee Gallery, New York. Photo Eric Pollitzer; 131 Howard Hodgkin In Bed in Venice 1984-88. Oil on wood, 98.1 × 119.1 (385% × 467%). Collection Paine Webber Group, Inc., New York. Photo courtesy the artist; 132 Leon Kossoff Christchurch Spitalfields, Morning 1990. Oil on board, 198 × 188.5 (78 × 741/2). Tate Gallery, London. Photo Prudence Cumming, London. Courtesy L. A. Louver, Venice, California; 133 Tim Rollins and K. O. S. Amerika VI 1986-87. Gold watercolour and charcoal on book pages on linen, 167.6 × 480.1 (66 × 189). Private collection; 134 Keith Haring Untitled September 1983. Chalk on black paper, 220.9 × 116.8 (87 × 46). © The Estate of Keith Haring. Used by permission; 135 Jean-Michel Basquiat Discography two 1983. Acrylic and oil-crayon on canvas, 168 × 152 (66 / 8 × 59 / 8). Courtesy Galerie Bischofberger, Zurich. © ADAGP, Paris and DACS, London 2002; 136 Philip Taaffe Overtone 1983. Linoprint, collage, acrylic on paper, 225 × 225 (885/8 × 885/8). Photo courtesy Galerie Ascan Crone, Hamburg; 137 David Wojnarowicz Sex Series 1988-89. Black-and-white photograph, 78.7 × 86.9 (31 × 341/4). Courtesy of P. P. O. W. Photo Adam Reich; 138 Frank Moore Arena 1992. Oil on canvas on wood with frame, overall 155 × 183 (61 × 72). Private collection. Courtesy Sperone Westwater, New York; 139 Gran Fury Untitled 1990. Three billboards. Exhibited at the 1990 Venice Biennale: 140 Ashley Bickerton Le Art (Composition with Logos 2) 1987. Silkscreen, acrylic lacquer on plywood with aluminium, 87.6 × 182.9 × 38.1 (341/2 × 72 × 15). Private collection: 141 Robert Gober Double Sink 1984. Plaster, wood, wire lathe, steel, latex and enamel paint, 91.4 × 162.6 × 71.1 (36 × 64 × 28). Private collection; 142 Robert Gober Untitled 1991. Wood, wax, leather, fabric and human hair, 38.7 × 41.9 × 114.3 $(15\frac{1}{4} \times 16\frac{1}{2} \times 45)$. Installed at Galerie Nationale du Jeu de Paume, Paris, 3 October 1991-I December 1991. Courtesy the

artist; 143 Peter Halley White Cell with Conduit 1986. Acrylic, Day-Glo and Roll-a-tex on canvas, 147.5 × 285 (58 × 1121/4). Private collection; 144 Haim Steinbach related and different 1985. Plastic laminated wood shelf, leather basketball shoes, brass candlesticks, 91 × 52 × 51 (36 × 201/2 × 20). Private collection. Courtesy the artist and Tanya Bonakdar Gallery, New York; 145 Jeff Koons One Ball Total Equilibrium Tank 1985. Glass, iron, water, sodium chloride reagent, basketball, 164.5 × 78.1 × 36 (643/4 × 303/4 × 131/4). Private collection; 146 Martin Kippenberger With the Best Intentions I Can't Find a Swastika 1984. Oil on canvas, 160 × 133 (63 × 523/8). Courtesy Buro Kippenberger, Galerie Gisela Capitain, Cologne; 147 Rosemarie Trockel Cogito, Ergo Sum 1988. Wool on canvas, 210 × 160 (825/8 × 63). Courtesy Galerie Monika Sprüth, Cologne; 148 Sigmar Polke Higher Powers Commanded: Paint the Upper Right Corner Black! 1969. Lacquer on canvas, 150 × 120 (60 × 49) Froehlich Collection, Stuttgart; 149 Katharina Fritsch Tischgesellschaft (Company at Table) 1988. 32 polyester figures, cotton clothes and table cloth, wooden table and benches, 140 > $1600 \times 175 (55\frac{1}{8} \times 630 \times 69)$. Museum für Moderne Kunst, Frankfurt-am-Main. On permanent loan from the Dresdener Bank, Frankfurt-am-Main. Photo Axel Schneider. © DACS 2002; 150 Louise Lawler How Many Pictures 1989. Cibachrome print, 157.2 × 122.1 (61% × 48). Edition of 5. Courtesy of the artist and Metro Pictures. New York: 151 Candida Höfer Natural History Museum, London II 1990. Cibachrome print, 36 × 52 (141/8 × 201/2). Courtesy Galerie Johnen & Schöttle, Cologne; 152 Jeff Wall Outburst 1989. Transparency in light box, 229 × 312 $(90^{1}/_{8} \times 122^{7}/_{8})$. Collection Vancouver Art Gallery, Vancouver; 153 Andreas Gursky Tokyo 1990. Cibachrome print, 165 × 200 (64.9 × 78.7). Courtesy Galerie Monika Sprüth, Cologne; 154 Sherrie Levine Untitled (After Walker Evans #3, 1936) 1981. Photograph, 25.4 × 20.3 (10 × 8). © Walker Evans Archive, The Metropolitan Museum of Art, New York. Courtesy Mary Boone Gallery, New York; 155 Cindy Sherman Untitled Film Still 1977. Black-and-white photograph, 20.3 × 25.4 (8 × 10). Courtesy of the artist and Metro Pictures, New York; 156 Jenny Holzer 'Truism' on T-shirt modelled by Lady Pink 1983. Copyright Barbara Gladstone. Photo courtesy Barbara Gladstone Gallery, New York; 157 Richard Serra Tilted Arc 1981. Cor-Ten steel, 3.66 × 36.58 m × 6 cm (12 × 120 ft × 21/2 in). Installed at Federal Plaza, New York. Photo courtesy of Pace Wildenstein, New York. © ARS, NY and DACS, London 2002; 158 Tony Cragg New Stones - Newton's Tones 1978. Plastic, 330 × 235 (1297/8 × 921/2). Arts Council Collection, London. Courtesy Lisson Gallery, London; 159 Richard Deacon Art for Other People No. 10 1984. Galvanized steel and linoleum, 40 × 90 × 90 (153/4 × 353/8 × 353/8). Private collection, New York. Courtesy Lisson Gallery, London; 160 Reinhard Mucha The Figure-Ground Problem in Baroque Architecture (Das Figur-Grund Problem in der Architektur des Barock [für dich allein bleibt nur das Grab]) 1985. Dodecahedron composed of 2 tiers of superimposed panels (tables) covered in matt

grey formica, assembled on an armature of aluminium bars, 8 step ladders and 36 neon lights, stands, partially lacquered glass plate. felt, trolleys raising the work by 17 cm (6%), 12 wooden socles 340 × 450 × 450 DIA 330 (1337/8 × 1771/8 × 1771/8 DIA 130). Musée National d'Art Moderne, Paris: 161 Hans Haacke Die Freiheit wird jetzt einfach gesponsert - aus der Portokasse (Freedom is now just going to be sponsored - out of pettycash) 1990. Exhibited at 'Die Endlichkeit der Freiheit', DAAD, Berlin, 1990, Courtesy John Weber Gallery, New York. Photo Werner Zellien. © DACS 2002; 162 Judith Barry Echo 1986. 2 slides, 2 film projections per side of wall which bisects room diagonally, dimensions variable; running time approximately I minute; sound track. Commissioned and produced by The Museum of Modern Art, New York. Photo courtesy the artist and Xavier Hufkens Gallery, Brussels; 163 Barbara Bloom The Reign of Narcissism 1988-89. Installed at Jay Gorney Modern Art, New York, September 1989. Collection of the Museum of Contemporary Art, Los Angeles. Photo courtesy the artist; 164 Sylvie Fleury Poison 1992. Shopping bags, 68.6 × 152.4 × 76.2 (27 × 60 × 30). Courtesy Postmasters Gallery, New York; 165 Christian Boltanski The Missing House, installed at Grosse Hamburger Strasse 15-16, Berlin, 1990. Plagues. Exhibited at 'Die Endlichkeit der Freiheit', DAAD, Berlin, 1990. Photo Werner Zellien, © ADAGP, Paris and DACS, London 2002; 166 Rachel Whiteread Untitled (House) 1993, Sprayed concrete. Commissioned by Artangel, sponsored by Becks. Courtesy Anthony d'Offay Gallery, London; 167 Mike Kelley Dialogue #2 (Transparent White Glass) Transparent Black Glass) 1991. Blanket, stuffed animals, cassette player, 187.9 x 124.5 × 27.9 (74 × 49 × 11). Courtesy the artist and Metro Pictures, New York. Photo © Ellen Page Wilson 1992; 168 Simon Patterson The Great Bear 1992. Lithograph print, $109 \times 134.8 \times 5 (42\% \times 53 \times 2)$. Courtesy Lisson Gallery, London. Photo John Riddy, London; 169 Damien Hirst I Wanna Be Me 1990-91. Old drug bottles in cabinet, 137.2 × 101.6 × 22.9 (54 × 40 × 9). Courtesy Jay Jopling, London; 170 Andres Serrano Piss Christ 1987. Cibachrome print, silicone, plexiglass, wood frame, 152.4 × 101.6 (60 × 40). Edition of 4. Courtesy Paula Cooper Gallery, New York; 171 Robert Mapplethorpe Thomas, 1986 1986, © The Estate of Robert Mapplethorpe/Courtesy A+C Anthology, New York; 172 Cheri Samba Les Capotes utilisées 1990. Acrylic on canvas, 132.1 × 200.7 (52 × 79). Courtesy Annina Nosei Gallery, New York; 173 Rasheed Araeen A Long Walk in the Wilderness 1991. Old/used shoes. Installed at Vancouver Art Gallery, Vancouver 1991; 174 Richard Long Red Earth Circle 1989. Installed at 'Magiciens de la Terre', Centre Georges Pompidou, Paris, 18 May-14 August 1989. Photo courtesy Anthony d'Offay Gallery, London. By permission of the artist, courtesy Anthony d'Offay Gallery, London. Below: ground painting by Yuendumu community, Australia; 175 Michael Jagamarra Nelson Five Dreamings 1984.

Synthetic polymer on canvas, 122 × 182 (48 × 71%). Gabrielle Pizzi Collection. © Courtesy Anthony Wallis, Aboriginal Artists Agency, Sydney, Australia; 176 Adrian Piper What It's Like, What It Is #3. Installed at the exhibition 'Dislocations'. The Museum of Modern Art, New York, 16 October 1991-7 January 1992. Photo © 1997 The Museum of Modern Art. New York; 177 David Hammons Yo-yo 1991. Mixed media, $15.55 \times 6.1 \times 5.49$ m (51 × 20 × 18 ft). Installed at 1991 Carnegie International, Pittsburgh. Reproduced with permission of the Carnegie Museum of Art. Pittsburgh. Courtesy of the Jack Tilton Gallery, New York. Photo Richard Stoner, 1991; 178, 179 Ilya Kabakov The Toilet 1992. Installed at Documenta IX, Kassel, 1992. Mixed media, $3.05 \times 11 \times 4.17$ m ($10 \times 36 \times$ 131/2 ft). Photos Bob Lebek (exterior), Dirk Powers (interior). Courtesy Ilya and Emilia Kabakov: 180 Sophie Calle Last Seen: A Lady and Gentleman in Black by Rembrandt 1991. Photograph, 241.9 × 154.9 × 1.3 (951/4 × 61 × $\frac{1}{2}$; text 163.2 × 130.8 (64 $\frac{1}{4}$ × 51 $\frac{1}{2}$). Photo courtesy Leo Castelli Gallery, New York; 181 Tony Oursler Sexplotter (from The Watching) 1992 (detail). Cloth, plastic, mini video projector, tripod. Courtesy the artist and Metro Pictures, New York; 182 Stan Douglas Hors-champs 1992. Installed at ICA, London, September-October 1994. 2 blackand-white video projections (featuring G. Lewis, D. Ewart, K. Carter), running time 13 hours, 20 minutes. Photo courtesy David Zwirner, New York; 183 Bill Viola Nantes Tribtych 1992. Video and sound installation. Edition I: Musée des Beaux-Arts de Nantes, France; edition 2: Tate Gallery, London. Courtesy Anthony d'Offay Gallery, London. Photo Musée des Beaux-Arts de Nantes; 184 Gary Hill Tall Ships 1992. Courtesy Barbara Gladstone Gallery, New York; 185 Sue Williams The Yellow Painting 1992. Acrylic and oil on canvas, 162.6 × 137.2 (64 × 54). Courtesy Regen Projects, Los Angeles; 186 Pepe Espaliú The Nest 1993. Painted iron, 125 × 65 × 65 (491/4 × 251/8 × 25%). Installed at 'Rites of Passage', Tate Gallery, London, 1995. Fundación Coca-Cola España, Madrid. Photo Marcus Leith/ Mark Heathcote; 187 Mona Hatoum Light Sentence 1992. Wire-mesh lockers, electric motor, timer, light bulb, 198 × 185 × 490 (78 × 721/8 × 1921/8). Photo Billups/Smith. Courtesy Jay Jopling, London; 188 Joseph Beuys Terremoto in Palazzo (Earthquake in the Palace) 1981. Mixed media, 500 × 700 (1961/8 × 275½). Installed at 'Rites of Passage', Tate Gallery, London, 1995. Fondazione Amelio. Istituto per l'Arte Contemporanea, Naples. Photo Marcus Leith. © DACS 2002; 189 Felix Gonzalez-Torres 'Untitled' (Lover Boy) 1990. Blue paper, endless copies, ideal height: $19.1 \times 73.7 \times 58.4 (7\frac{1}{2} \times 29 \times 23)$. Collection of Andrea Rosen, New York. Courtesy of Andrea Rosen, New York. Photo Peter Muscato; 190 Matthew Barney CREMASTER 5: her Giant 1997. C-print in acrylic frame, 134 × 108.3 × 2.5 (523/4 × 425/8 × 1). © 1997 Matthew Barney. Photo Michael James O'Brien. Courtesy Barbara Gladstone, New York; 191 Rirkrit Tiravanija dAPERTutto 1999. Installation view at the Venice Biennale (Royal Pavilion). Wood

floor, teak tree. Courtesy Gavin Brown's enterprise, New York; 192 Kim Sooja Cities on the Move - 2727 Kilometers Botari Truck 1997. One ton truck, used clothes and bedcovers, II-day performance across Korea. Photo Lee Sang-Kil. Video still image Lee Seong Hwan. Courtesy Art & Public, Geneva, The Project, New York; 193 Vanessa Beecroft VB43 2000, Performance, Gagosian Gallery, London, Photo Todd Eberle. Courtesy of the artist and Gagosian Gallery, London; 194 Paul McCarthy Plaster Your Head and One Arm into a Wall 1973. Performance, from 'Instructions', Pasadena, California. Photo Karen McCarthy; 195 Dieter Roth Solo Scenes (Solo Szenen) 1997-98. 128 video monitors, including players, 3 wood shelves, 128 VHS videotapes. 2 racks. Edition of 3. Installation view 48th Venice Biennale, 1999, Photo A. Burger, Zurich. Courtesy Galerie Hauser & Wirth & Presenhuber, Zurich; 196 Gregor Schneider Haus u r, Rheydt 1985-2001. Photo Gregor Schneider. © DACS 2002; 197 Francis Alÿs Zocalo May 20, 1999. Single-screen DVD projection with soundtrack. Courtesy Lisson Gallery, London; 198 Eija-Liisa Ahtila Consolation Service 1999. 24 minutes, 35mm film and DVD installation for two projections with sound, chairs, paint. Installation view at Klemens Gasser & Tanja Grunert, Inc., New York. Copyright Crystal Eye Ltd, Helsinki. Courtesy Klemans Gasser & Tania Grunert. Inc., New York; 199 Pipilotti Rist Cinquante Fifty 2000. Video installation, Art Unlimited, Basel, 2001, photo walter + spehr. Courtesy Galerie Hauser & Wirth, Zurich and Luhring Augustine, New York; 200 Doug Aitken Electric Earth 1999, 8 Laserdisc installation. production still. Courtesy 303 Gallery, New York and Victoria Miro Gallery, London; 201 Ann-Sofi Sidén QM, I Think I Call Her QM 1997. 35mm film, film still. Courtesy of the artist and Galerie Nordenhake, Berlin; 202, 203 Shirin Neshat Turbulent 1998. Video still © 1998 Shirin Neshat. Courtesy Barbara Gladstone Gallery, New York; 204 Luc Tuymans Maybole 2000. Oil on canvas, 234 × 116 (921/8 × 455/8). Courtesy Zeno × Gallery, Antwerp. Photo Stefan Maria Rother; 205 Laura Owens, installation view, Sadie Coles HQ, London, November 1999. © the Artist, courtesy Sadie Coles HO, London; 206 Tadashi Kawamata Bridge Walkway 1996. Metal scaffolding, wood, paint, walkway, 114 \times 216 \times 2600 (44\% \times 85 \times 1023\%), viewing platform 114 × 453 × 518 (447/8 × 1783/8 × 203%). Installation at MACBA, Barcelona, 1996. Courtesy Annely Juda Fine Art, London; 207 Jorge Pardo 4166 Seaview Lane 1998. The Museum of Contemporary Art, Los Angeles; 208 Martin Creed Work No. 225: Everything Is Going To Be Alright 2000. Neon, aluminium. Times Square, 42nd Street and 8th Avenue, New York, January 2000. Commissioned by the Public Art Fund. Courtesy Gavin Brown's enterprise, New York; 209 Tobias Rehberger nana 2000. Installation view. Courtesy neugerriemschneider, Berlin; 210 Liam Gillick Prototype Design for the Conference Room, with Joke by Matthew Modine. Arranged by Marcus Weisbeck 1999. Frankfurter Kunstverein. Courtesy Corvi-Mora, London; 211 Rosemarie Trockel and Carsten Höller A

House for Pigs and People 1997. Installation view, Documenta X, Kassel, Courtesy Schipper & Krome, Berlin. © DACS 2002; 212 Maurizio Cattelan Bidibidobidiboo 1995. Mixed media, approx. 50 × 58 (195/8 × 227/8). Photograph Laure Genillard Gallery. Bovingdon; 213 Darren Almond Traction 1999. Three-part video installation. Duration 28 minutes. Courtesy Jay Jopling/ White Cube, London, © the artist; 214 Tracey Emin Everyone I Have Ever Slept With, 1963-1995 1995. Appliquéd tent, mattress and light, 122 × 245 × 215 (48 × 961/2 × 841/2). Courtesy Jay Jopling/White Cube, London. © the artist; 215 Jake and Dinos Chapman Rhizome 2000, Mixed media, 36 × $98.5 \times 98.5 \ (14\frac{1}{8} \times 38\frac{3}{4} \times 38\frac{3}{4})$. Courtesy Jay Jopling/White Cube, London. © the artist; 216 Franz West Haider haidert 2001. CALSI Digital print, 340 × 900 (1337/8 × 3543/8). Secession Façade Project 28 February to 13 March 2001, Secession, Vienna. Photo Matthais Hermann; 217 Manfred Pernice Klagenfurt u. A. 1999. Installation view, Galerie Nächst St Stephan, Vienna. Courtesy Galerie NEU; 218 Olafur Eliasson Green River 2000. Green colour, water. Realization in Stockholm, Sweden: 219 Thomas Hirschhorn Public Works - The Bridge 2000. 'Protest and Survive', Whitechapel Art Gallery, London: 220 Andreas Slominski Golfball-Aktion 1995. Installation, 11 March 1995, Museum Haus Esters, Krefeld: 221 Anri Sala Intervista 1998. Still from colour video. Video. 26 minutes. Courtesy Galerie Chantal Crousel, Paris; 222 Bruce Nauman Square Depression 1997-2007. Installation for Skulptur Projekte Münster 07. Photo Roman Mensing, artdoc. de. © ARS, NY and DACS, London 2014; 223 Seth Price Hostage Video Still with Time Stamp 2012. Freeze-frame from Jihadi execution video-file screen-printed on archival polyester librarian's film with signage ink, steel grommets, dimensions variable. Courtesy the artist and Petzel Gallery, New York. © Seth Price; 224 Jeremy Deller The Battle Of Orgreave 2001. Performance view. Courtesy the artist and Artangel; 225 Deimantas Narkevicius Once in the XX Century 2004. Video beta cam SP film transferred onto DVD, colour, sound (ambient), 8 minutes. Courtesy the artist, gb agency, Paris and Barbara Weiss, Berlin; 226 Felix Gmelin Farbtest, Die Rote Fahne II, (Colour Test, The Red Flag II) 2002, After Gerd Conradt's Farbtest, Die Rote Fahne 1968.

Video installation with two small projections, 22 × 30 (85/8 × 113/4), two small LCD-projectors, two manipulated Manfrotto stands. Courtesy Galerie Nordenhake, Berlin and Stockholm. © Felix Gmelin/Gerd Conradt; 227 Mircea Cantor Deeparture 2005. In loop, 16 mm transfered to BETA digital, colour, silent, 2:43 minutes. Courtesy the artist and Yvon Lambert, Paris. © 2005 Mircea Cantor. All rights reserved; 228 Artur Zmijewski Repetition 2005. Video. Courtesy the artist, Foksal Gallery Foundation, Warsaw and Galerie Peter Kilchmann, Zurich; 229 Aernout Mik Training Ground 2006. Two-channel video installation. Courtesy the artist and carlier | gebauer, Berlin. Set photography Florian Braun; 230 Paul Chan Baghdad in No Particular Order 2003. Single-channel video, 51 minutes. Courtesy the artist and Greene Naftali, New York; 231 Danh Vo We The People 2011-13, detail. Copper, dimensions variable. Courtesy the artist and Galerie Chantal Crousel, Paris, Photo Danh Vo; 232 Cao Fei/China Tracy RMB CITY: A Second Life City Planning 2007. 3D machinima, colour, sound, 5:57 minutes. Courtesy Vitamin Creative Space 2014: 233 Ed Fornieles Ivy Pink 2012. Mixed media and Tumblr feed, 130 × 115 (511/8 × 451/4), Courtesy Carlos/ Ishikawa. © Ed Fornieles; 234 Jon Rafman 9 Eves of Google Street View: Calle de Osona, Santa Perpetua de Mogoda, España 2010. Archival pigment print mounted on dibond, 101.6 × 162.6 (40 × 64). Courtesy the artist; 235 Christian Marclay The Clock 2010. Single-channel video, 24 hours. Courtesy White Cube. Photo Ben Westoby; 236 Ai Weiwei Sunflower Seeds 2010, 100 million sunflower seeds, porcelain, paint. Photo Tate, London. Courtesy the artist. © The artist; 237 Liu Xiaodong Into Taihu 2010. Oil on canvas, 300 × 400 (1181/8 × 1571/2). Courtesy the artist. © Liu Xiaodong Studio; 238 Sunyuan & Pengyu Old People's Home 2007. Electric wheelchair, fiberglass, silica gel, simulation of sculpture. Artists Sunyuan & Pengyu: 239 Rabih Mroué The Fall of a Hair Part 1: The Pixelated Revolution 2012, Video. colour, sound, 21:58 minutes. Commissioned and produced by dOCUMENTA (13), with the support of Sfeir-Semler Gallery, Beirut/Hamburg. Courtesy the artist and Sfeir-Semler Gallery, Beirut/Hamburg; 240 Wael Shawky Cabaret Crusades: The Path to Cairo 2012. HD video, colour, sound, 60:53 minutes. Courtesy the

artist and Sfeir-Semler Gallery, Beirut/ Hamburg; 241 Rayyane Tabet Steel Rings from the series The Shortest Distance Between Two Points 2013. Rolled, engraved steel with km, longitude, latitude and elevation marking of a specific location on the TAPLine, Each 80 (311/2) diameter, 10 (4) deep, 0.6 (1/4) thick. Courtesy the artist and Sfeir-Semler Gallery, Beirut/Hamburg; 242 Camille Henrot Grosse Fatigue 2013. Video, colour, sound, 13 minutes, Courtesy the artist. Silex Films and kamel mennour. Paris. © ADAGP Camille Henrot: 243 Hito Steyerl Lovely Andrea 2007. Installation view/still image, single-channel video, sound, English, Japanese and German, English subtitles, colour, 30 minutes. Courtesy Wilfried Lentz Rotterdam. © Hito Steyerl; 244 R. H. Quaytman Passing Through the Opposite of What It Approaches, Chapter 25 (after James Coleman's slide piece) 2012. Oil, tempera, silkscreen ink, gesso on wood, wood shelf, 94.1 × 152.4 (37 × 60). Courtesy the artist and Miguel Abreu Gallery, New York. Photo Christian Erroi; 245 Jana Euler Whitney 2013. Oil on canvas, 190 × 300 (743/4 × 1181/8). Courtesy dépendance, Brussels, Photo Michael De Lausnay; 246 Tauba Auerbach Untitled (Fold) 2013. Acrylic paint on canvas/ wooden stretcher, 182.9 × 137.2 × 4.6 (72 × 54 × 13/4). Collection Musée National d'Art Moderne Centre Pompidou, Paris. Courtesy STANDARD (OSLO), Oslo. Photo Vegard Kleven; 247 Bernadette Corporation Get Rid of Yourself 2003. Video, colour, sound, featuring Chloe Sevigny and Werner von Delmont, 61 minutes. Courtesy Electronic Arts Intermix (EAI), New York; 248 Paweł Althamer Common Task (Brussels) 2009. Courtesy the artist, Foksal Gallery Foundation, Warsaw; neugerriemschneider, Berlin and Open Art Projects, Warsaw; 249 Damián Ortega Cosmic Thing 2002. Stainless steel, wire, Beetle '83 and plexiglass, dimensions variable. Courtesy White Cube and Kurimanzutto, Mexico City. © Damián Ortega: 250 Amalia Pica Venn Diagrams (under the spotlight) 2011. Installation view, ILLUMInations, Venice Biennial 2011. Courtesy the artist; Herald St, London; Marc Foxx, Los Angeles and Stigter van Doesburg, Amsterdam. Photo Kiki Triantafyllou.

Index

Numbers in italic refer to illustrations

ABC art 46 Abramovic, Marina 105, 241–44; 94 Abstract Expressionism 13–16, 18, 25, 35, 39–40, 46, 76, 154, 165 Acconci, Vito 103, 241–44; 92 Actionism 103–105 Afif, Saådane 248 Agam 25 Ahtila, Eija-Liisa 221; 198 Ai Weiwei 260–61; 236 Aitken, Doug 221–23; 200
Alberola, Jean-Michel 145
Alloway, Lawrence 23–25
Almond, Darren 235; 2/3
Althamer, Pawel 273; 248
Althoff, Kai 230
Alys, Francis 219; 197
Anarchitecture 135
Anastasi, William 69
Anatsui, El 273
Anderson, Laurie 126, 135
Andre, Carl 13, 44, 46, 53–56, 89, 109, 110, 153; 49, 50
Andrews, Michael 155
Anselmo, Giovanni 65, 84, 86; 78

Anti-Form 61–62, 65–66 Antin, Eleanor 126 Antonakos, Stephen 44 Anuszkiewicz, Richard 27 Apple, Jackie 26 Araeen, Rasheed 197–99; 173 Arbus, Diane 114 Arcangel, Cory 257–58 Armajan, Siah 185 Armaly, Fareed 189 Arman 29, 30–33; 26 Armleder, John 164 Art & Language 79–81, 139; 72, 118 Art Workers' Coalition (AWC) 110 Arte Povera 28, 61, 65, 84–88, 146 Artschwager, Richard 164 Åsdam, Knut 221 Ashcan school 49 Asher, Michael 96, 136, 175, 189–90; 116, 117 assemblage 11–12 Atkins, Ed 266 Auerbach, Frank 155 Auerbach, Frank 155 Avedon, Richard 183 Aycock, Alice 94; 86

Bacon, Francis 155 Baer, Jo 40-42, 109 Bainbridge, David 79 Baker, Bobby 126 Baldessari, John 74, 79; 69 Baldwin, Michael 79; 71 Ball, Hugo 12 Barceló, Miguel 145 Barney, Matthew 204, 219; 190 Barry, Judith 184; 162 Barry, Robert 72-74, 76; 70 Bartana, Yael 265 Barth, Uta 221 Baselitz, Georg 145, 146–48, 165; *122* Basquiat, Jean-Michel 157–58; *135* Becher, Bernhard and Hilla 92, 172; 83 Beckmann, Max 152 Beecroft, Vanessa 219; 193 Bell, Larry 44, 118, 183 Benglis, Lynda 63-65; 57 Bengston, Billy Al 22 Bennett, Gordon 200 Bernadette Corporation 271-72; 247 Beuys, Joseph 36, 100, 105-108, 113, 140, 149, 151–52, 170, 184–85, 197–99, 208, 244-45; 95, 96, 188 Bickerton, Ashley 163, 166; 140 Bidlo, Mike 164 Bijl, Guillaume 186 Billingham, Richard 235 Biumo, Count Giuseppe Panza di 144, 153 Bladen, Ronald 44 Blais, Jean-Charles 145 Blake, Peter 23 Bleckner, Ross 160-61, 226 Bloom, Barbara 184; 163 Bochner, Mel 53, 74 Body art 8, 61, 103 Boetti, Alighiero e 84 Bollinger, Bill 44, 65 Boltanski, Christian 186; 165 Bolus, Michael 43 Bomberg, David 155 Bömmels, Peter 168 Bontecou, Lee 40 Boshier, Derek 25 Bourgeois, Louise 120, 201; 102, 105 Bourke-White, Margaret 114 Brancusi, Constantin 55 Braque, Georges 28, 44 Brätsch, Kerstin 268, 269 Brecht, George 100 Brehmer, K. P. 36-38, 114 Breitz, Candice 221 Brisley, Stuart 105 Broodthaers, Marcel 83, 175, 189-90; 74 Brouwn, Stanley 102 Bruguera, Tania 273 Brüs, Gunter 102 Bulloch, Angela 192, 235

Burden, Chris 103, 244

Buren, Daniel 69-72, 74, 164; 63

Burgin, Victor 74, 114-15, 137

Burn, Ian 81 Bury, Pol 25 Butler, Reg 116 Butt, Hamad 208 Büttner, Werner 168 Byrne, Gerard 249

Cabaret Voltaire 12 Cadere, André 102 Cage, John 36, 47, 100 Calame, Ingrid 226 Calder, Alexander 43 Calle, Sophie 201-203; 180 Calzolari, Pier Paolo 84, 146 Campbell, Duncan 267 Campbell Jnr, Robert 200 Cantor, Mircea 251-52; 227 Cao Fei/China Tracy 256; 232 Capitalist Realism 35 Caro, Anthony 42-43, 53, 67, 163; 39 Carpenter, Merlin 235 Cattelan, Maurizio 235; 212 Ceccobelli, Bruno 146 Celant, Germano 84, 87 César 11, 29, 30; 23 Chadwick, Helen 27 Chamberlain, John 30, 153; 22 Chan, Paul 255; 230 Chapman, Dinos 236; 215 Chapman, Jake 236; 215 Chetwynd, Marvin Gaye 266 Chia, Sandro 145-46 Chicago, Judy 44, 117-18, 122; 99 Chillida, Eduardo 153 Christo and Jeanne-Claude 31-33, 132; 113 Chto Delat? (What is to be Done?) 272-73 Cibulka, Heinz 103 Clemente, Francesco 145-46; 121 Combas, Robert 145 Conceptualism 8, 61, 68, 74, 81-83, 102, 109, 123, 136-37, 164, 174, 186, 200 Constructivism 25 Coplans, John 208 Cragg, Tony 180-81; 158 Creed, Martin 230; 208 Croft, Brenda 200 Cubism 11, 28, 40 Cucchi, Enzo 145, 146 Currin, John 224 Cytter, Keren 267

Dadaism 11, 36, 46 Dahn, Walter 168 Daniëls, René 145 Darboven, Hanne 73; 64 Deacon, Richard 180; 159 Deganello, Paolo 185 DeLap, Tony 44 Deller, Jeremy 250; 224 Demuth, Charles 49 Dessi, Gianni 146 Diamond, Jessica 189 Dibbets, Jan 67, 89 Dijkstra, Rineke 221 Dine, Jim 11 Dion, Mark 189 Dokoupil, Georg Jiri 168 Douglas, Stan 204, 207; 182 Duchamp, Marcel 12, 27, 33, 44-46, 56, 76, 165

Edelson, Mary Beth 119, 122 Eliasson, Olafur 240; 218 Emin, Tracey 236; 214 English, Rose 126 Environmental art 61, 96, 136 Epaminonda, Haris 249 Espaliú, Pepe 208; 186 Euler, Jana 268; 245 Evans, Walker 174–75 Export, Valie 105, 239; 93 Expressionism 147, 170

Fabro, Luciano 84 Fahlström, Öyvind 33-35 Fahrenholz, Loretta 268 Fast, Omer 255 Federle, Helmut 164 Feminism 8, 115-17, 123 Fend, Peter 189 Fetting, Rainer 147 Finlay, Ian Hamilton 93; 84 Finn-Kelcey, Rose 126 Fischl, Eric 145, 149, 152; 127 Flanagan, Barry 66; 59 Flavin, Dan 44, 52-53, 106, 153; 45 Fletcher, Harrell 257 Fleury, Sylvie 186; 164 Floyer, Ceal 235 Fluxus 36, 100, 108 Flynt, Henry 68 Fontana, Lucio 28 Fornieles, Ed 256-57; 233 Fowler, Luke 249 Frampton, Hollis 51-52 Frankenthaler, Helen 39 Fraser, Andrea 189, 248 Fried, Michael 58-59, 61, 68, 139 Fritsch, Katharina 170-72; 149 Fulton, Hamish 67, 88, 89-90 Fusco, Coco 254 Futurism 11

Gabo, Naum 25 Gallaccio, Anya 192 Garouste, Gérard 145 Gates, Theaster 272 Geldzahler, Henry 15 Gilbert and George 67, 101-102; 91 Gilbert-Rolfe, Jeremy 184 Gillick, Liam 230, 232, 235; 210 Ginnever, Charles 43 Girouard, Tina 134 Glass, Philip 59 Gmelin, Felix 250-51; 226 Gober, Robert 165-66, 208; 141, 142 Goldstein, Jack 145, 164 Golub, Leon 112-13; 98 Gonzalez, Julio 153 Gonzalez-Foerster, Dominique 235 Gonzalez-Torres, Felix 210-11, 244; 189 Goodden, Carol 134 Gormley, Antony 180 graffiti art 155-57 Graham, Dan 81, 96, 135-36; 73, 89 Gran Fury 158; 139 Graves, Nancy 121; 103 Greenberg, Clement 8, 40, 42, 45-46, 56, 58, 80-81, 111, 116, 137, 224 Greenfort, Tue 272 Grooms, Red 11 Grosvenor, Robert 44 Gursky, Andreas 172, 174; 153 Guston, Philip 154-55; 130 Guzmán, Federico 152-53

Haacke, Hans 96, 110–12, 186–87, 189–90; 97, 161 Hacker, Dieter 114, 147 Hains, Raymond 30 Halley, Peter 163–64, 225; 143 Hamilton, Richard 21, 23–25, 38 Hammond, Harmony 121-22; 104 Hammons, David 200-201; 177 Happenings 21, 108 Hard-edge painting 40 Haring, Keith 157-58; 134 Harrison, Helen and Newton 96 Harvey, Marcus 236 Hatoum, Mona 208-10: 187 Haus Rucker Co. 185 Hazoumé, Romuald 273 Heartfield, John 114 Heizer, Michael 90, 92-93 Henderson, Nigel 23 Henri, Robert 49 Henrot, Camille 266; 242 Herold, Georg 168, 170 Hesse, Eva 63–65, 106, 119–21; 54, 55, 101 Heyward, Julia 126 Higgins, Dick 100 Hill, Gary 204-207; 184 Hiller, Susan 129, 208; 111, 112 Hirschhorn, Thomas 240; 219 Hirst, Damien 191-94, 236; 169 Hockney, David 25, 102; 16 Hodgkin, Howard 155; 131 Hödicke, K. H. 147 Höfer, Candida 172: 151 Hollein, Hans 185 Höller, Carsten 232-33: 211

Hoyland, John 25 Huebler, Douglas 74–76; 67 Hughes, Robert 103 Hume, Gary 192, 193, 226 Hurrell, Harold 79 Huxley, Bethan 89 Huxley, Paul 25 Huyghe, Pierre 221, 235 Hybert, Fabrice 230 Hyper Realism 154

Iglesias, Cristina 152

Holzer, Jenny 174, 177; 156 Horn, Rebecca 128–29, 186; 110

Houshiary, Shirazeh 180

Holt, Nancy 94

Immendorff, Jörg 113, 147, 149, 168; 123 Impressionism 40 Independent Group 38 Indiana, Robert 22, 30 Installation 8, 96, 184, 200–204 International Trans-avantgarde 143–44 Irwin, Robert 96, 118 Isermann, Jim 230 Isozaki, Arata 185

Jacir, Emily 264–65 Jagamarra Nelson, Michael 199–200; 175 Johns, Jasper 12, 15, 30; 7 Johnson, Larry 189 Johnson, Tim 200 Jonas, Joan 126 Jones, Allen 25 Jones, Sarah 221 Jorn, Asger 36, 168 Judd, Donald 44, 46, 55, 57–58, 78, 93, 109, 153, 193; 42, 46, 47

153, 193; 42, 46, 47 July, Miranda 257 Kabakov, Ilya 201, 203–204; 178, 179 Kaltenbach, Stephen 65, 74 Kapoor, Anish 180 Kaprow, Allan II Kawamata, Tadashi 229; 206 Kawara, On 73; 65 Keane, Tina 126 Kelley, Mike 190, 216–17; 167

Kelly, Ellsworth 42, 43, 163; 37 Kelly, Mary 127-28, 189-90; 109 Kennard, Peter 114 Kentridge, William 214, 219 Kids of Survival (K. O. S.) see Tim Rollins Kiefer, Anselm 145, 148, 151, 165, 168, 170, 200; 125 Kienholz, Ed 22, 38; 14 Kilimnik, Karen 190 Kinetic art 25, 28 King, Phillip 43; 40 Kippenberger, Martin 168-70; 146 Kirchner, Ernst Ludwig 147 Kirkeby, Per 145 Kitaj, R. B. 25, 155 Klein, Yves 11, 29, 30-33, 79; 28 Knowles, Alison 100 Koberling, Bernd 147 Koether, Jutta 268 Komar, Vitali 203 Kooning, Willem de 46, 154; 129 Koons, Jeff 166-68, 184, 186, 194; 145 Kossoff, Leon 155; 132 Kosuth, Joseph 74-75, 76-78, 81: 68 Kounellis, Jannis 84, 87, 146, 186; 75 Kozlov, Christine 81 Krisanamis, Udomsak 224 Kruger, Barbara 174-75

Kusama, Yayoi 31; 25

Land art 8, 61, 93-94, 102, 136 Landers, Sean 190 Landry, Richard 134 Lasker, Jonathan 163, 225 Latham, John 33, 113 Lawler, Louise 174-75, 184; 150 LeBrun, Christopher 145 Leccia, Ange 185 Leckey, Mark 266 Leonard, Zoë 189 Le Parc, Julio 25 Le Va, Barry 65, 105 Levine, Sherrie 164, 174–75, 184; *154* LeWitt, Sol 44, 52, 68, 81, 99; *60*, *61* Lichtenstein, Roy 13-14, 18, 25, 29, 35; 6, 11 Ligon, Glenn 273 Lin, Maya Ying 133-34; 114 Lippard, Lucy 61, 110, 115-16, 124-25 Lissitzky, El 186 Liu Wei 261 Liu Xiaodong 261; 237 Long, Richard 67, 88-91, 102, 199; 80, 174 Longobardi, Nino 146 Louis, Morris 39, 40, 43, 49, 63-65; 35 Lueg, Konrad 35; 30 Lukin, Sven 40 Luminism 28

Maciunas, George 100
Mack, Heinz 28
Macuga, Goshka 249
Magritte, René 83
Malevich, Kasimir 44–45, 157, 163
Manetas, Miltos 224
Mangold, Robert 69
Manzoni, Piero 33; 27
Mapplethorpe, Robert 194–95, 239; 171
Marclay, Christian 258; 235
Marden, Brice 155
Marden, Brice 155
Maria, Nicola de 146
Maria, Walter de 90–93, 96; 85
Marten, Helen 266
Martin, Agnes 155

Lüpertz, Markus 144, 145, 147; 120

Luxemburg, Rut Blees 221

Martinez, Daniel J. 208 Matta-Clark, Gordon 134-36, 210; 115 McCarthy, Paul 216-17, 219; 194 McCracken, John 63; 52 McLean, Bruce 67, 145 Meireles, Cildo 82 Melamid, Alexander 203 Merz, Mario 28, 68, 84, 87, 146; 79 Merz, Marisa 84 Metzger, Gustav 114 Meuser 181 Middendorf, Helmut 147 Mik, Aernout 252-53; 229 Miller, John 216 Milroy, Lisa 190-91 Minimalism 8, 13, 44-59, 61-62, 63, 68-69, 74, 81, 90, 96, 106, 119, 134, 140, 153, 155, 164, 186, 190, 200, 219, 232, 235 Miss, Mary 94; 87 modernism 140-41 Moore, Frank 158; 138 Moore, Henry 43 Moorman, Charlotte 100 Morellet, François 27 Morley, Malcolm 154; 128 Morris, Robert 44, 46, 57-59, 65, 79, 105; 41,51 Morris, Sarah 224 Morrison, Jasper 185 Morton, Ree 121 Mosset, Olivier 69, 164 Mroué, Rabih 262-63: 239

Narkevicius, Deimantas 250; 225 Nauman, Bruce 65, 96-99, 103, 189-90, 219, 247; 56, 88, 90, 222 neo-Conceptualism 166, 184 neo-Dada 12, 36 neo-Expressionism 143-44, 147, 168 neo-Geo 164 Neshat, Shirin 214, 221, 223; 202, 203 Neue Sachlichkeit 149, 268 Neue Wilde 147 Newman, Barnett 11, 42, 49, 52-53, 62, 154, 163, 165: 44 Nitsch, Hermann 102-103 Noland, Kenneth 39, 40, 43, 49, 67; 36 Nonas, Richard 135 Nouveau Réalisme 29-33 Nul group 28

Mucha, Reinhard 181; 160

Muñoz, Juan 152, 201; 119

Muehl, Otto 102

Oehlen, Albert 168-70 Oehlen, Markus 168 Ofili, Chris 238 Oiticica, Helio 82 Oldenburg, Claes 11, 13, 18-19, 21, 25, 38; 12 Olitski, Jules 43, 163 Ondák, Roman 248 Ono, Yoko 100 Op art 27, 160-61, 226 Opalka, Roman 73 Opie, Julian 190-91 Oppenheim, Dennis 105 Oppenheim, Meret 120 Orozco, Gabriel 219 Ortega, Damián 273; 249 Ortner, Laurids 185 Ortner, Manfred 185 Oursler, Tony 204, 216; 181 Owens, Laura 225; 205 Paik, Nam June 99-100 Paladino, Mimmo 145, 146

Palermo, Blinky 96 Panamarenko 66 Pane, Gina 105, 241-44 Paolini, Giulio 84-86 Paolozzi, Eduardo 23-25 Pardo, Jorge 230, 232; 207 Parreno, Philippe 235 Pascali, Pino 84 Patterson, Simon 192-93; 168 Penck, A. R. 149 Penone, Giuseppe 84, 86-87; 76 Performance art 8, 61, 100-102, 103-105, 123, 125-26, 141 Pernice, Manfred 240; 217 Peterman, Dan 230 Pettibon, Raymond 190 Peyton, Elizabeth 224 Phillips, Peter 25 Phinthong, Pratchaya 273 Pica, Amalia 273; 250 Picasso, Pablo 28, 35, 42, 113, 153, 164 Piene, Otto 28 Pierson, Jack 190 Piper, Adrian 123, 200-201; 106, 176 Pistoletto, Michelangelo 28, 84; 21, 77 Poledna, Matthias 249 Political art 61, 137 Polke, Sigmar 35, 36, 147, 151, 168, 170; 31, 148 Pollock, Jackson 11, 15, 18, 33, 39, 46, 65, 121, 208 Poons, Larry 43 Pop art 8, 13-29, 35, 36-38, 49, 59, 61, 109, 140, 164 post-minimalism 62, 105-106, 136, 190 postmodernism 8, 143-45, 165 Post-painterly Abstraction 25, 40, 80 Potter, Sally 126 Precisionism 49 Price, Elizabeth 266 Price, Seth 249; 223 Prieto, Monique 226 Primary Structures 46 Primitivism 196-97 Process art 61-62

Quaytman, R. H. 268; 244 Qiu Zhijie 261

public art 131-32, 141, 177, 187-89

Prouvost, Laure 266

Raad, Walid (The Atlas Group) 263-64 Rafman, Jon 258-59; 234 Rainer, Arnulf 105 Rainer, Yvonne 59 Ramos, Mel 22 Ramsden, Mel 79, 81 Rags Media Collective 267 Rauch, Neo 224 Rauschenberg, Robert 11, 12, 30, 36-38; 3, 5 Ray, Man 33 Raysse, Martial 31 Rego, Paula 145 Rehberger, Tobias 230, 232; 209 Reich, Steve 59 Reinhardt, Ad 76-77, 101, 157 Rhoades, Jason 217 Richter, Gerhard 35, 36, 145, 147, 151, 164; 1, 29, 30, 124 Riley, Bridget 27, 160, 226; 19 Rist, Pipilotti 221; 199 Rivera, Diego 132 Rochfort, Desmond 132 Rockenschaub, Gerwald 164 Röder, Adele 269

Rollins, Tim, and K. O. S. 156; 133 Rosenbach, Ulrike 128 Rosenquist, James 13, 15, 18; 8 Rosler, Martha 124 Rotella, Mimmo 31 Roth, Dieter 219; 195 Rothko, Mark 62, 154 Rückriem, Ulrich 103 Ruff, Thomas 172 Ruscha, Edward 22, 30, 74; 15 Ruthenbeck, Reiner 103 Ryman, Robert 66, 155; 58 Saint-Phalle, Niki de 29, 33

Sala, Anri 241: 221 Salle, David 145, 149, 152 Salome 147 Samba, Cheri 197; 172 Sander, August 114 Saret, Alan 65 Schapiro, Miriam 117 Scharf, Kenny 157 Schnabel, Julian 145, 149, 165; 126 Schneeman, Carolee 103 Schneider, Gregor 219; 196 School of London 155 Schütte, Thomas 185 Schuyff, Peter 160 Schwarzkogler, Rudolf 102 Scott, Tim 43 Segal, George 22 Sehgal, Tino 248 Self, Colin 38; 32 Serra, Richard 62-63, 65, 109, 153, 178-79: 53, 157 Serrano, Andres 194-95, 239; 170 Sevilla, Ferrán Garcia 145 Shaker design 49 Shawky, Wael 263; 240 Sheeler, Charles 49 Sherman, Cindy 174-78, 184; 155 Sidén, Ann-Sofi 221; 201 Sietsema, Paul 249 Sillman, Amy 268, 269 Simonds, Charles 129-31 Simpson, Lorna 207 Sigueiros, David Alfaro 132 Situationism 36 Sjoo, Monica 118; 100 Slominski, Andreas 241: 220 Smith, David 42 Smith, Richard 25, 40; 38 Smithson, Robert 44, 89-92, 102, 189-90; Social art 137 Socialist Realism 28, 35, 139 Solakov, Nedko 267 Solano, Susana 152-53 Sonfist, Alan 96 Song Dong 261 Sonnier, Keith 65 Sooja, Kim 214; 192 Soto, Jesús Rafaël 25-27; 17 Sottsass, Ettore 185 Spatialism 28 Spero, Nancy 124; 108

Sturtevant, Elaine 164 Sunyuan & Pengyu 261–62; 238 Suvero, Mark di 43, 255

Taaffe, Philip 160, 161, 165, 226; 136 Tabet, Rayyane 263; 241 Takis 110 Thiebaud, Wayne 22 Tillers, Imants 165, 200 Tillmans, Wolfgang 221 Tinguely, Jean 11; 25-27, 29, 30, 33; 4 Tiravanija, Rirkrit 210, 213, 255; 191 Tjapaltjarri, Clifford Possum 199-200 Tordoir, Mareisse 145 Toroni, Niele, 69, 164; 62 Trans-avantgarde art 143-44 Trecartin, Ryan 266 Trockel, Rosemarie 170, 232-33; 147, 211 Truitt, Anne 40 Turner Prize 53-54 Turnell, James 92, 96, 118 Tuttle, Richard 66 Tuymans, Luc 224-25; 204 Twombly-Cy, 155 Tzara, Tristan 12 ** Uecker, Gunther 28; 20 Ukeles, Mierle 126; 2

Vaísman, Meyer 164 van Warmerdâm, Marêjke 221 Vasarely, Victor 27, 160; 18 Villeglé, Jacques de la 30; 24 Viola, Bill 204–205; 183 Vo. Danh 255: 231

Viola, Bill 204–205; 183 Vo, Danh 255; 231 von Hausswolff, Annika 220 von Wedemeyer, Clemens 267 Vostell, Wolf 36–38, 100, 114; 33 Vries, Herman de 28

Walker, Kara 273 Walker, Kate 126 Wall, Jeff 174; 152 Wang Jianwei 261 Warhol, Andy 13, 15-18, 29, 31, 35, 38-39, 49, 55, 109, 153, 157, 168, 177, 183-84, 185-86, 245; 9, 10, 34 Weibel, Peter 105 Weiner, Lawrence 74-75, 81; 66 Wentworth, Richard 180 Wesselmann, Tom 13, 21-22, 30; 13 West, Franz 239; 216 Weston, Edward 174-75 Whiteread, Rachel 189; 166 Wilding, Alison 180 Willats, Stephen 132-33 Williams, Sue 208; 185 Wilson, Martha 26 Winsor, Jackie 121 Wodiczko, Krzysztof 177, 195 Wojnarowicz, David 158-60; 137

Women Artists in Revolution (WAR) 115

Woodrow, Bill 180 Xu Zhen 269–70

Wolfson, Jordan 266

Yang Fudong 261 Young, LaMonte 100 Yuskavage, Lisa 224

Zamp-Kelp, Günter 185 Zero group 28 Żmijewski, Artur 252; 228 Zorio, Gilberto 65, 84 Zox, Larry 43

Spoerri, Daniel 29, 31

Stevens, May 124; 107

Steyerl, Hito 265-67; 243

Stockhausen, Karlheinz 100

Steinbach, Haim 166-68, 184, 186; 144

Stella, Frank 47, 49, 51-52, 163, 175;

Staeck, Klaus 114

43 48

Strand, Paul 114

Struth, Thomas 172